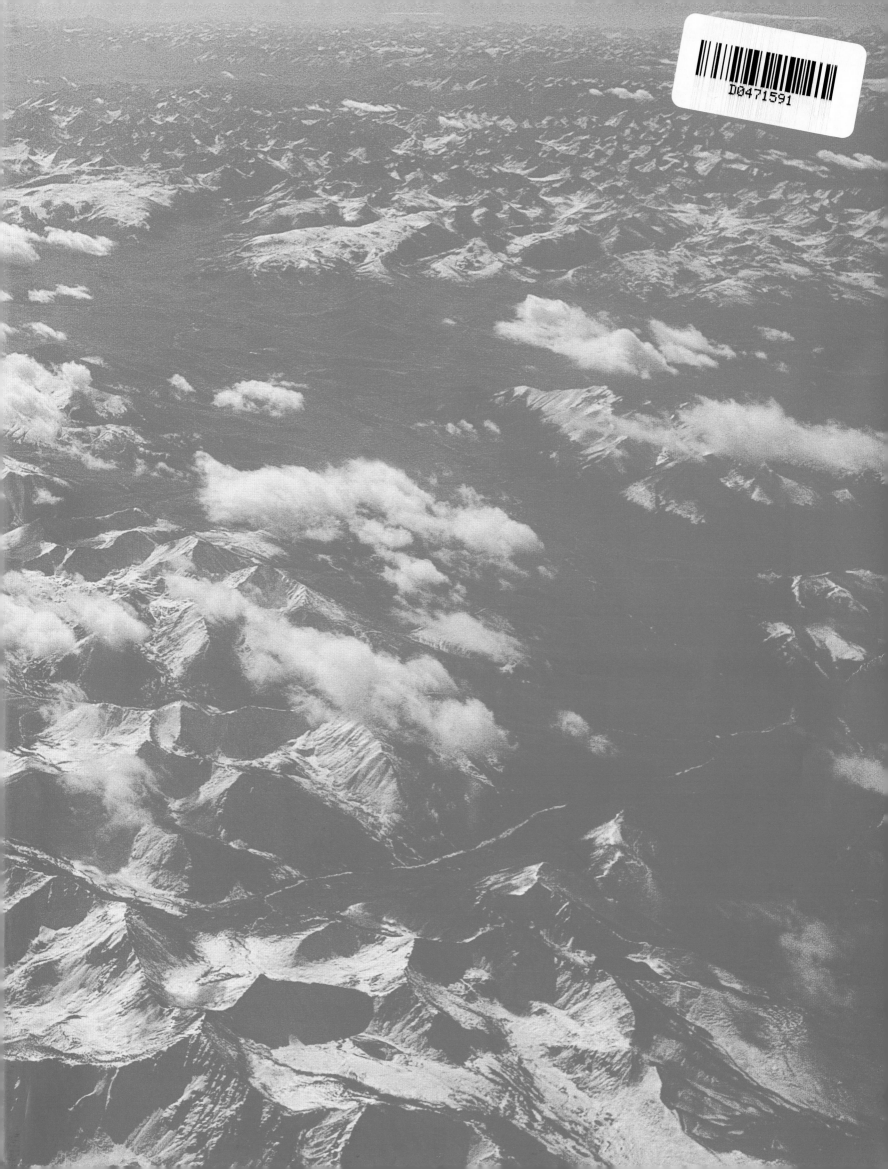

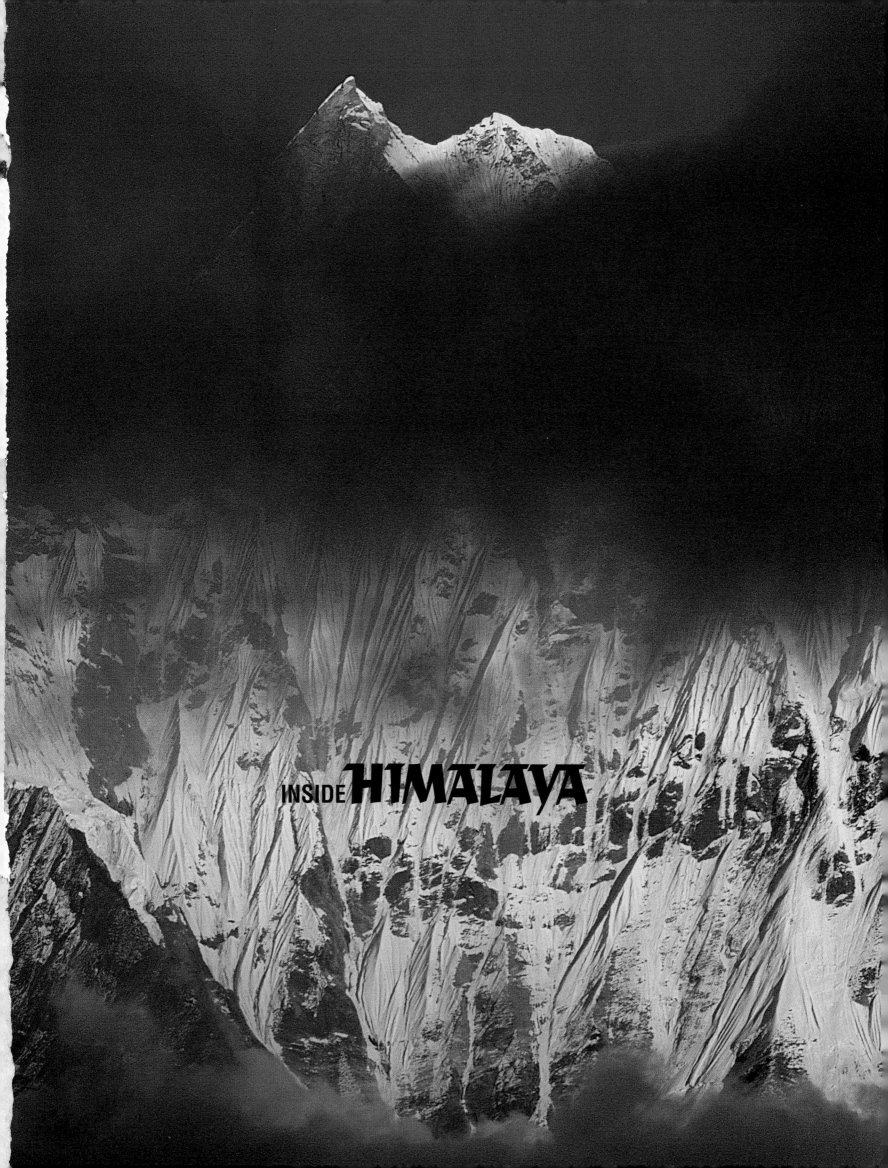

INSIDE HIMALAYA

FOR JOHN, DEREK, GEORGE & POKEY. AND ALL WHO DWELL WITHIN MY HEART AND BEYOND THE CLOUDS.

INSIDE HIMALAYA

PHOTOGRAPHS BY BASIL PAO FOREWORD BY MICHAEL PALIN

WEIDENFELD & NICOLSON

CONTENTS 6 FOREWORD 10 MAP OF THE JOURNEY 12 PAKISTAN 42 INDIA

88 NEPAL 104 TIBET 138 CHINA 152 BHUTAN 168 BANGLADESH 188 POSTSCRIPT

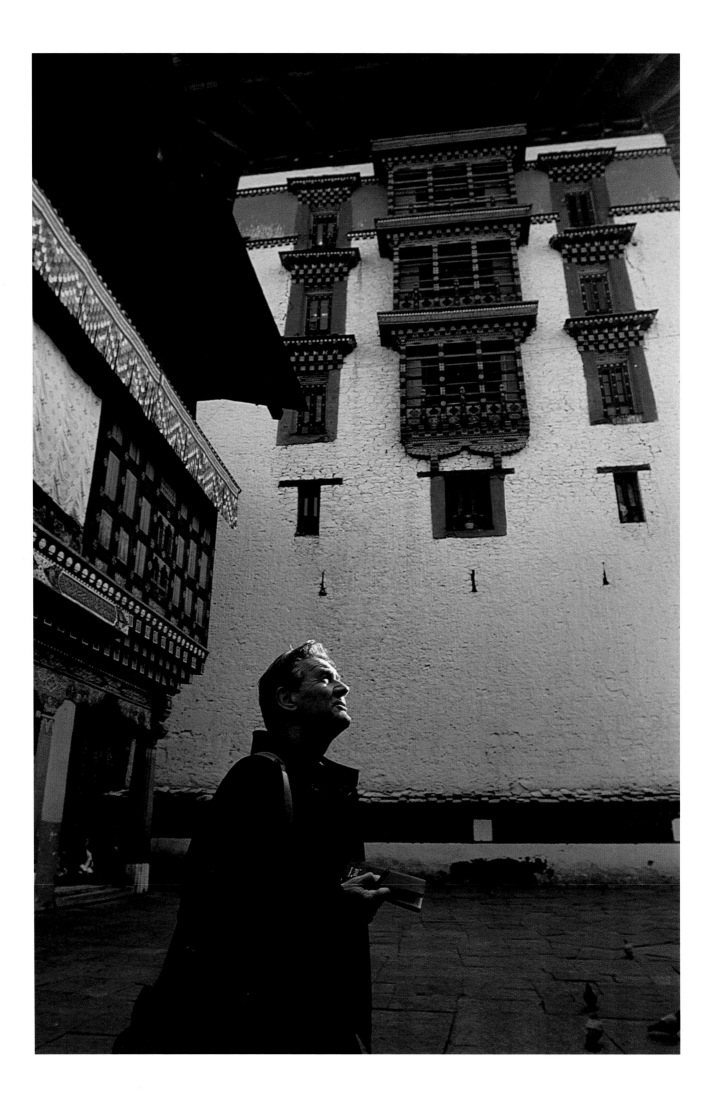

In my introduction to *Inside Sahara* I expressed my feeling that though crossing the desert might not be the most comfortable journey I've made with Basil, I hoped it wouldn't be the last. *Inside Himalaya* is here to prove that Sahara wasn't the last, and it certainly wasn't the least comfortable. On a map of the world, the Himalaya range looks almost innocuous. The great brown vastness of the Sahara dominates any map, as do the Great Lakes or the Greenland Ice Sheet or even the Andes. The Himalaya, on the other hand, though 1500 miles long, comes over as a smudge of crumply contours, upstaged by mighty China to the north and seething India to the south, with a cluster of glamorous and oddly familiar names squeezed in amongst them. Kashmir, Ladakh, Nepal, Bhutan. Countries that have been confused with Shangri-la so often you're no longer quite sure if they're real or not. If the Himalaya, the Abode of Snow, fails to punch its full weight on the page, it is because, as Basil and I have discovered to our cost, their size and scale and impact is in the vertical not the horizontal. Mount Everest is five and a half miles high and unless your cartographer is especially gifted, this kind of upward spread is hard to put across.

More than anywhere else I've travelled, the Himalaya is a case of seeing is believing. Whatever you've heard or read is going to fall a long way short of the sheer power of the reality. Though you may have seen Annapurna or K2, Lhotse or Everest, on calendars or in magazines, nothing prepares you for the sight of hundreds of thousands of other largely nameless peaks, thrust up into the sky by the massive impact of intercontinental collision 50 million years ago. In mountain-building terms, 50 million years is like the day before yesterday. There are hills you can walk up in Scotland that are ten times as old as the Himalaya. What this means is that the smoothing, flattening, equalizing forces of erosion have barely got to work on the world's highest mountain range. As a result, the Himalaya is the greatest concentration of vertical surfaces on the planet, a constantly breathtaking vision of a world thrown skywards, an infinitely spectacular catalogue of peaks and pinnacles, precipices, summits and snowfields, gorges, crags and canyons.

The basic challenge for a photographer is getting it all in; finding a way to transfer the drama we saw out there into two dimensions without losing the raw punch of it all. Overcoming a natural disinclination to walk up, or down, mountains, Basil has, as usual, been in the right place at the right time and if I want to remember how beautiful it was up there, and how hard it was too, I can just take a look at these pictures.

But the other element that impressed me on this journey was the relationship of man to nature. The contrast of mighty mountainside with tiny human presence, whether it be terraces of rice on the tip of a crag or an old woman carrying her own weight in firewood, offered some of the most surprising and surreal images of the journey. Here was even greater drama than the soaring slopes and rock stacks. Basil's photographs have perfectly caught this combination of the sublime and the mundane that only happens in the high mountains.

The Himalaya were never easy to penetrate, but once in there, the chances of meeting the unusual, unexpected and downright bizarre were greatly increased. Remote monasteries, isolated religious sites, magic rituals, lives lived virtually cut off from the rest of the world were a series of rare treats, a reward for putting ourselves in awkward and frequently uncomfortable situations. Situations that any sensible person would probably have avoided.

The high Himalaya may seem a monochrome world of shades of grey, but my memory of almost everywhere we went is of bold and vibrant colour, from the robes of the monks, the elaborate *thangkas* and the vivid decoration of houses in Tibet and Bhutan, to the bright saris and the golden temples of India, the liveries of the bull racers in Pakistan and the multitude of shades of green in the fields of Bangladesh. Almost every view had something eye-catching in it, and Basil's problem when compiling this book was the same as ours when compiling the film – there was just too much good material.

It's never easy taking photographs with a crew at work. Already laden down with gear, the stills man has to choose his moment carefully, squeezing his shots in between those moments when film camera and sound are turning. Basil's pretty used to that now, but I'm sure he'd be the first to agree that things don't get any easier. The fact that *Inside Himalaya* is yet another eye-opener of a book, a glimpse of the raw life and rich beauty we all saw, says much for Basil's tenacity and the sharpness of his eye. I think he was helped by the fact that much of this trip was on his patch, as it were. His work with Bertolucci on the movie *Little Buddha* gave him rare insights into the Buddhist religion, and, having been born in Hong Kong, he has a good eye for China and the Chinese.

The only thing Basil is no good at is taking a photograph that someone else might have taken, so you won't find any of those in here. What you will find is fresh, inventive and unique. One of the world's most extraordinary places matched by someone who will go to the most extraordinary lengths to make sure he gets the best. And that's just when it comes to choosing a tent.

The title of this collection, *Inside Himalaya*, neatly sums up the privilege we all had of being somewhere special, of seeing things that few outsiders had seen before. Neither Basil nor I are getting any younger and Himalaya was undoubtedly the toughest travelling we've done together. But this collection proves beyond doubt that we were right to aim high.

Michael Palin, London, April 2004

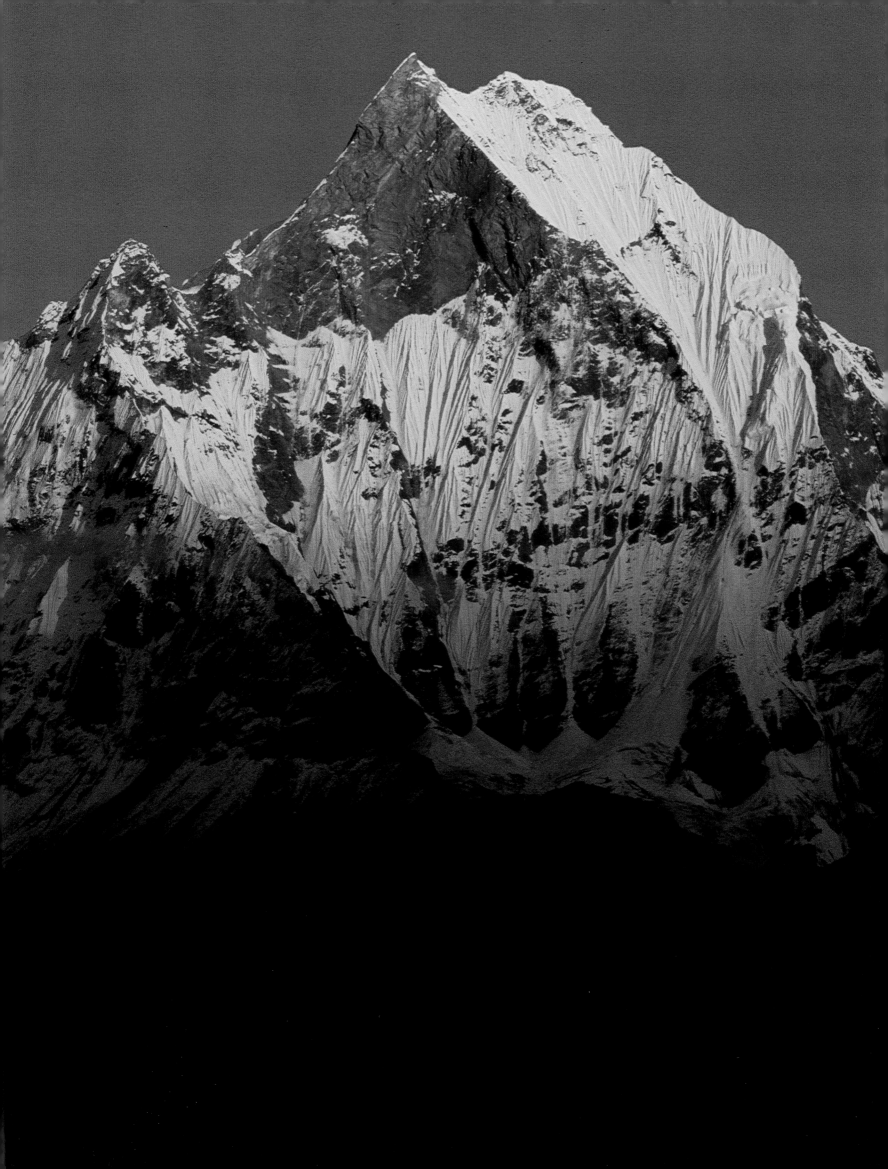

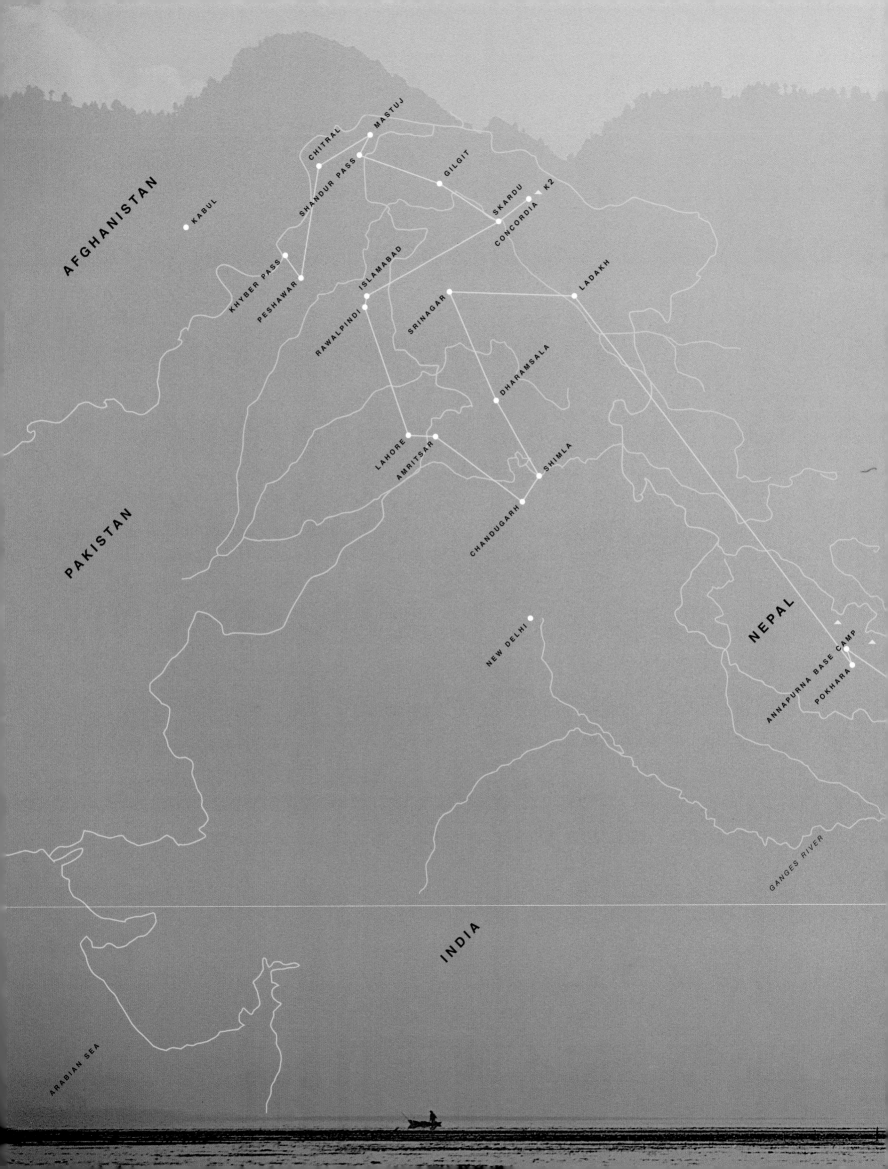

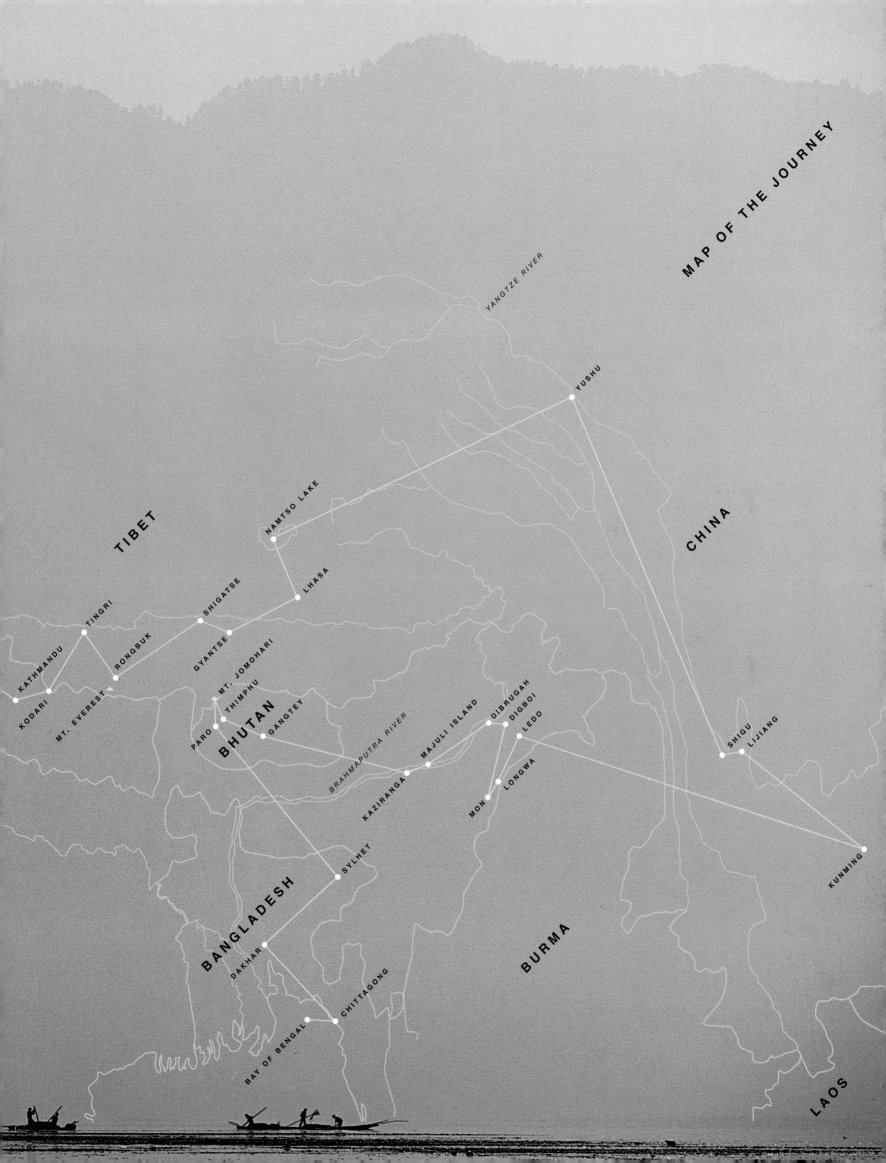

MAP OF THE JOURNEY

TIBET

CHINA

Yangtze River

YUSHU

NAMTSO LAKE

SHIGATSE
TINGRI
KATHMANDU
RONGBUK
GYANTSE
LHASA

KODARI
MT. EVEREST
MT. JOMOHARI
THIMPHU
PARO
GANGTEY
BHUTAN

Brahmaputra River

KAZIRANGA
MAJULI ISLAND

DIBRUGAH
DIGBOI
LEDO

LONGWA
MON

SHIGU
LIJIANG

KUNMING

SYLHET

BANGLADESH

DAKHAR

BURMA

CHITTAGONG

BAY OF BENGAL

LAOS

PAKISTAN

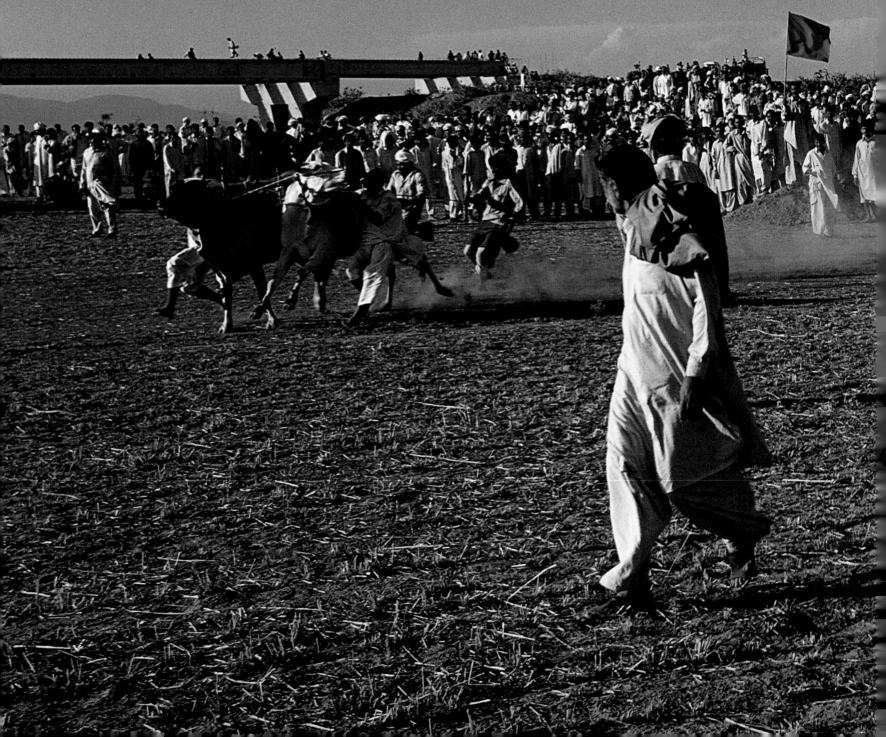

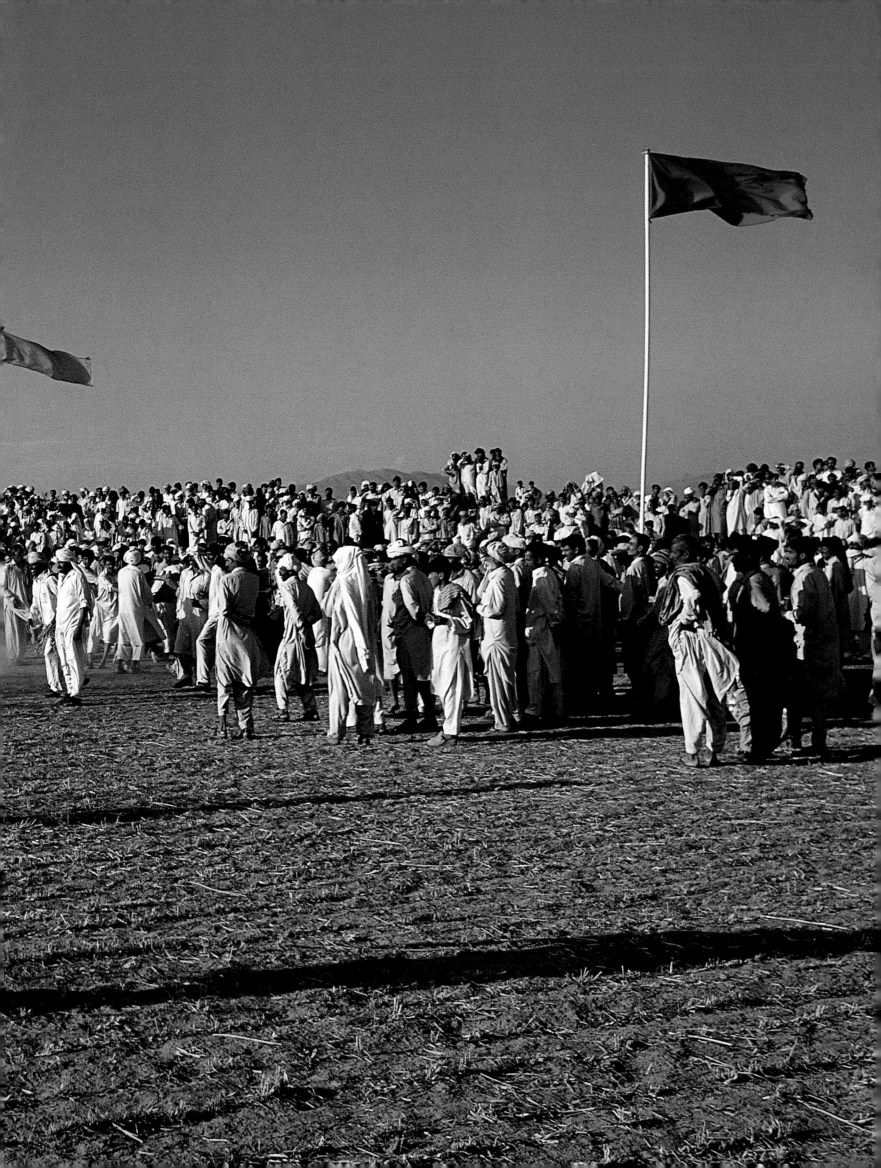

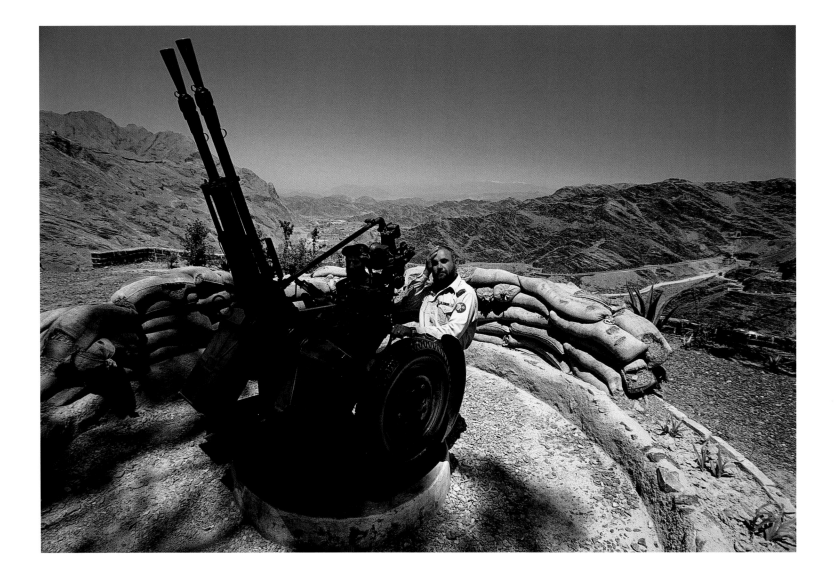

THE KHYBER PASS has been the main route between Peshawar and Kabul since the Kushans invaded Gandhara in the 1st century AD. For the British Empire, it was the Gateway to India. Legend has it that for 25 centuries, invading armies, from the Persians to Alexander the Great, have marched through this narrow gap on their way to the riches of the Indus Valley. **(ABOVE)** Border guards at Michni checkpoint. **(TOP RIGHT)** Qissa Kwani Bazaar (Storyteller Street) was the main thoroughfare from the city gate back when Peshawar was known as Lotus Land. **(BOTTOM RIGHT)** The son of a merchant of fragrances with his father's spring collection. **(PRECEDING PAGES)** The bull race in Taxila.

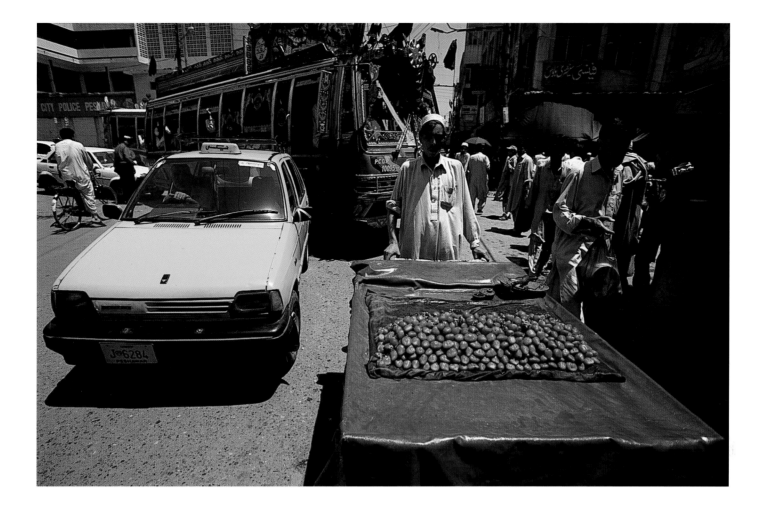

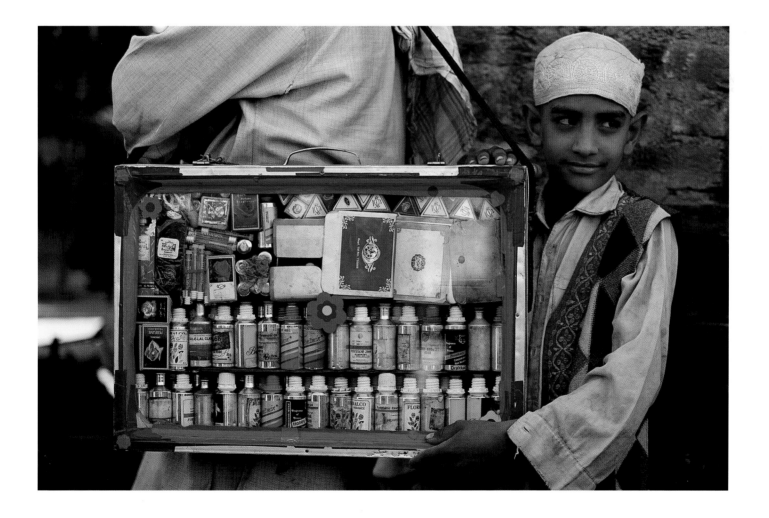

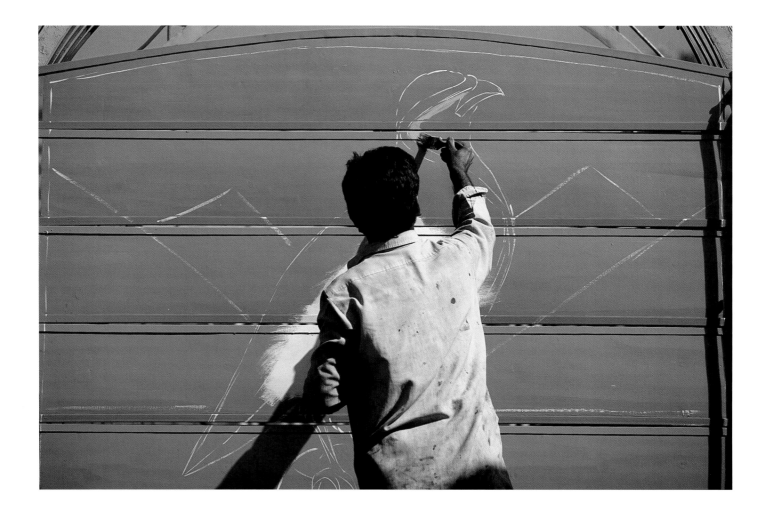

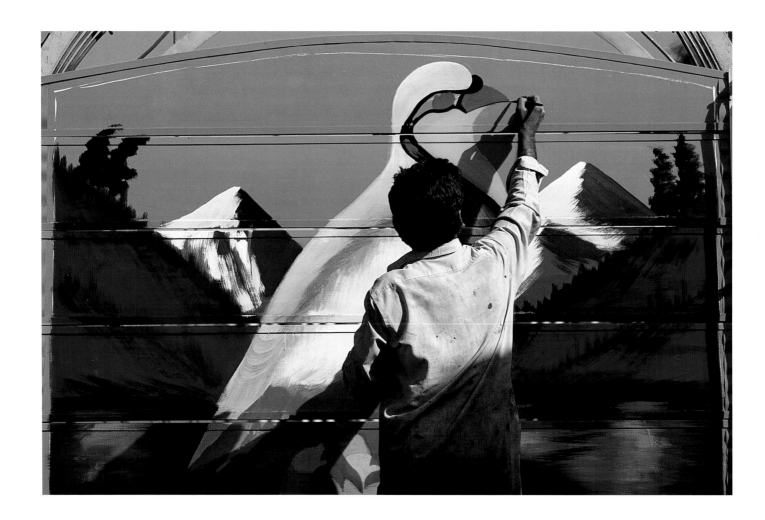

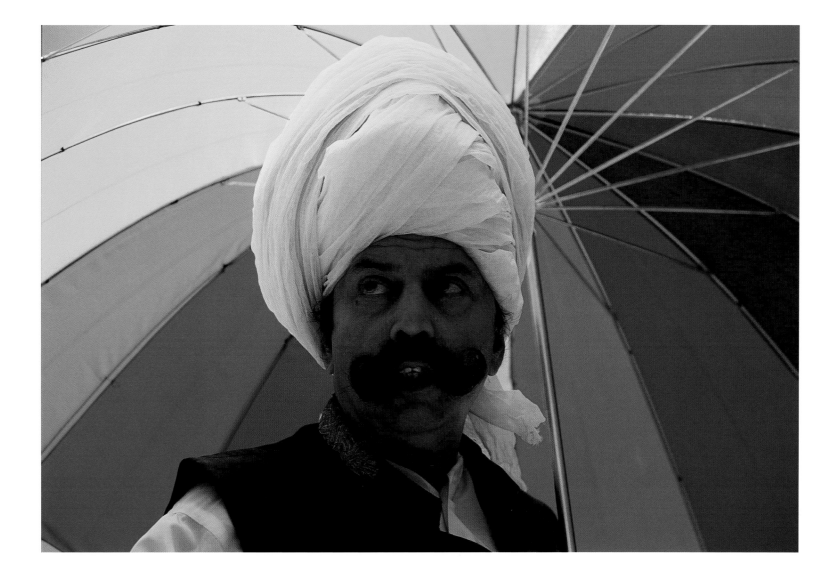

THE GRAND TRUNK ROAD is full of some of the world's most elaborately decorated trucks and buses, all screaming down the highway like belly dancers chasing after Christmas trees. Apart from being an expression of pride and individuality, the paintings are also prayers, invoking the protection of Allah, ancestral spirits and nature. (LEFT) The truck 'Flower of Darband' is named after the owner's home village, and the partridge is revered by the Pathans as a holy bird with powers to ward off evil. (ABOVE) Prince Malik Ata, the hereditary lord and master of Fatehjang, and undoubtedly one of the most colourful characters of this journey, is seen here with an umbrella to match his 'X-Large' personality.

Pakistan

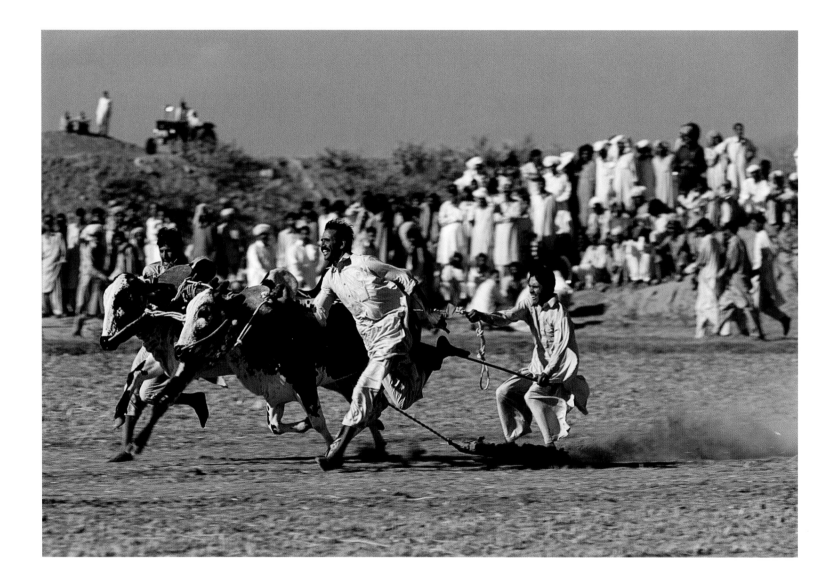

TAXILA WAS A CAPITAL OF GANDHARA, the easternmost kingdom of the Persian Empire, and the most important centre of early Buddhist art and scholarship, where Greek craftsmen, who stayed behind from Alexander the Great's campaign, sculpted the first likeness of the Buddha, based on the head of Apollo. One of the greatest universities of the ancient world flourished in Taxila from the 4th century BC, and it was also the key city from which Buddhism made its eastward trek into China

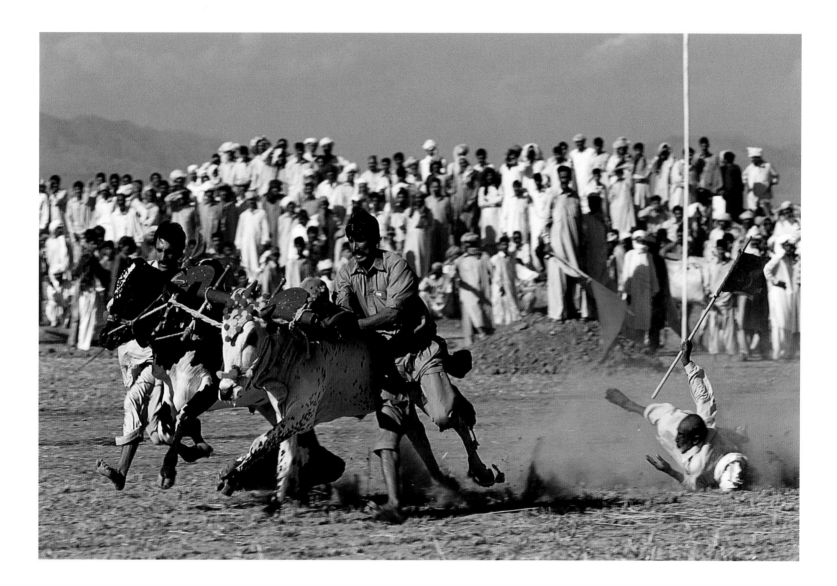

along the Silk Road. It is against this rich cultural and historical backdrop that we witness the 'Far Side' of human folly and exuberance, the bull race. Very few of the competitors actually manage to complete the 500-yard course.

(OVERLEAF) The beginning stretch of the 47 hairpin turns leading down to the Chitral Valley from the 10,000-ft (3050-m) Lowari Pass.

Pakistan

19

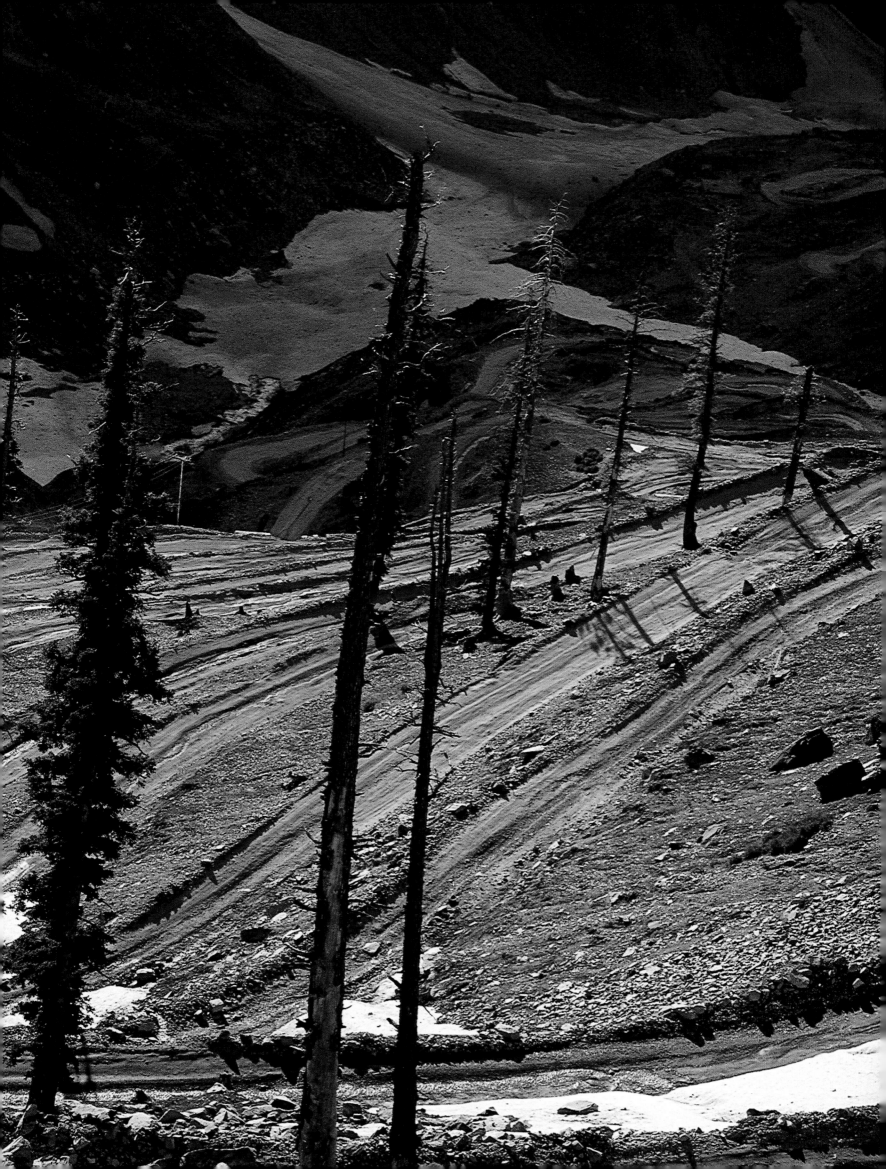

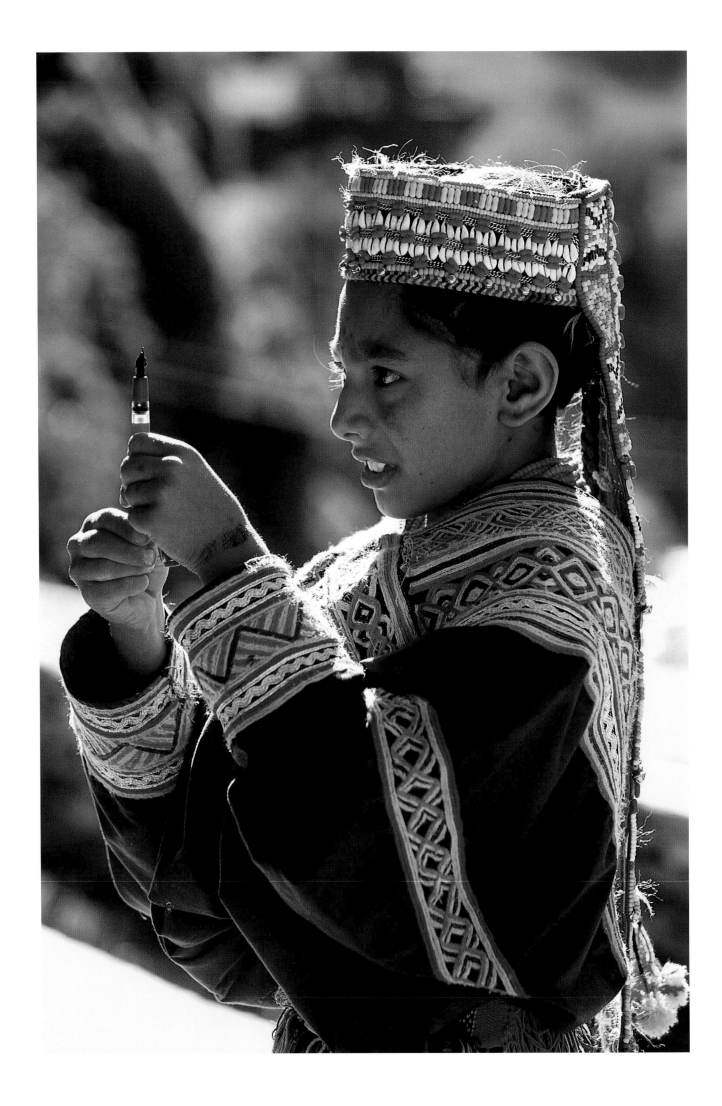

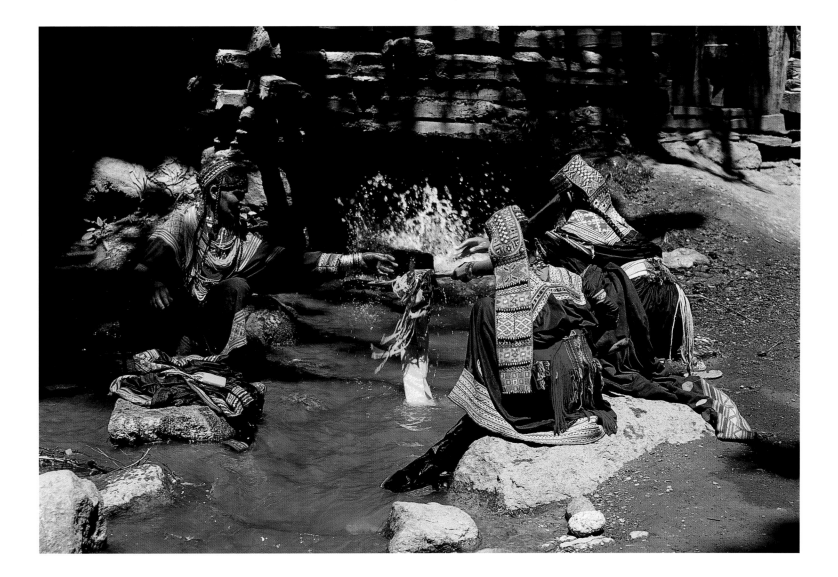

THE CULTURALLY UNIQUE KALASH TRIBE lives in three well-hidden valleys along the Afghanistan border southwest of Chitral. With their own language, customs and religion, they are part of the original group who settled in the Hindu Kush. The Muslims called them Kafirs (pagans), after Islam successfully pushed aside Buddhism in the valleys beyond. Today only about 3000 Kalash (meaning black, for the colour of their clothing) people are left in 20 small settlements; a tiny oasis of colours and laughter, just around the corner from the rising tide of Islamic fundamentalism and Sharia law that is sweeping across the North-West Frontier Province.

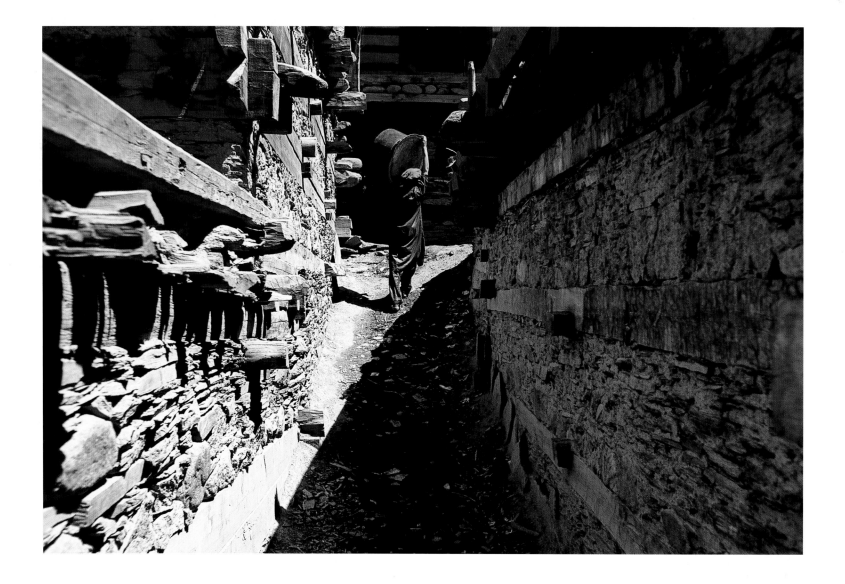

THE VILLAGE OF RUMBUR consists of 50 families and about 300 people, who live in houses stacked one on top of the other along the incline of the mountain like rice terraces. The sophisticated stone work of the houses **(ABOVE)**, so reminiscent of Inca ruins in the Andes, belies the poverty of their existence as subsistence farmers stuck with a very short growing season. Before Rumbur, I spend a lot of time being told off. Bearded men give me the evil eye or threaten me with stoning for just raising the camera in the general direction of what may be a woman, but could just as easily be a walking teepee. **(RIGHT)** It is such a joy to finally have eye contact with a subject of the opposite sex.

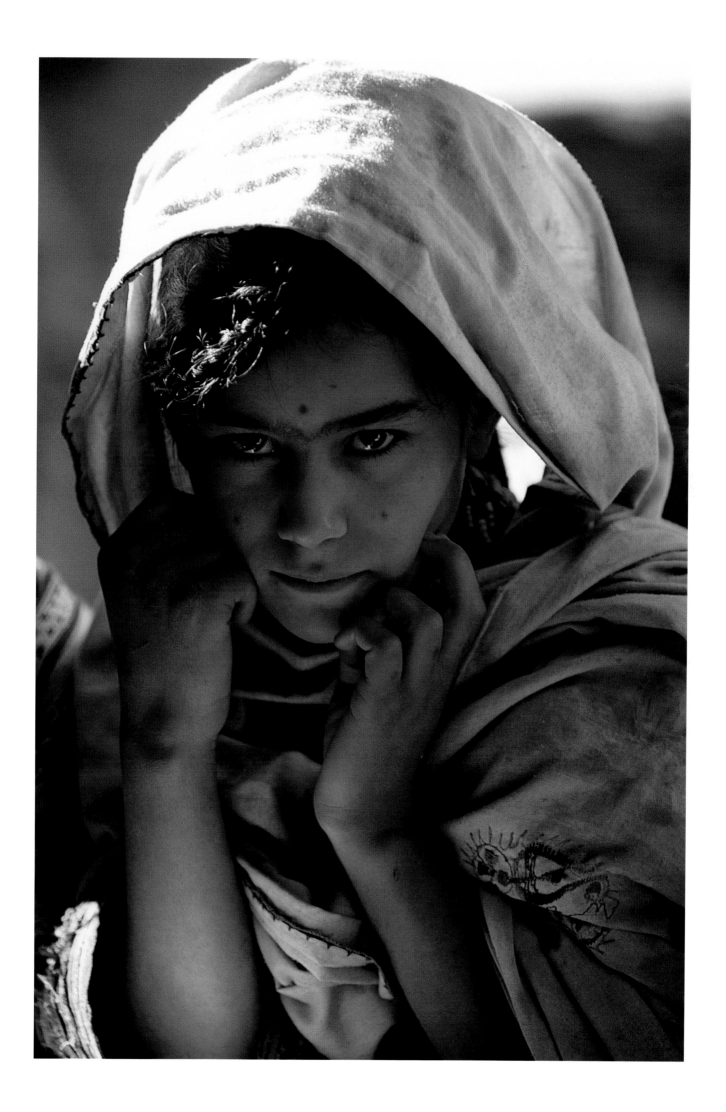

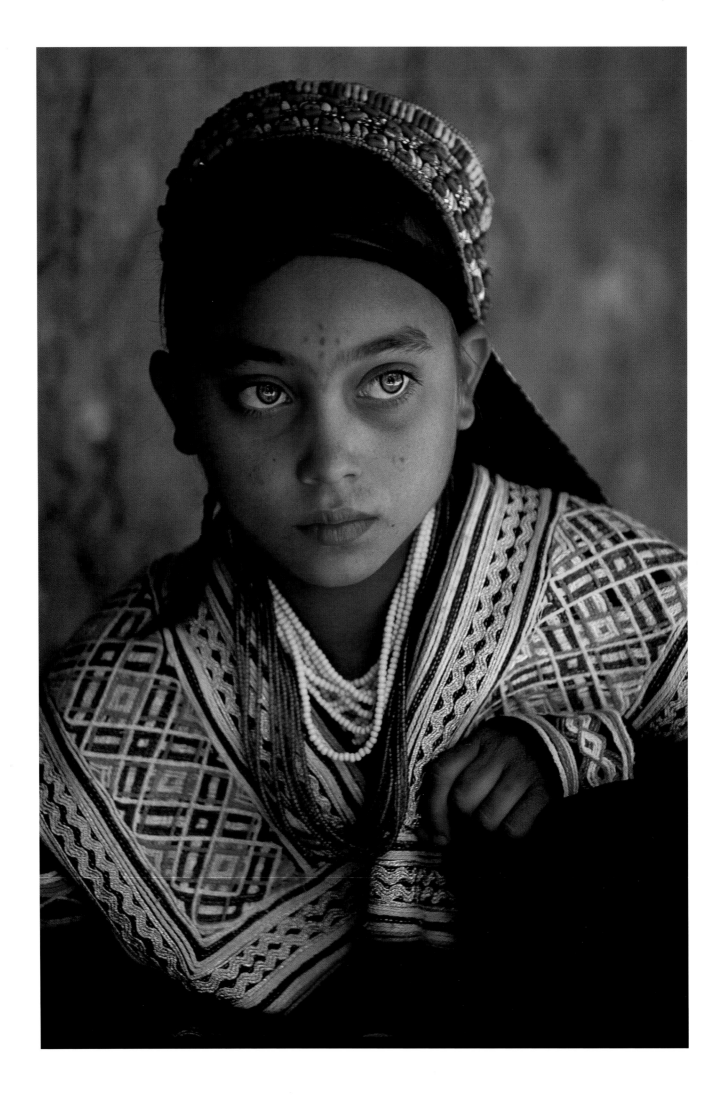

WHILE THIS GIRL has eyes like a Siberian husky (**LEFT**), some Kalash people have blond hair and blue eyes. Though the theory that they may be the descendants of the deserters from Alexander the Great's army is largely unsubstantiated, the idea appeals to the romantic in me. After a journey through the lush Chitral Valley along the Kunar River, we arrive back in the land of the purdah. (**ABOVE**) Schoolgirls pass in front of the crumbling Chitral Fort, site of the famous siege of 1895, when British troops were forced to eat their horses to survive until their rescuers finally arrived after 48 days.

ON THE WAY from Chitral to Mastuj (ABOVE), we come across this unusual method of evening out the field for planting after the plough and oxen have done the digging. (RIGHT) The view from Mastuj Fort. The last time I saw rock formations like this was outside Turfan on the Silk Road, at a hellhole called Flaming Mountains, a name made famous by the Chinese fantasy classic *Journey to the West*, a *Planet of the Apes* version of Tang Dynasty monk Hsuan Tsang's historic pilgrimage to India from 629 to 645 AD. He had passed through this area on his way to Peshawar and Taxila, where he is known to have spent a long time studying in the monasteries and universities of Gandhara.

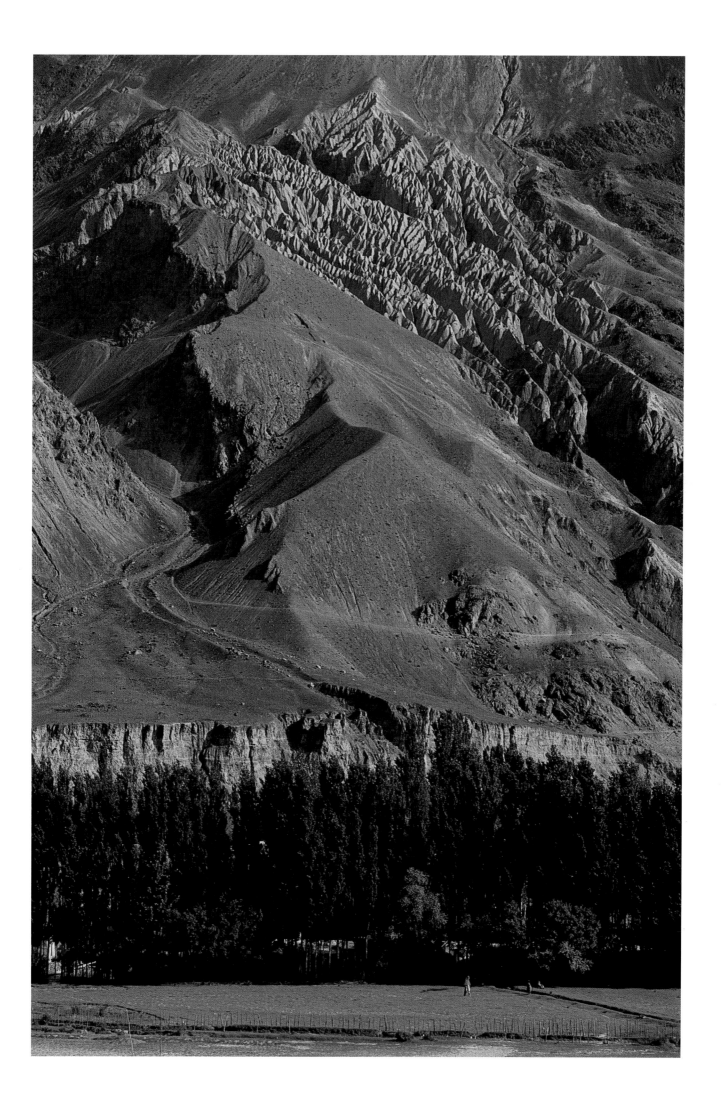

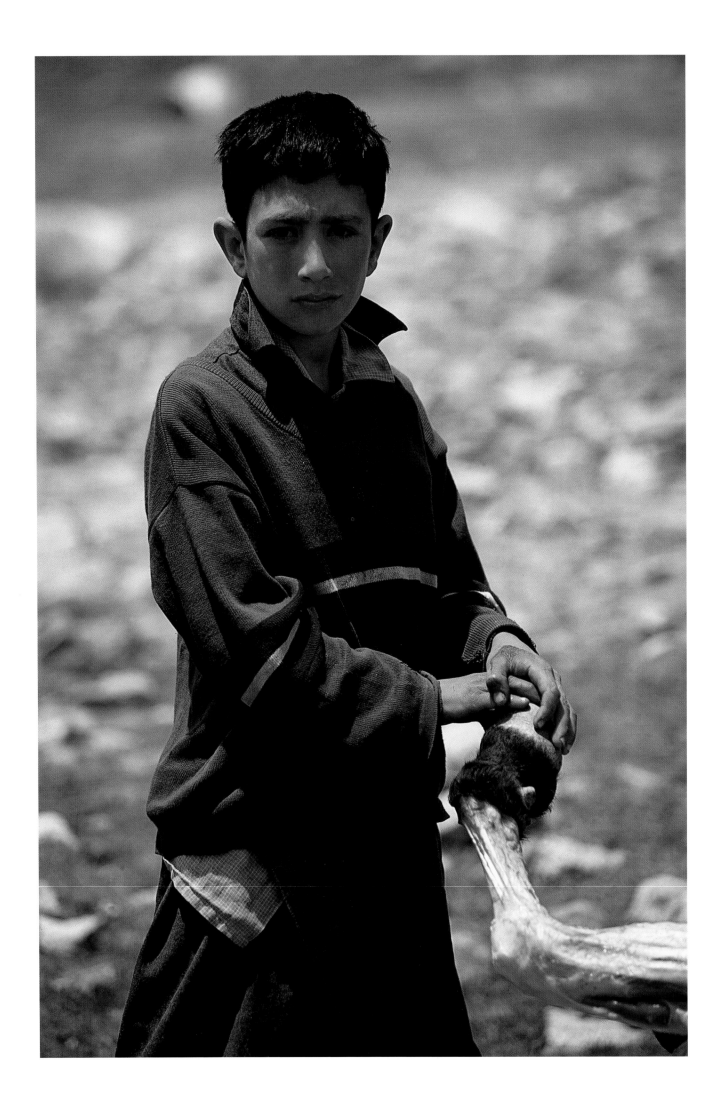

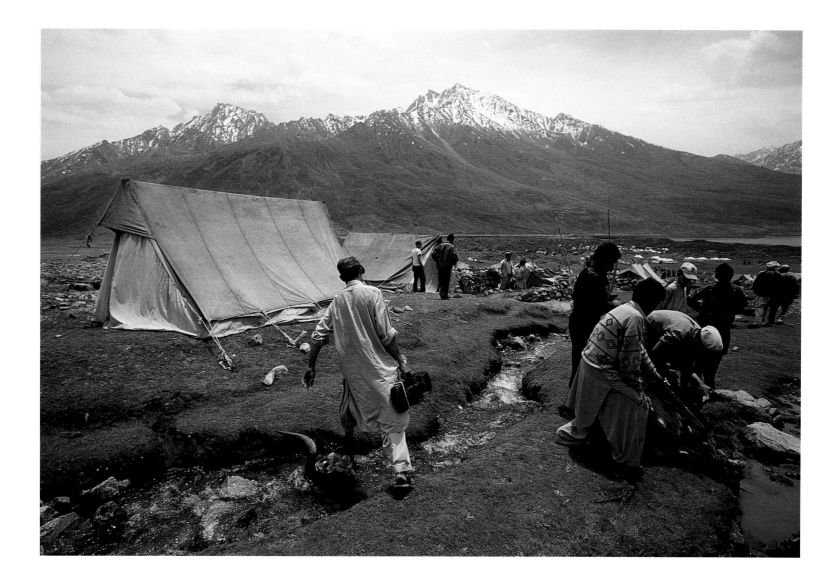

AFTER AN ARDUOUS DRIVE up precipitous dirt tracks with treacherous bends, we arrive at Shandur Pass, a lush plateau nestling beside a sparkling lake in between the spectacular mountains of the Hindu Kush and Thui ranges. The pass owes its fame to the annual polo festival, when over 15,000 people from villages all around gather to support their teams, trade, and sing and dance through the night. A city of tents rises up along the foothills of the valley, and with it comes a market that sells everything from rugs to nuts to Boom-Boxes, with butchers **(ABOVE)** and restaurants and Karaoke cafés for the hungry and the mindless. **(LEFT)** The butcher's apprentice gets his hands dirty.

Pakistan

31

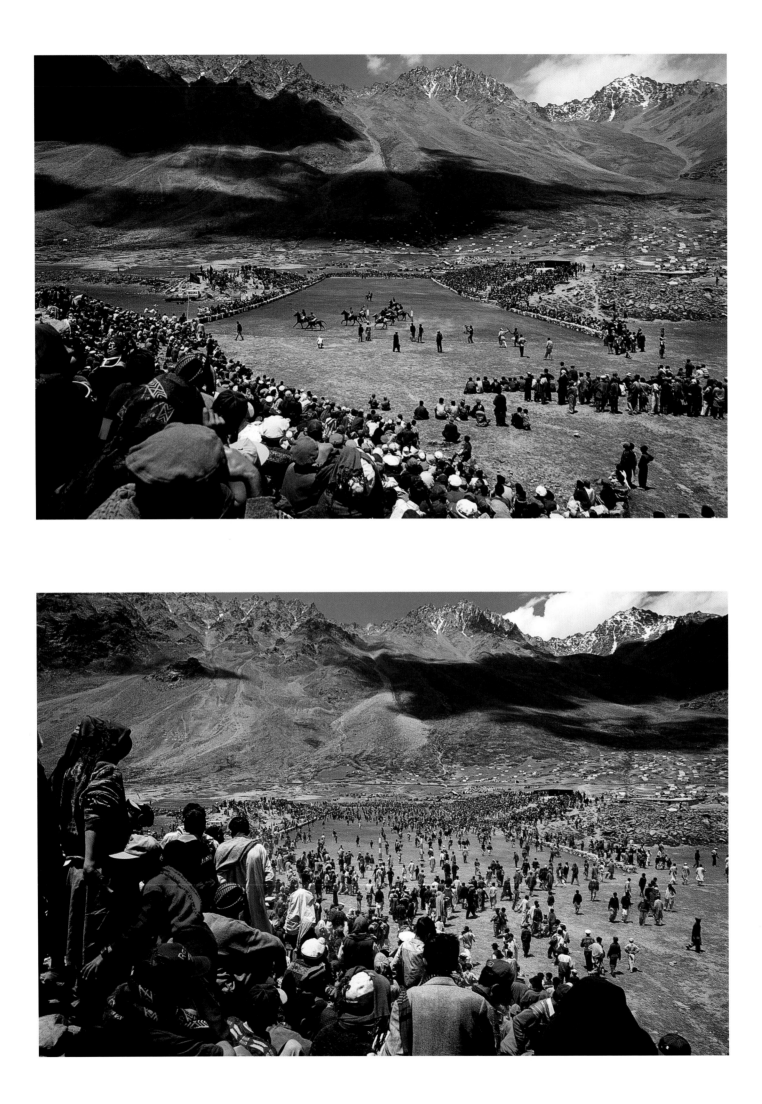

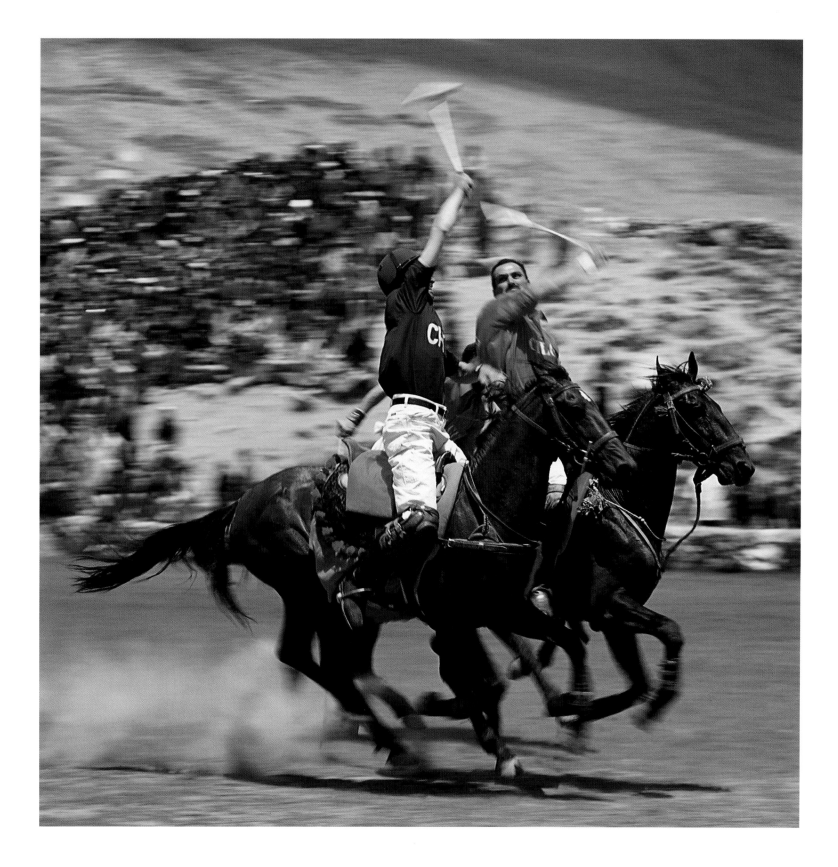

AT OVER 12,254 FEET (3730 m), the three matches played between the teams of arch-rivals Gilgit and Chitral are the highest polo games in the world. The rules, or lack of them, make this free-style game the closest we have to the original Persian one. Unlike modern polo, which was a reinvention of the British Raj, the horses must play for the duration of the 50-minute game and cannot be substituted; in fact, one pony died of a heart attack during the second match. There is no referee and the level of physical contact between the players is often only marginally gentler than in ice hockey.

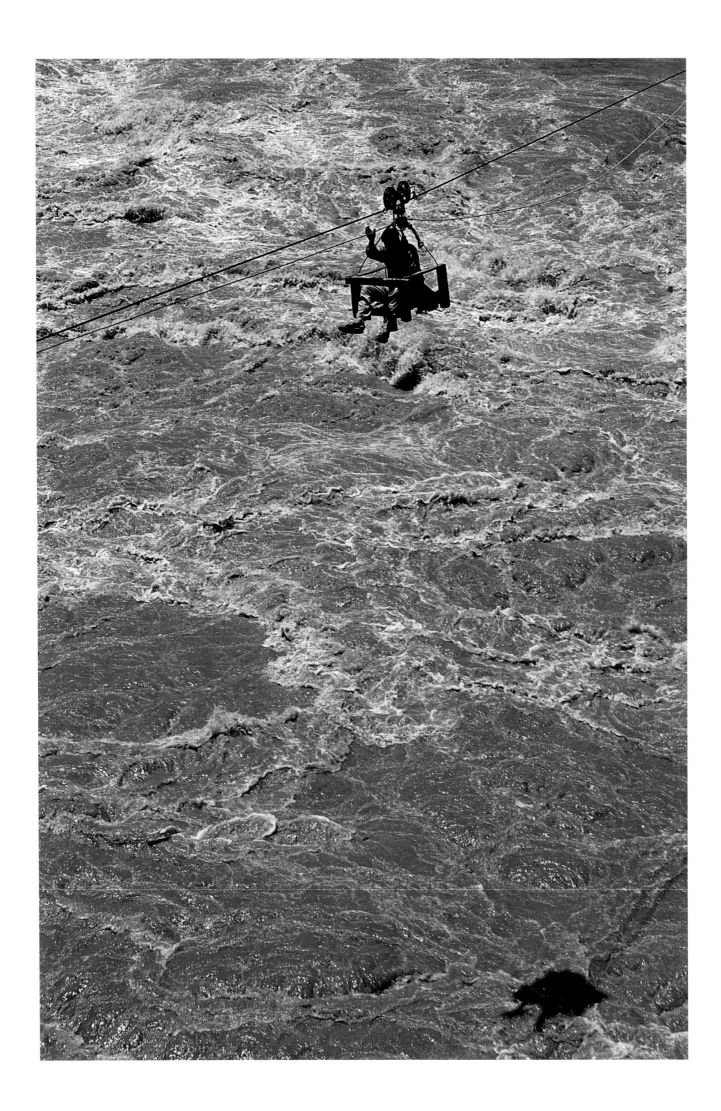

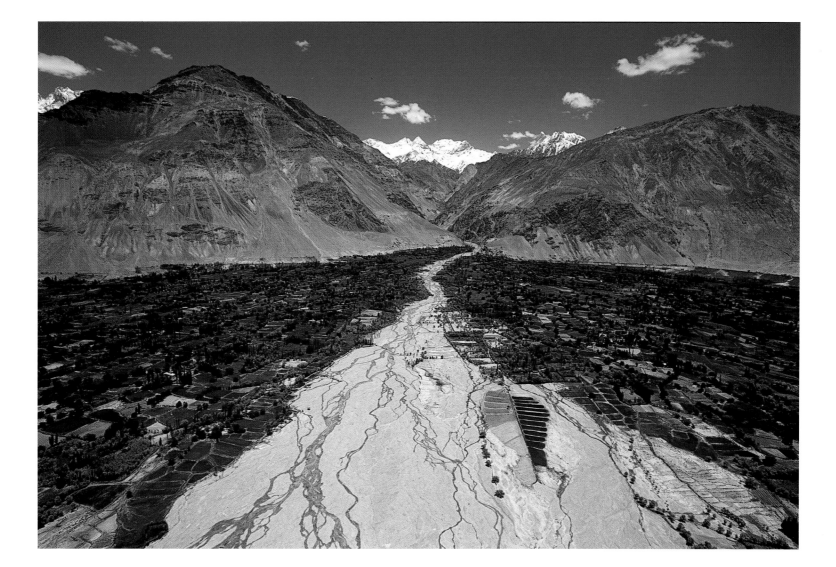

THE INDUS RIVER is the great-grandmother of some of the world's greatest civilizations, which started flourishing in its fertile valleys 5000 years ago. From high in the Karakoram Mountains, it flows through Punjab and Sindh before emptying out into the Arabian Sea. On the road between Gilgit and Skardu, **(LEFT)** a man pulls himself across its fast-moving currents by rope and trolley. **(RIGHT)** In the Skardu Valley, where the Indus meanders gently through wide plains and giant sand dunes, we pick up our ride with the Pakistan army to the inner sanctum of the Karakoram, where monumental peaks of unimaginable beauty await us.

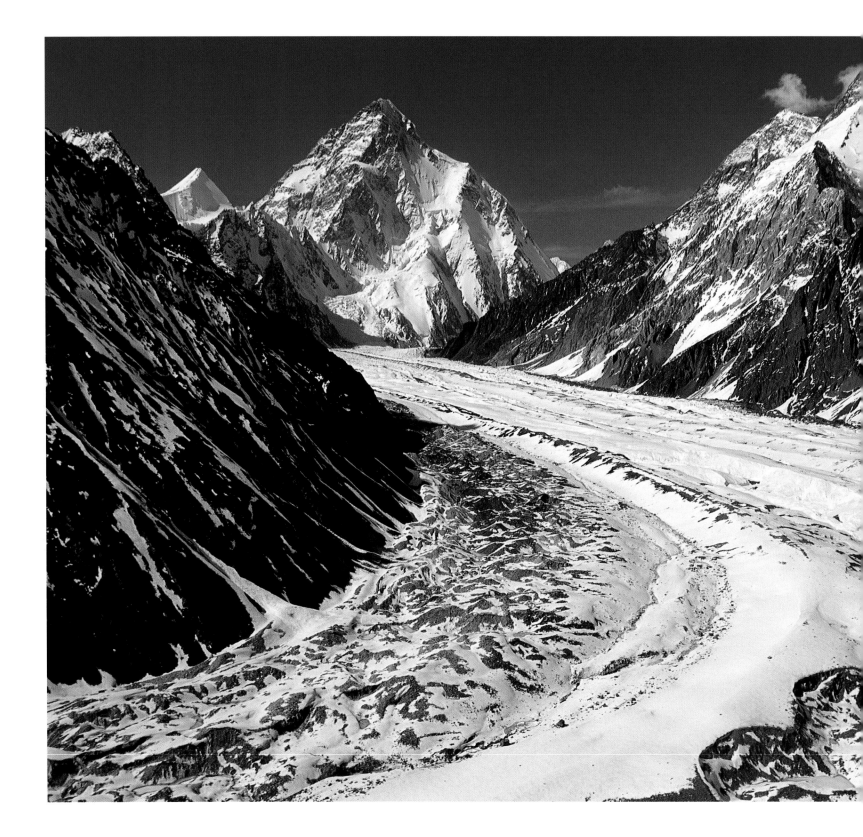

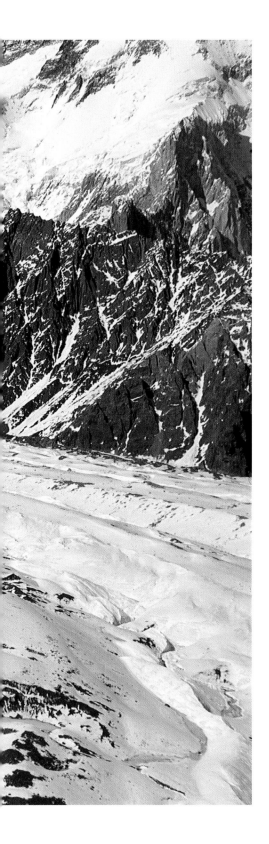

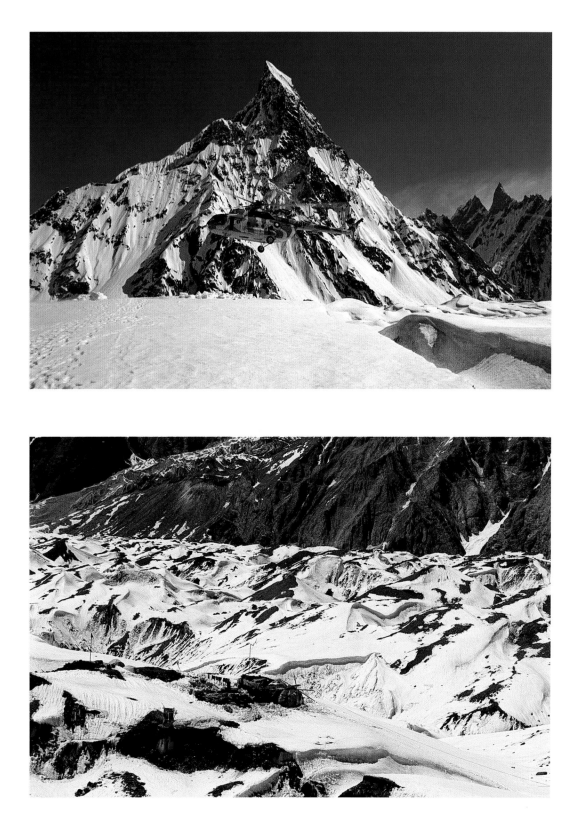

CONCORDIA. The army's M-17 helicopter drops us off at the confluence of the Baltoro and Godwin-Austen glaciers (**TOP RIGHT**), where two soldiers, who live in this small military outpost 15,000 ft (4570 m) up on the Pakistan-China border (**BOTTOM RIGHT**), are waiting to assist us with our filming. (**LEFT**) The base camp of K2, the second highest peak in the world, is only five miles from where we landed.

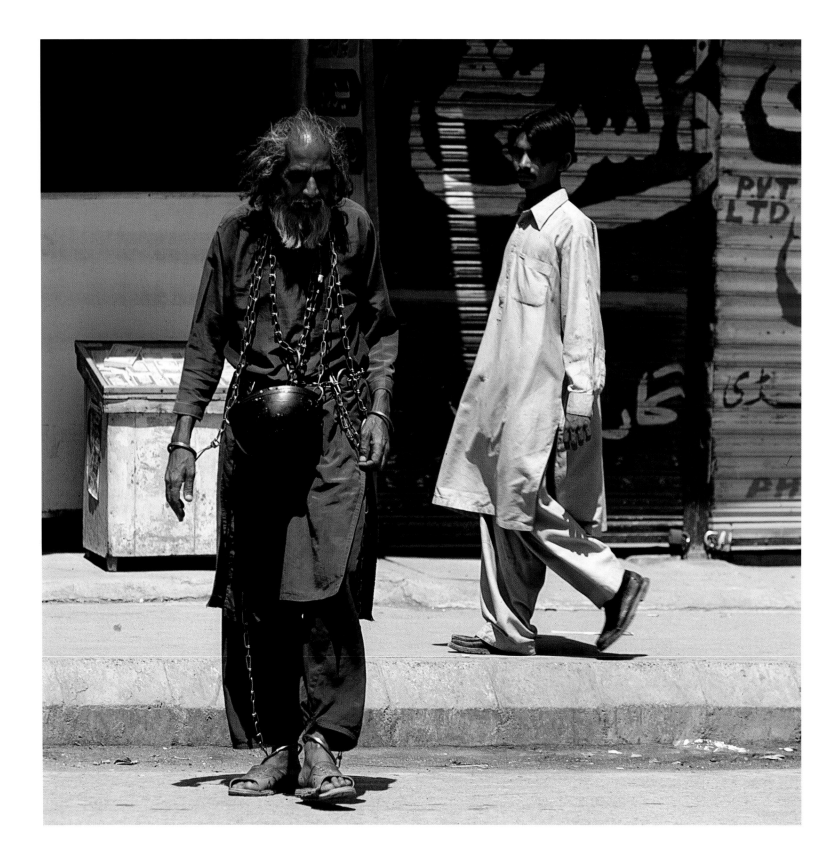

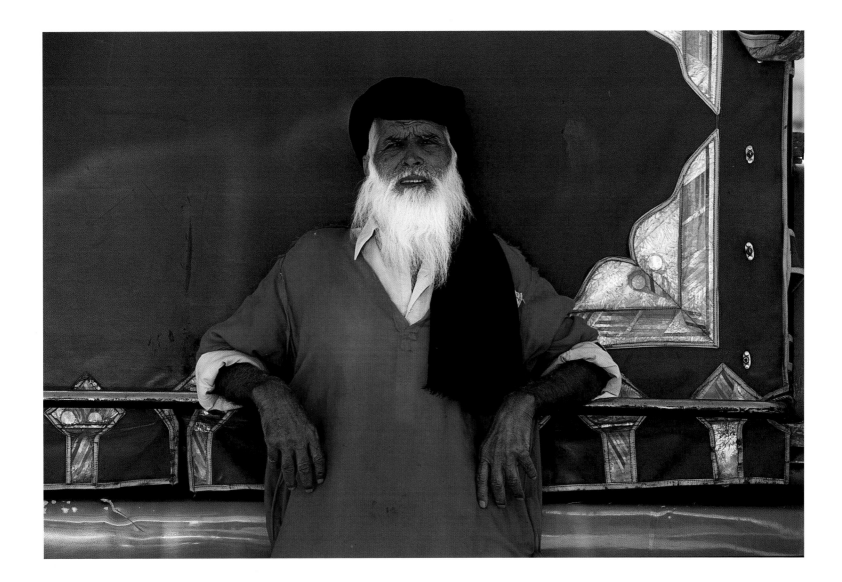

RAWALPINDI is the crazy-sister city to Islamabad (the Abode of Islam), the 45-year-old purpose-built new capital of Pakistan and a very good example of bad city planning. While ancient Rawalpindi is a hectic, jumbled mess, bursting with exhilarating energy, its brother, a few miles away, is the exact opposite. Awkward 'modern' buildings sit uncomfortably on a grid of wide avenues like abandoned monuments, occupying the space where a modern, thriving city has simply failed to materialize. (LEFT) The crew wit suggests that this man may be one of the original city planners, doing his penance. (ABOVE) This is the scene that greets us as we step out of the coach at the Rawalpindi Railway Station.

Pakistan

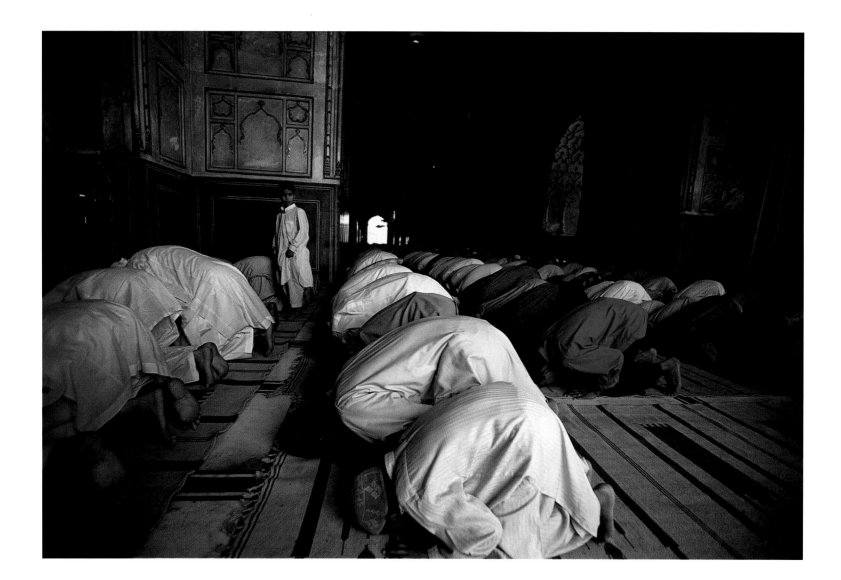

LAHORE WAS IN THE GRIP of the fiercest heat wave in 75 years, with average temperatures of 48°C.
(ABOVE) The surface of the sandstone slabs in the grand courtyard of the Badshahi Mosque are too hot
even to walk on, so thousands of worshippers crowd into the sweltering galleries for midday prayer.
(RIGHT) Patriotism is the name of the game at Wagah, the only land border-crossing between Pakistan
and India. The flag-lowering ceremony at sunset, which attracts thousands of spectators on both sides
of the border gates, is the ultimate display of military pomp and macho showmanship. This old man is
a semi-official cheerleader and has been whipping the Pakistani crowd into a frenzy for many years.

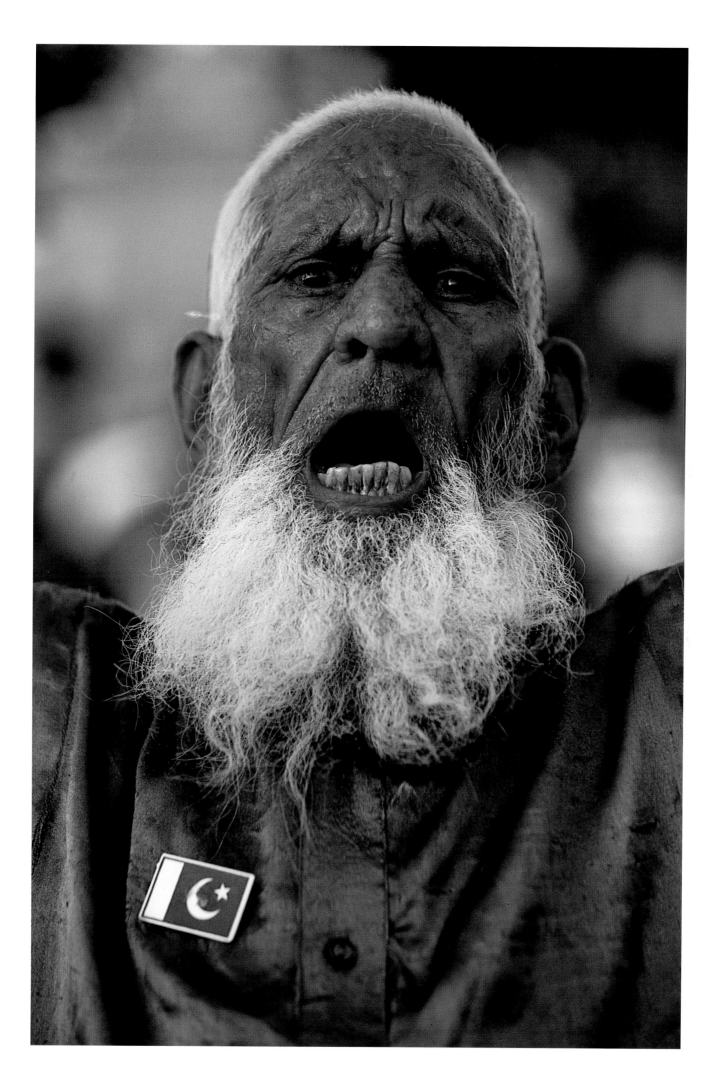

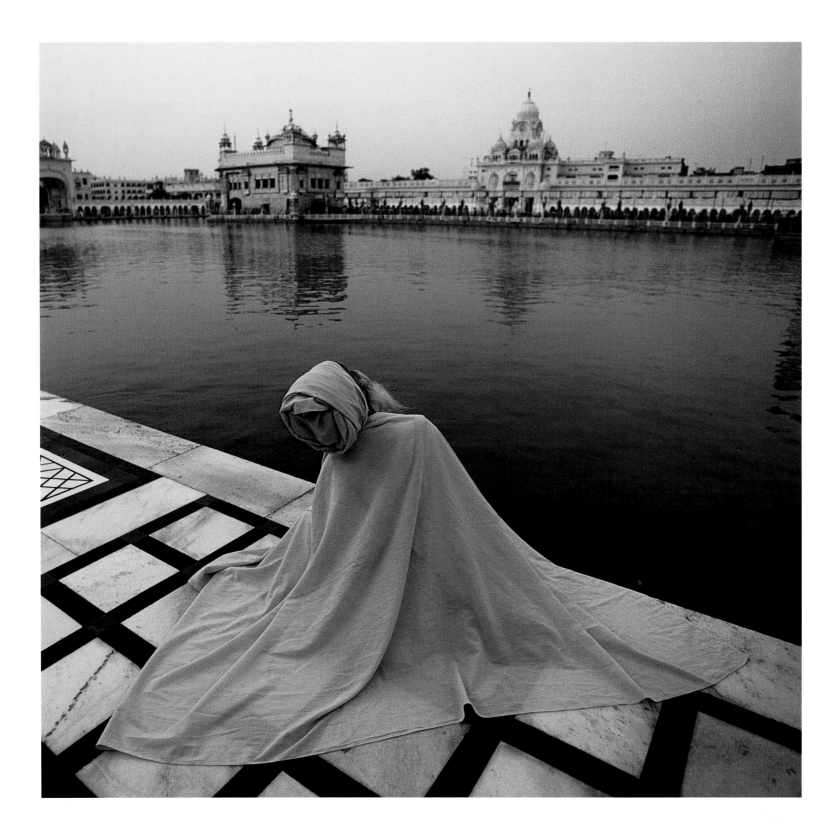

THE GOLDEN TEMPLE sits, as if floating on a bed of light, at the centre of a massive pool inside the complex known as Gurudwara (Gateway to the Gurus). It is the holiest shrine for the 20 million or more Sikhs in India and around the world. As many as 50,000 worshippers visit the site daily, where, from dawn till dusk, pilgrims of all ages (**ABOVE & RIGHT**) meditate on the edge of the pool, or bathe in the holy water to cleanse their sins. Though Sikh militants do exist, the peaceful atmosphere within the Gurudwara complex bespeaks the gentle and benevolent nature of the religion itself.

(**PRECEDING PAGES**) A driver stranded outside Leh in Ladakh.

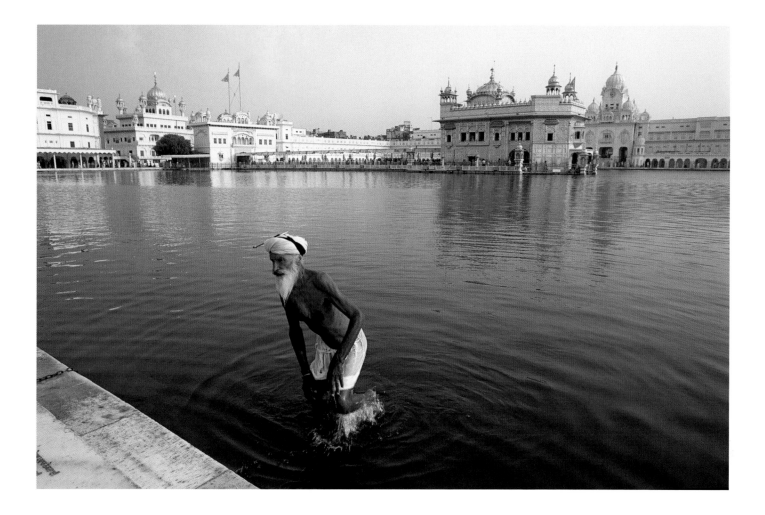

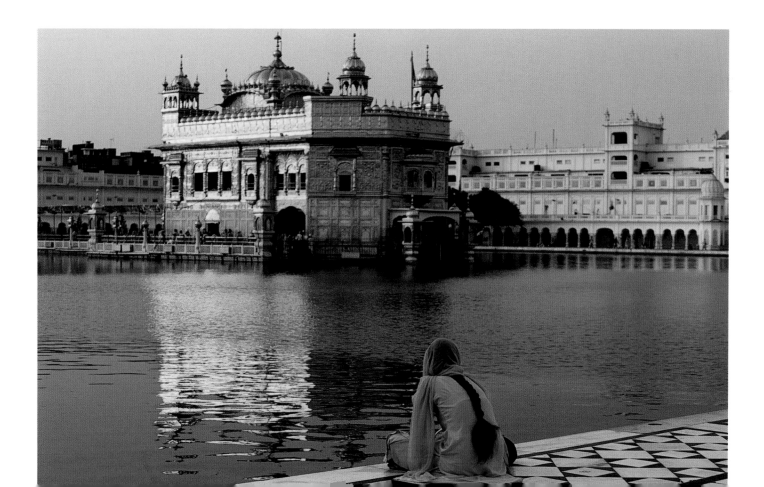

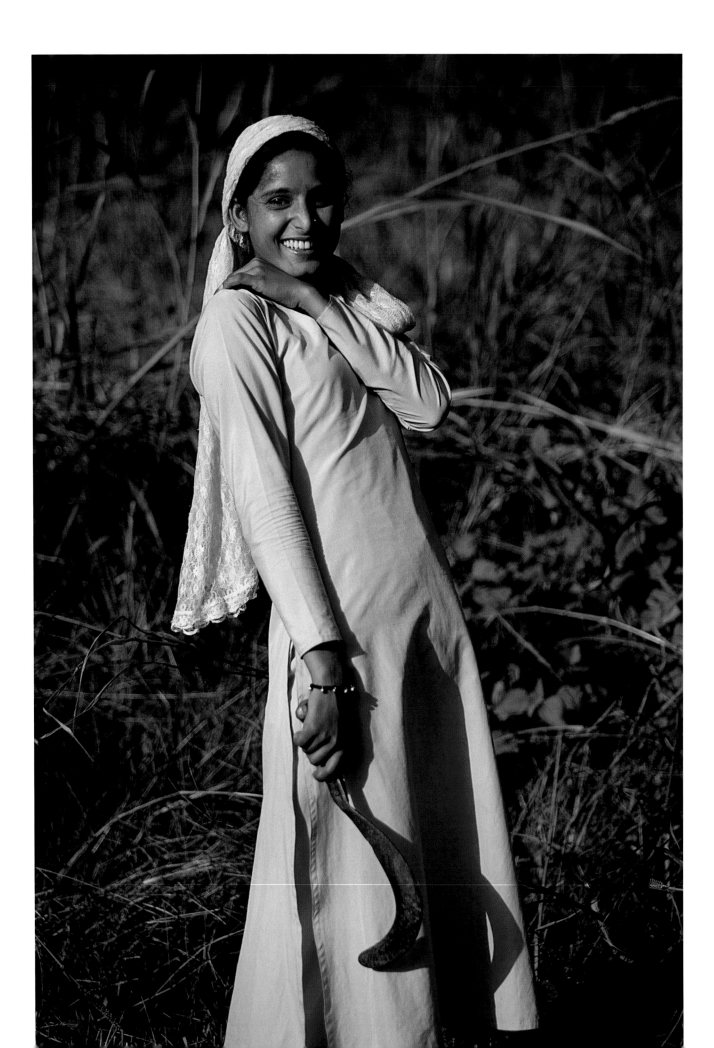

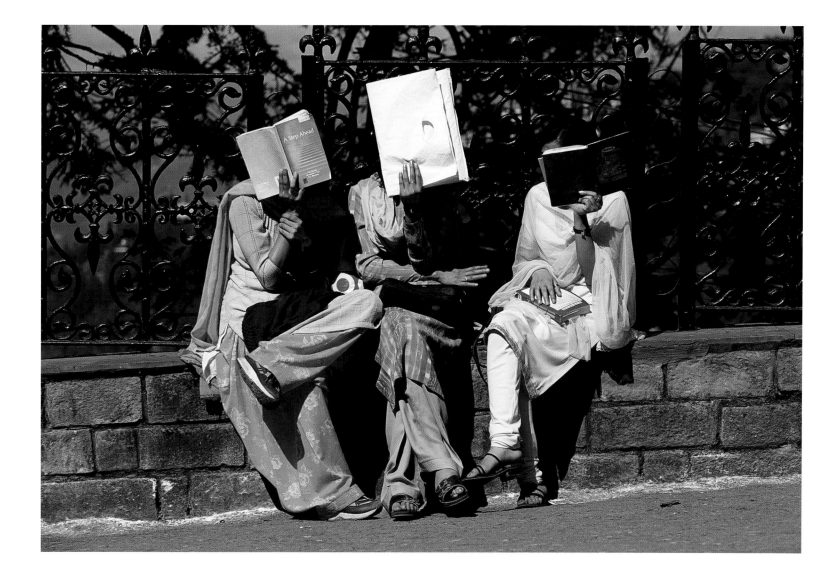

SHIMLA WAS THE SUMMER CAPITAL of India during the British Raj from 1864 onwards. It is well known that 'At that time, one fifth of the human race was administered from Shimla'. Today, it is a university town, with many of the colonial buildings converted into research centres. These college students (**ABOVE**) are not, as you may be thinking, hiding from my camera; they are simply protecting their faces from the fierce Himalayan sun. (**LEFT**) On the road to Dharamsala, we stopped near the place where a mother and her two young daughters were clearing a fallow field; they are possibly the most elegantly dressed farmers I have ever seen anywhere in the world.

India

47

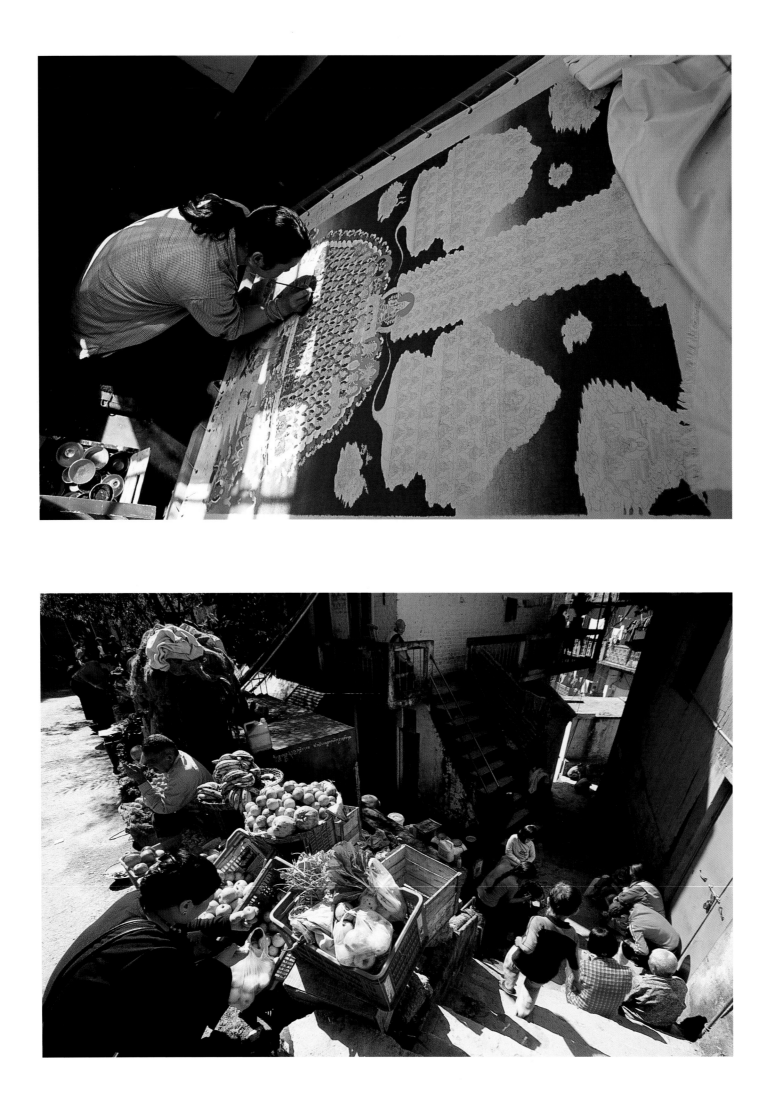

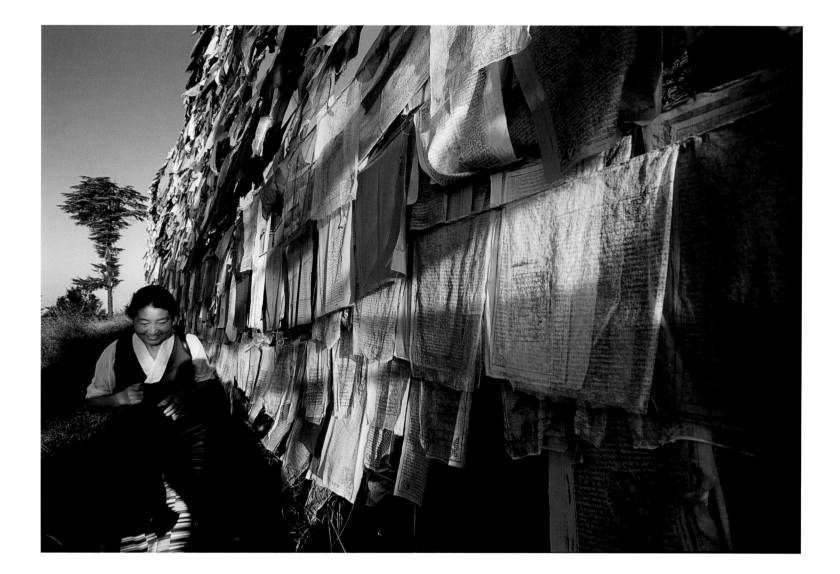

WHEN THE DALAI LAMA went into exile 44 years ago, Prime Minister Nehru of India made the brave and compassionate decision to give him sanctuary. Later, he gave him a permanent home in Dharamsala, where the Tibetan government in exile is now based. (ABOVE) Dawn at McLeodganj; cheerful Tibetan exiles put up long strings of prayer flags on top of the hill behind the Lhagyal Ri Temple. (TOP LEFT) At the Norbulingka Institute, which is dedicated to the preservation of Tibetan culture, a *thangka* painter concentrates on his commission, destined for a monastery overseas. (BOTTOM LEFT) The narrow streets in the village of McLeodganj are buzzing with activity like a beehive.

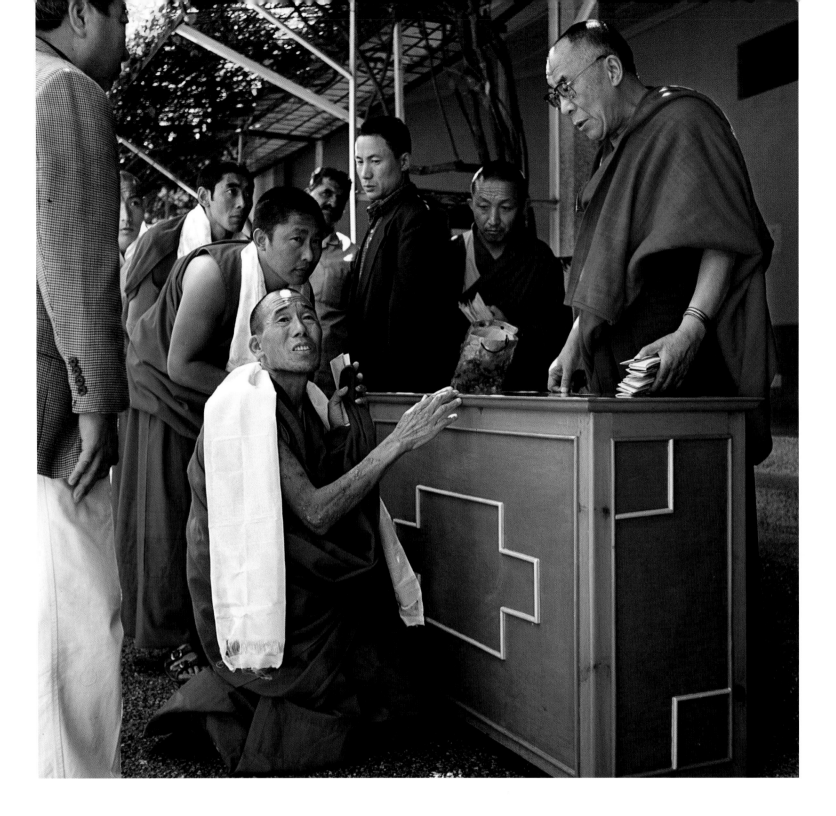

IT IS A GREAT PRIVILEGE to meet a fully realized and awakened human being. Being in the audience at the hour-long meeting between His Holiness the Dalai Lama and Michael is the highlight of the journey for me. And when he takes Mike aside after the interview and thanks him for doing his television journeys, because they are bringing a better understanding to the world, I feel gratified to be a part of the travelling circus. **(ABOVE)** Earlier in the day, the Dalai Lama greeted over 700 people from all over the world in a public audience, amongst them this Tibetan monk, who is pleading for divine intervention for his ailments.

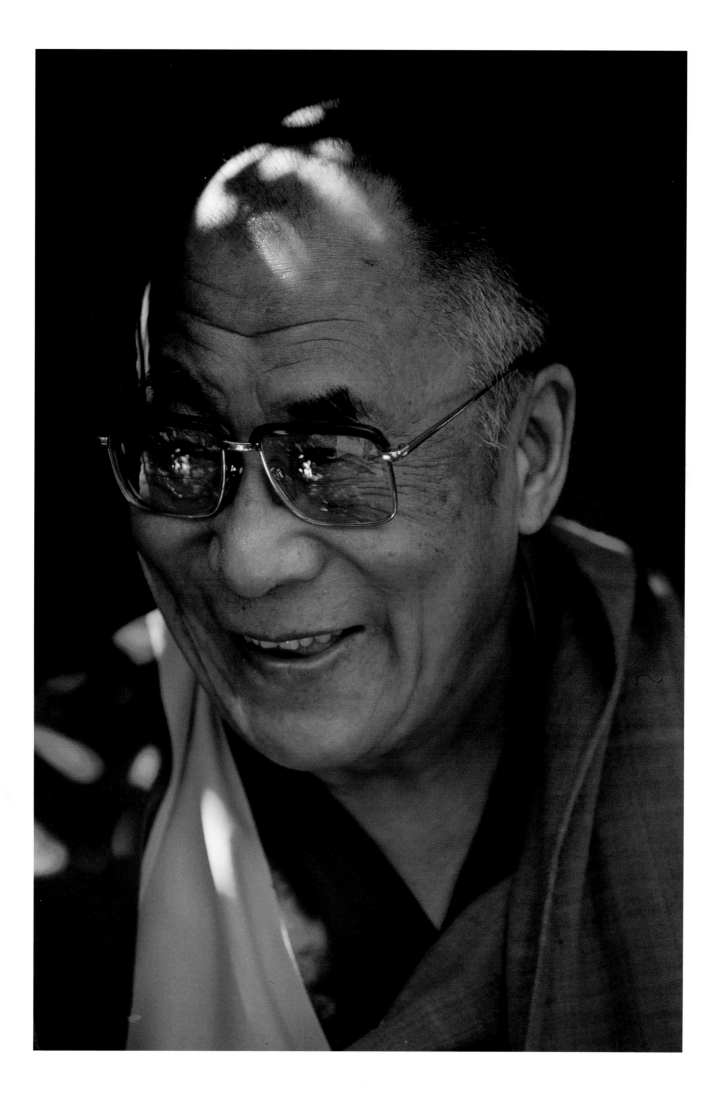

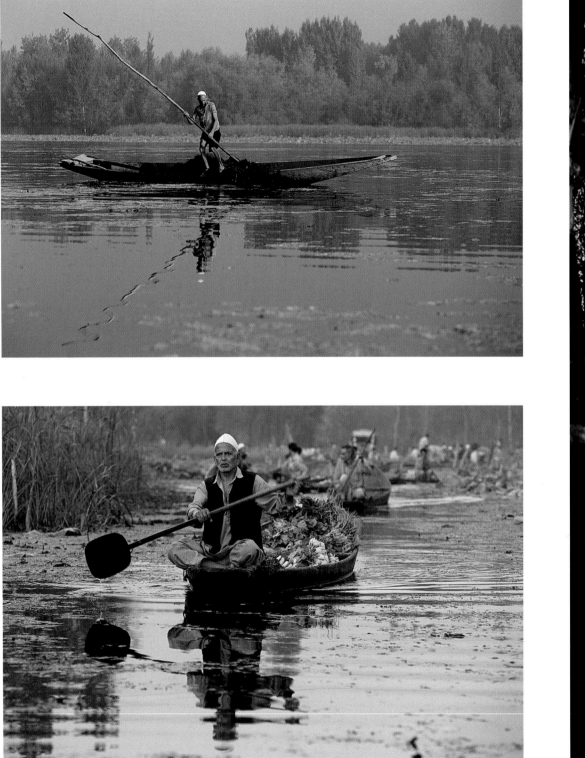

LAKE DAL IN SRINAGAR seems to exist in its own time and space. Since the use of outboard motors is banned, the lake is wrapped in a delicious silence, disturbed only by the voices of nature and the sound of paddles slicing through water. None of the activities on the mirror surface of the lake gives a clue as to which century you're actually in.

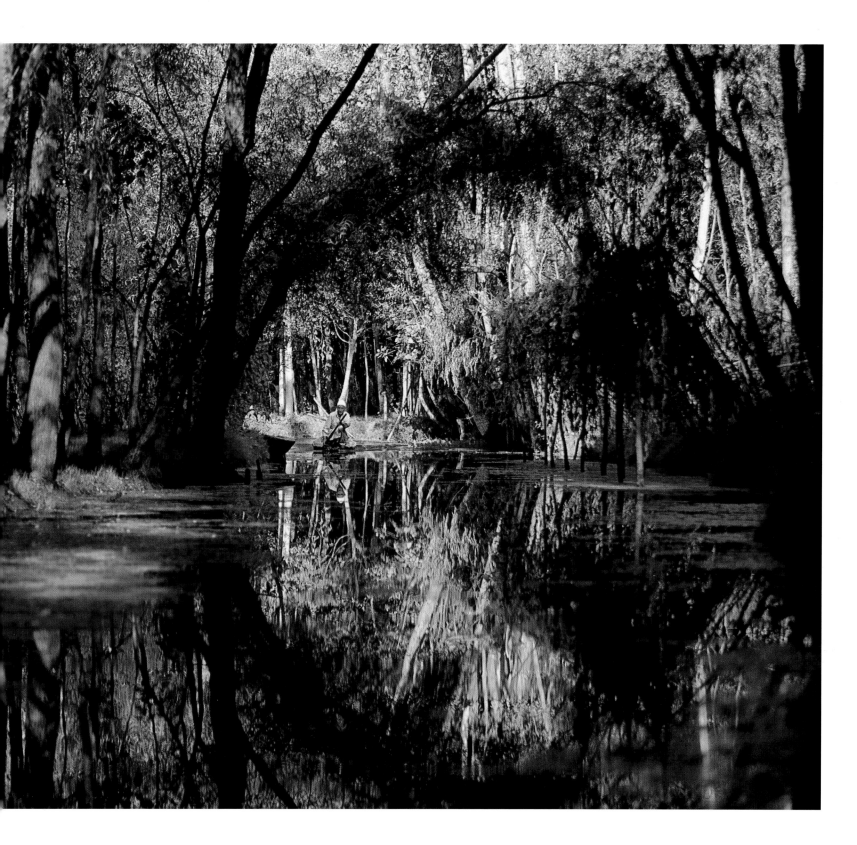

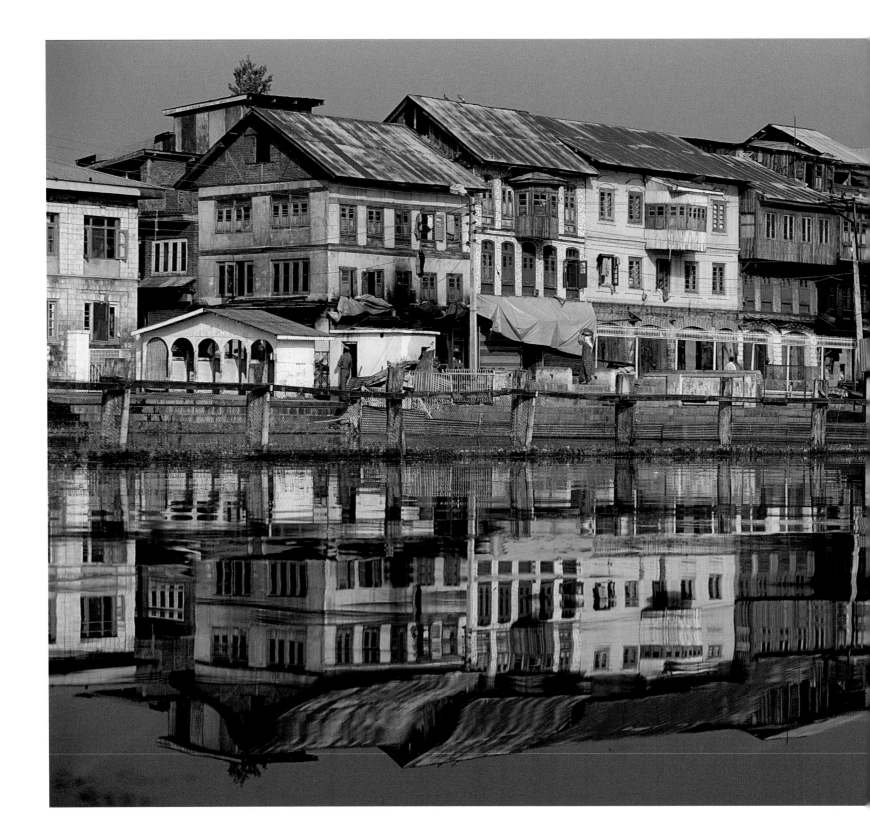

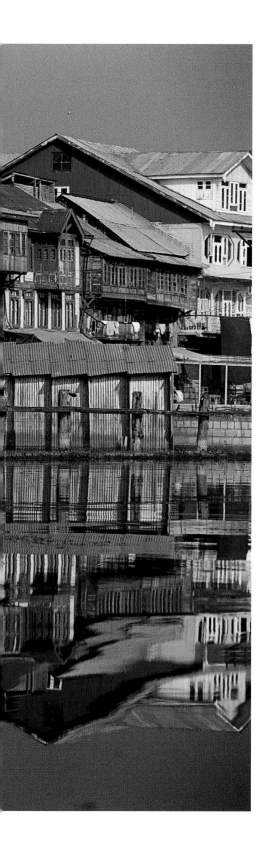

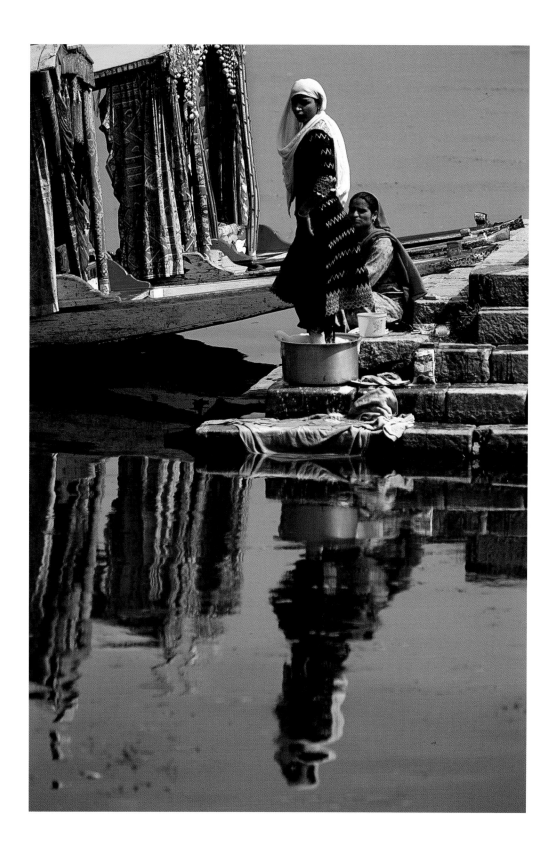

BEING IN SRINAGAR is like living with a schizophrenic. Once outside the gates of Mr Butt's Clermont Houseboats in a secluded corner of the lake, tranquillity is abruptly displaced by the grim reality of a city under siege. Peace of mind is instantly crushed by the overwhelming military presence, with road-blocks, barbed wire and bombed-out buildings replacing the willows, herons and lotus beds.

India

55

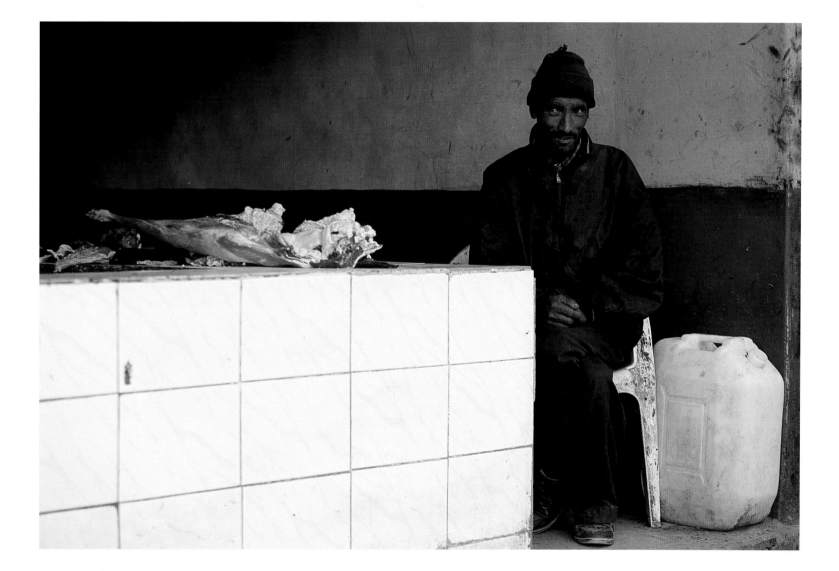

LADAKH means 'many passes', from its geographical location at the crossroad of four major mountain ranges, the Karakoram, Ladakh, Zanskar and Himalaya, crisscrossed by the Indus and its tributaries. **(TOP LEFT)** Songs echo across the Indus valley below the Hemis monastery, where women sing out messages to their distant neighbours. **(BOTTOM LEFT)** Nigel and John film the ruins of the Leh Palace from the field of *chortens*. **(ABOVE)** The small butcher shop just outside Thikse offers a surprising lesson in the composition of textures and colours, and, of course, in buying lamb chops.

India

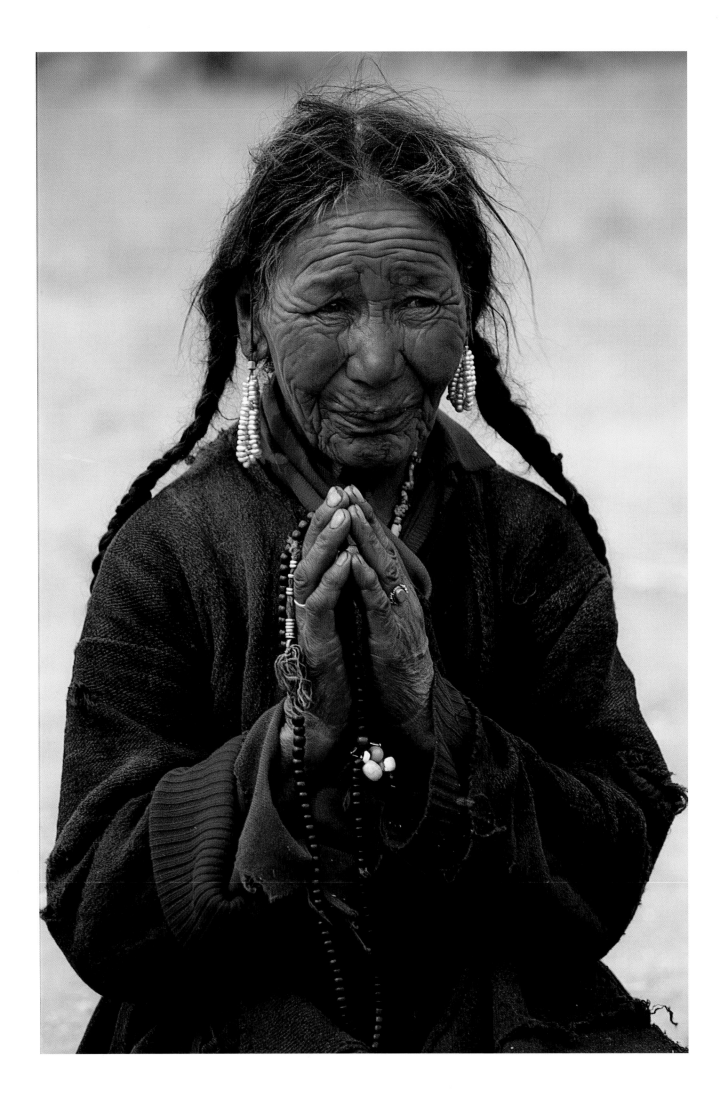

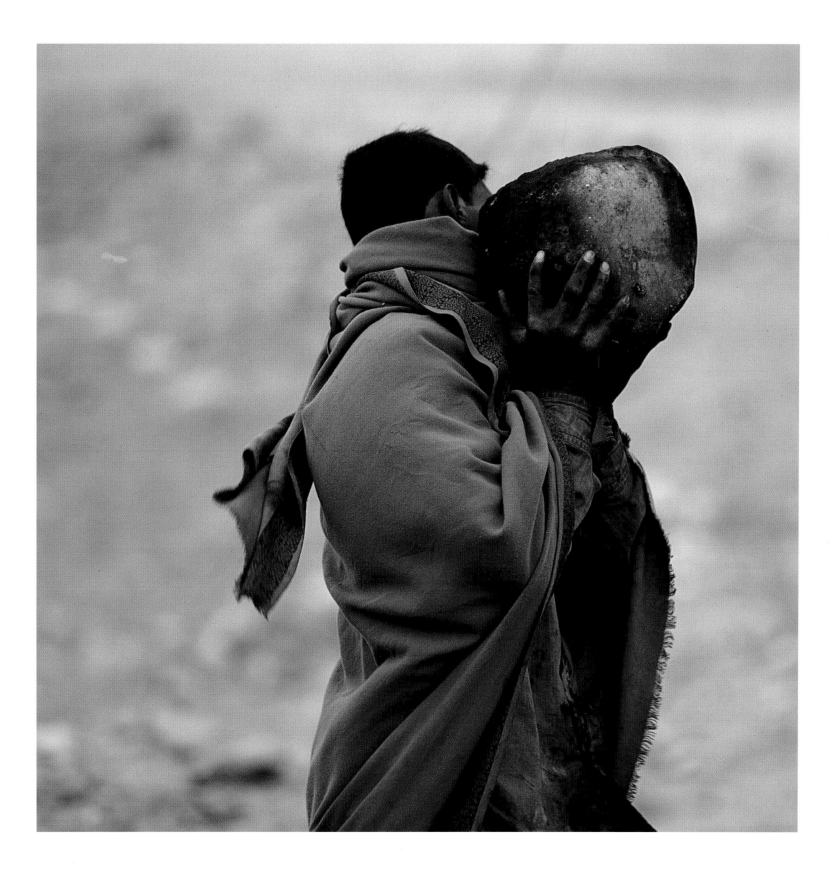

IN ITS HEYDAY, Ladakh was a trading centre, which, along with Kashmir, formed an important feeder route on the Silk Road. With it came the diverse cultural influences that are still evident today. The most dominant is Tibetan Buddhism, which arrived in the 10th century. Over half the current population, including this woman **(LEFT)**, are followers of the esoteric sect of Vajrayana (Way of the Adamantine Thunder Bolt). **(ABOVE)** A member of an Indian road gang quarrying boulders from the banks of the Zanskar River to be broken down for road construction.

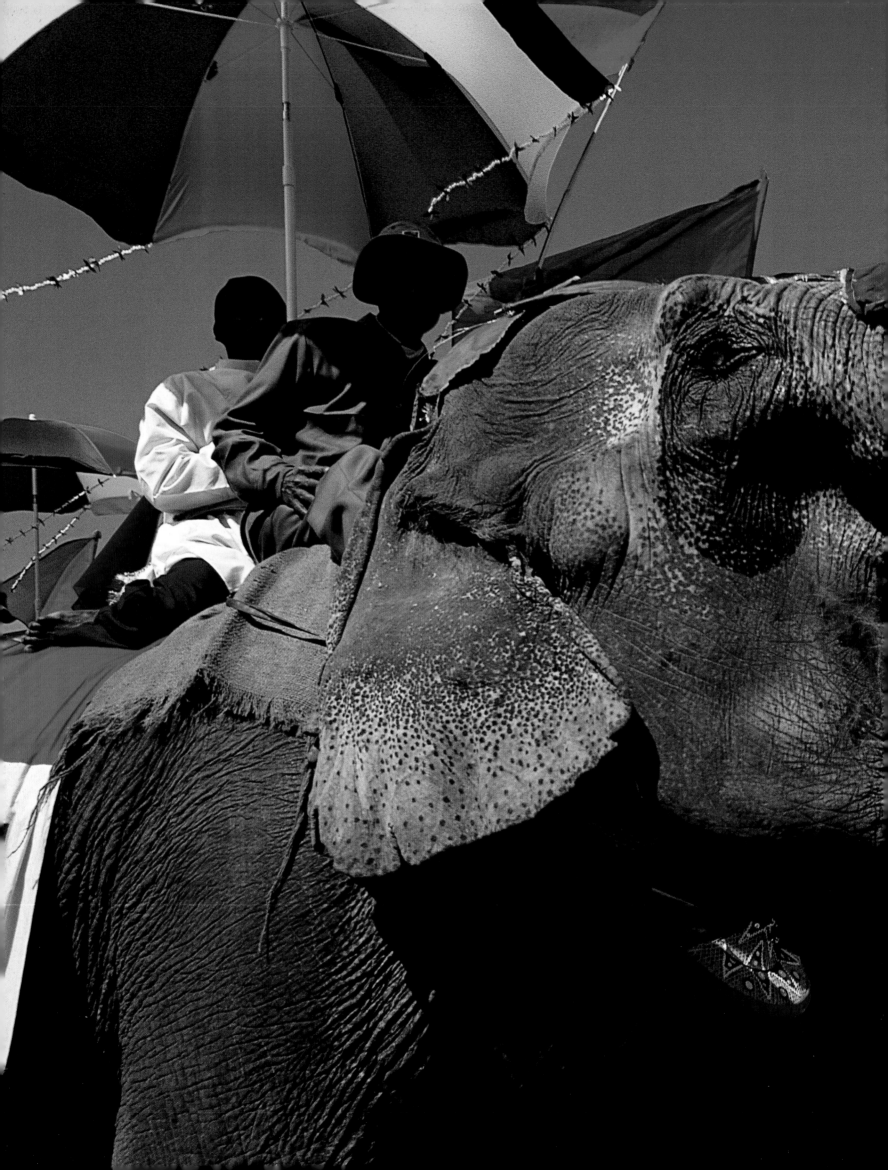

NORTH EAST **INDIA**

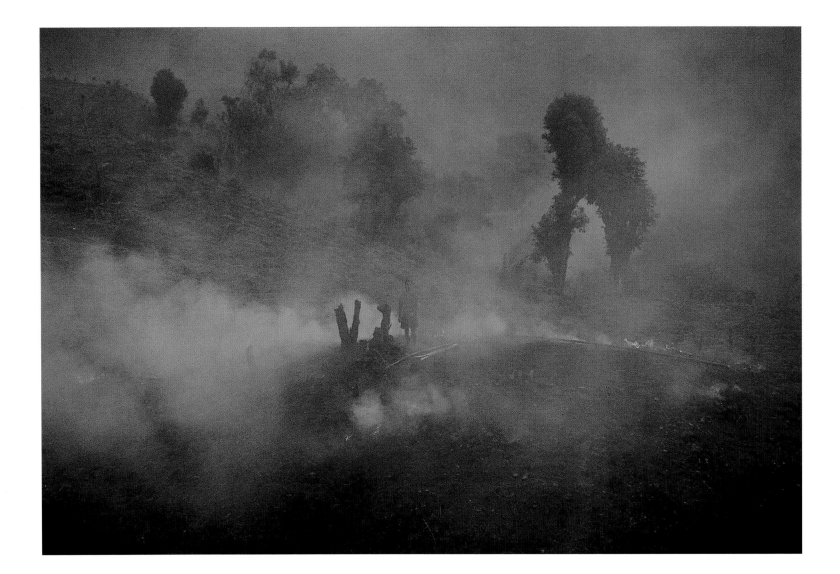

ALONG A NARROW CORRIDOR in the foothills of the Himalaya, at the far northeastern corner of India, bordering Bhutan, China, Burma and Bangladesh, live the Naga tribes. They are primarily subsistence farmers and hunter-gatherers, but their trophies, until as recently as 1991, included the heads of their enemies. Smoke covers the hills of Nagaland (**ABOVE**) as farmers burn off scrub in

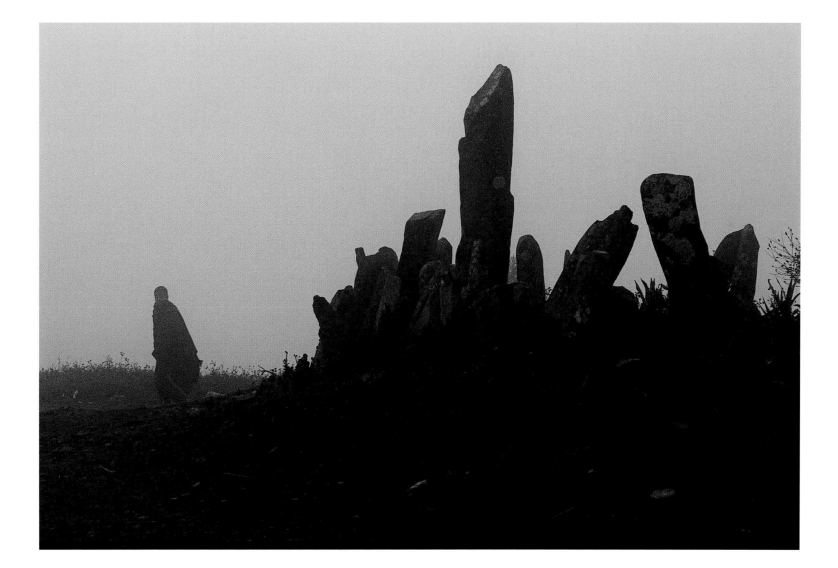

preparation for spring planting. **(ABOVE)** At the entrance to the village of Longwa, stone tablets are erected to commemorate the raids of their warriors and to keep score of the number of heads they brought back to the village.

(PRECEDING PAGES) Opening ceremony of the 2nd Elephant Festival at Kazirangar National Park.

India

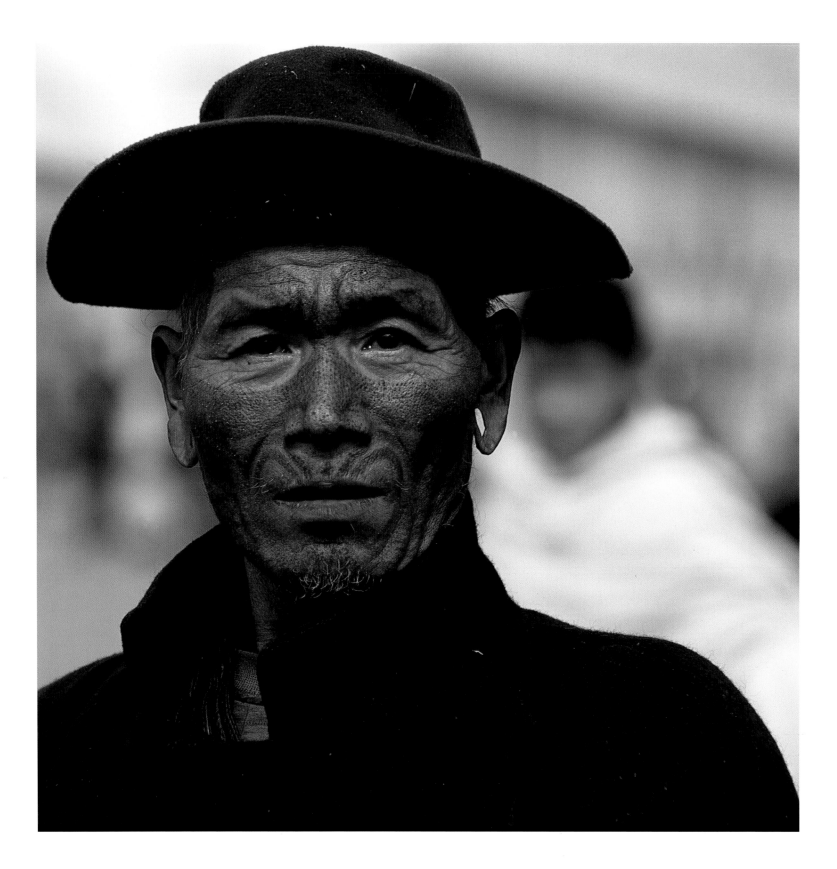

FASHIONS HAVE CHANGED in Longwa since the introduction of satellite dishes into Nagaland, and headgear is no exception. From the baseball caps favoured by teenagers in jeans, to the porkpie of this rather elegant gentleman (**ABOVE**), whom we dubbed the 'Humphrey Bogart of Naga', to grandpa's traditional 'headhunter's feathered, up-side-down basket' (**RIGHT**), all seem to go rather well with the intricate indigo tattoos on their faces.

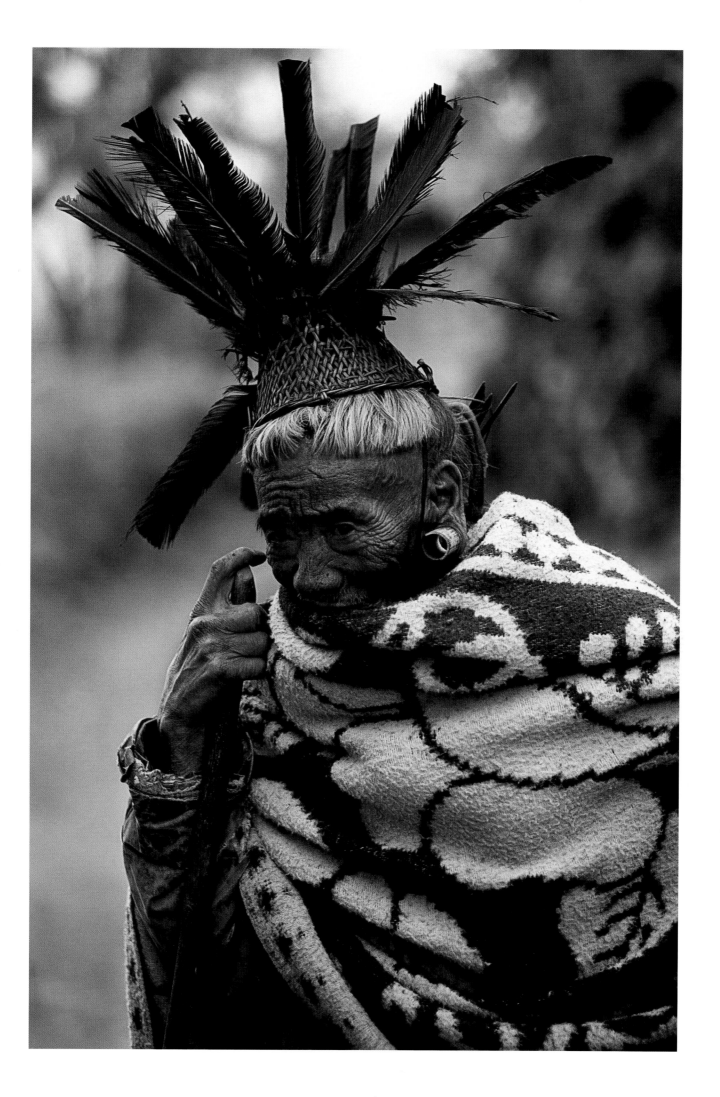

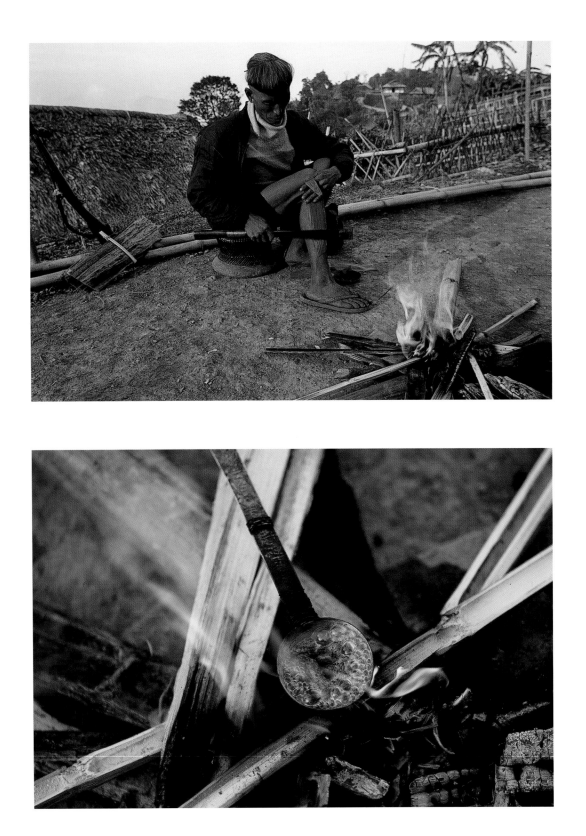

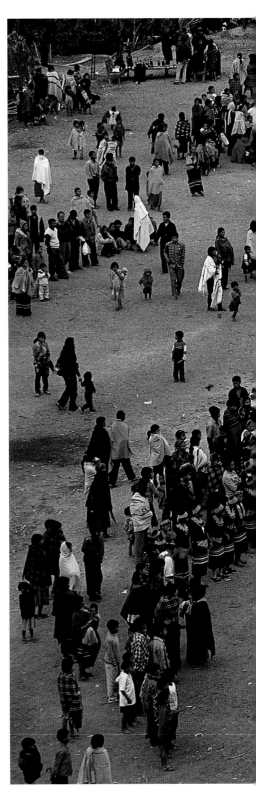

LONGWA is situated directly on the borderline, so everything on the right is in Burma, and the huts on the left belong to India. Nagas from villages on both sides of the border – some several days' walk away – gather at Longwa to celebrate the Spring Festival. **(LEFT)** Opium is being prepared to welcome distant cousins. **(RIGHT)** Warriors reenact a raid on an enemy's village in the Python Dance.

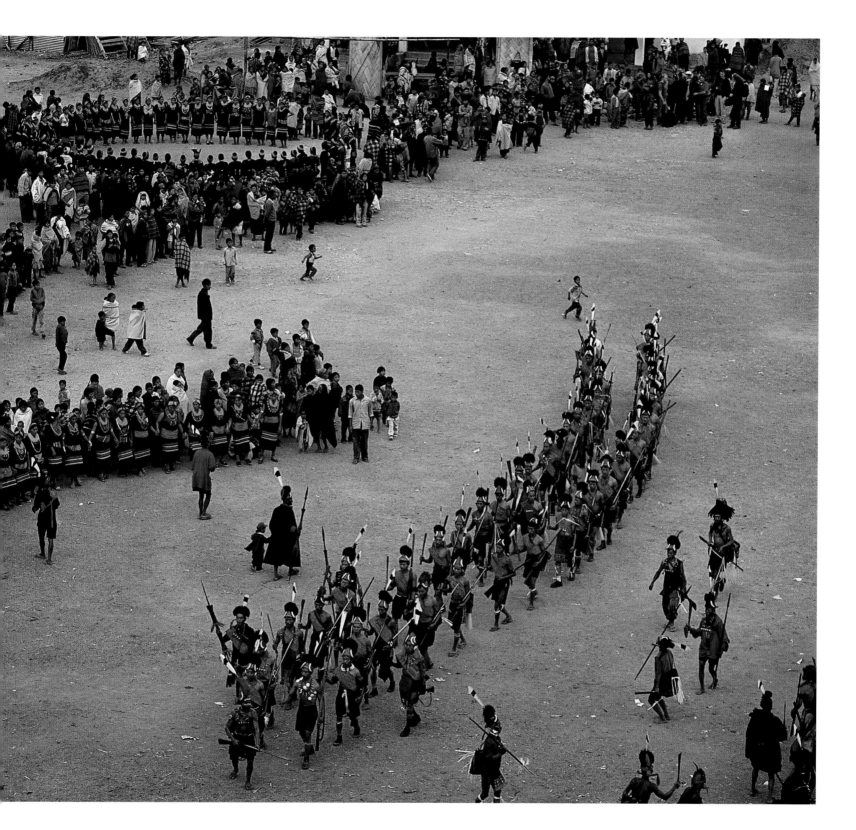

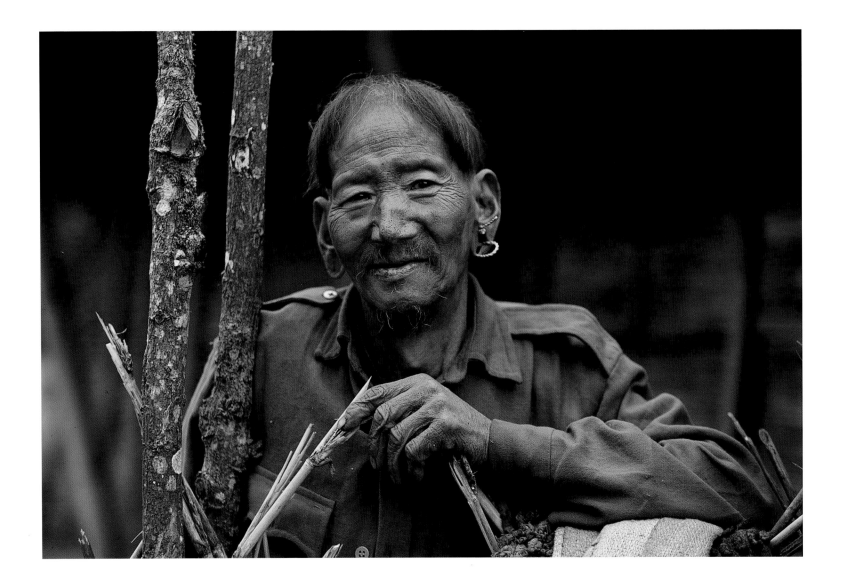

THEIR APPEARANCE may be similar, but they cannot be more different as subjects. While this man **(ABOVE)** was initially shy and surprised, he soon settled down and struck a regal pose. But our friend here **(RIGHT)** is another story entirely. He either turned away or lost himself in a crowd every time I raised the camera in his direction. But I persisted and, after an hour, he abruptly turned and faced the camera, no doubt thinking, 'OK, Chinaman, you want my picture, here it is, but I'm going to ruin it for you by making a face!' To which I can only say, thank you very much indeed.

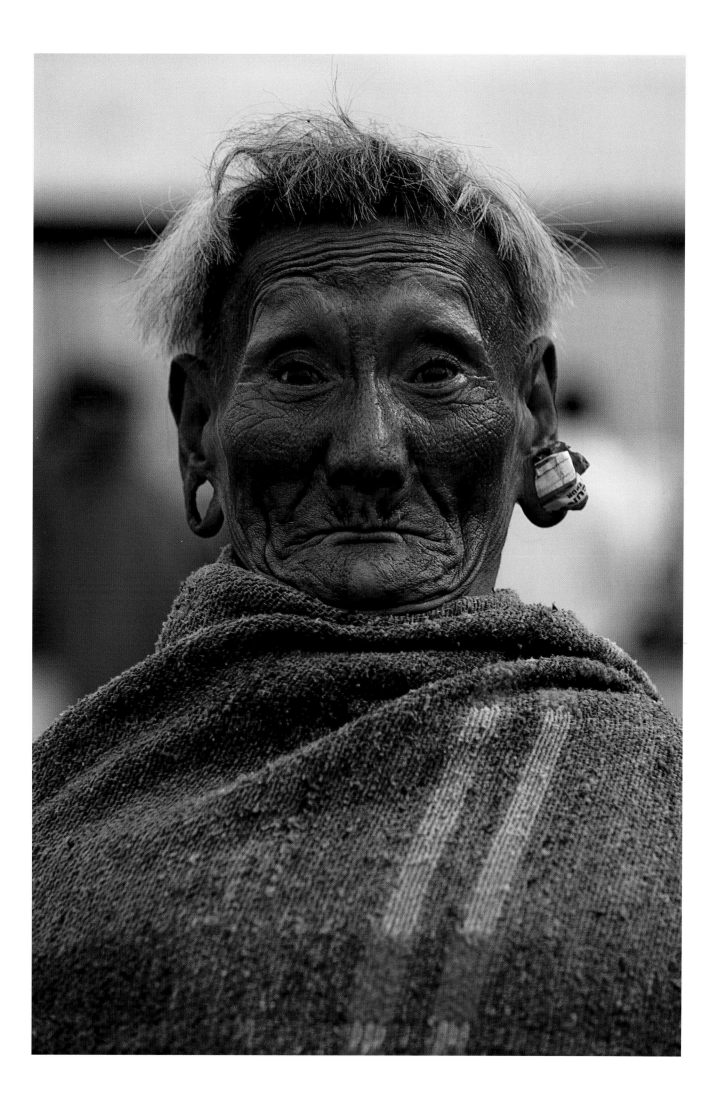

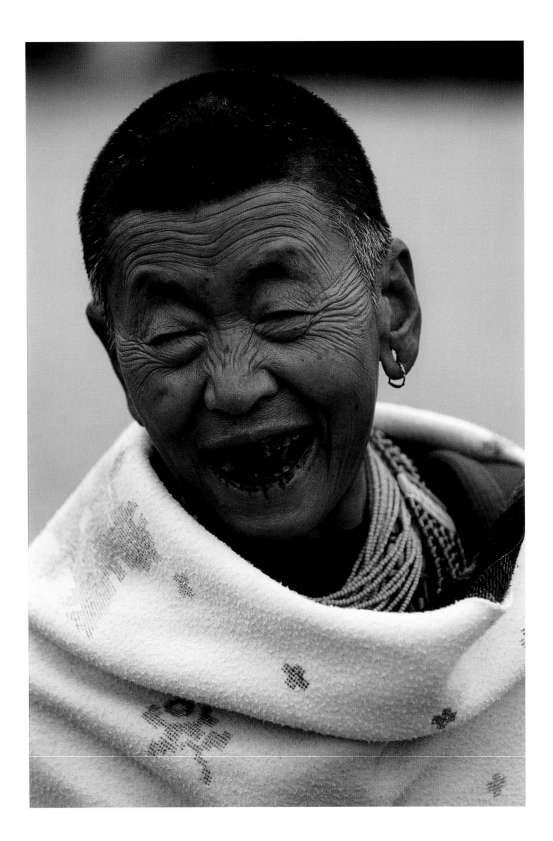

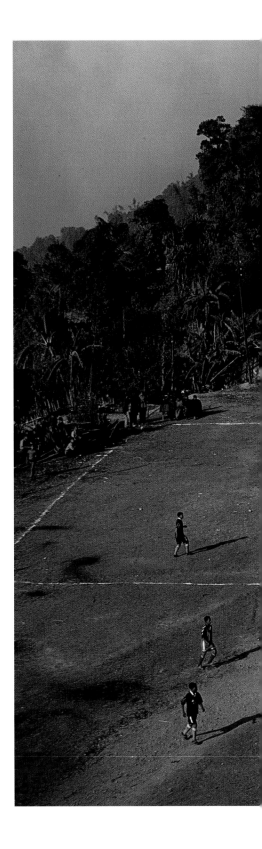

THE AMERICAN BAPTIST CHURCH has really 'scored' in Nagaland since it first arrived in the 19th century; 99 per cent of the Nagas are now Christians. **(RIGHT)** In this 'International' match, played in front of their imposing church between Longwa and the Burmese village of Khemoi, the home team eventually won 8-2. **(LEFT)** A hysterical Naga lady and her betel nut.

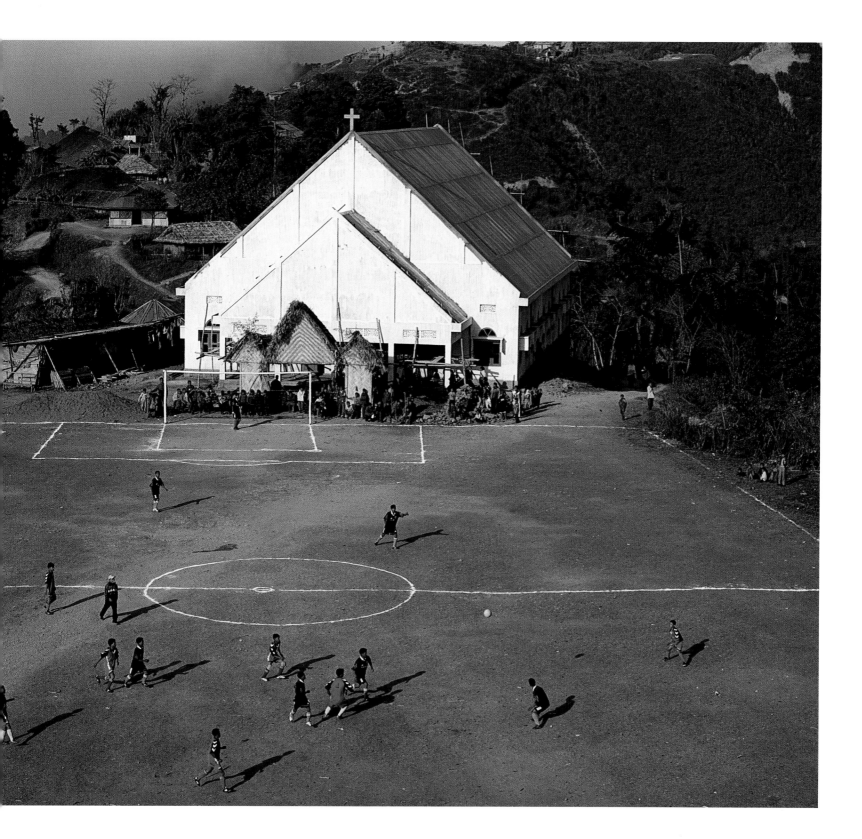

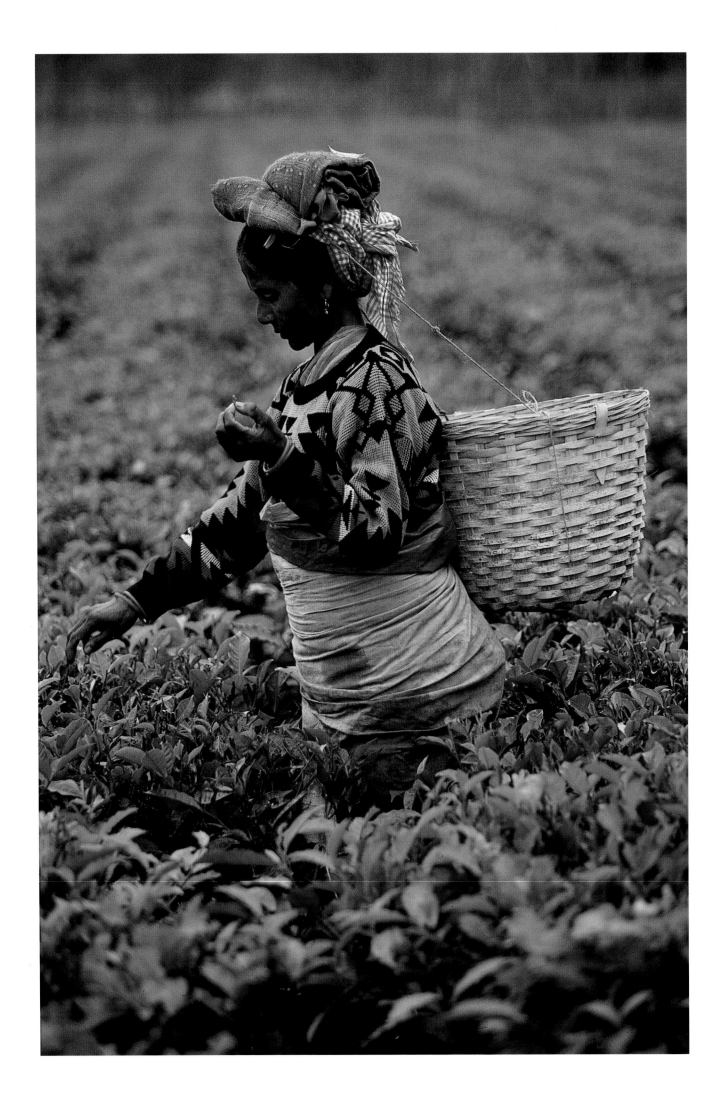

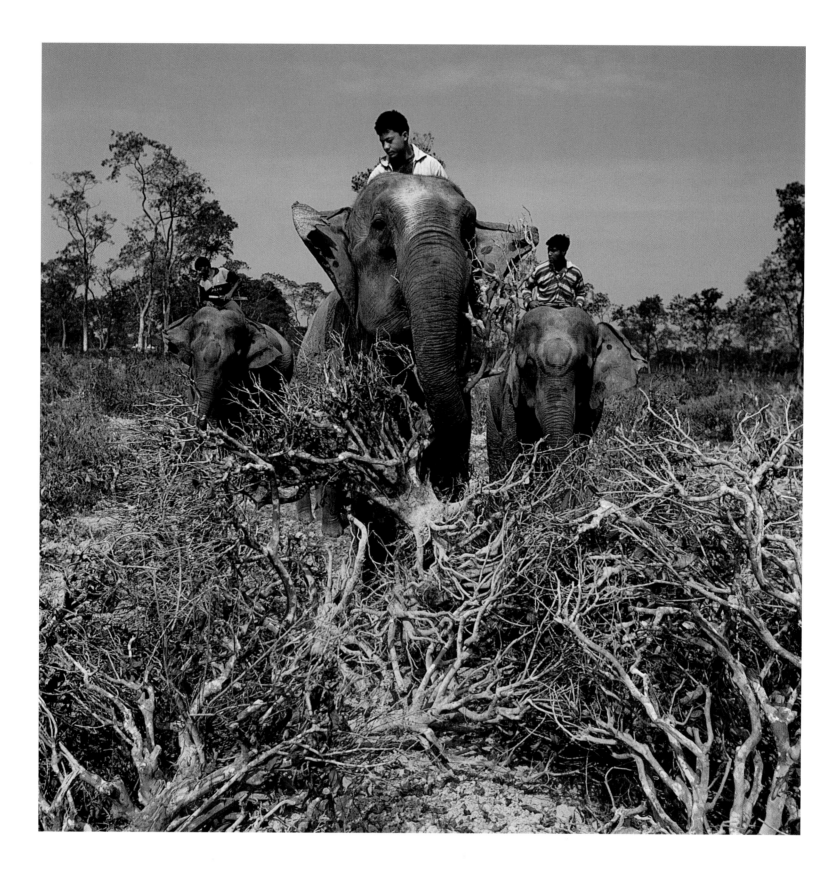

OWNERS OF THE TEA PLANTATIONS in Assam have Scotsman Robert Bruce to thank for first recognizing the commercial potential of the wild tea plants in the area back in 1823. **(LEFT)** Today, they produce an average of 380 million kg of the world famous tea annually, almost half of India's total output. **(ABOVE)** Mahouts and elephants clearing a field of dead root at the Mancotta tea estates in Dibrugah. The Assamese are reputed to be the first to master the art of taming elephants for industrial purposes.

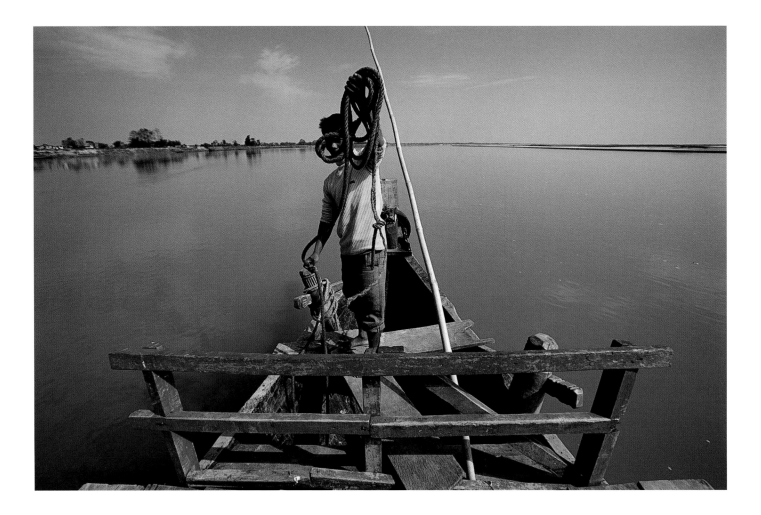

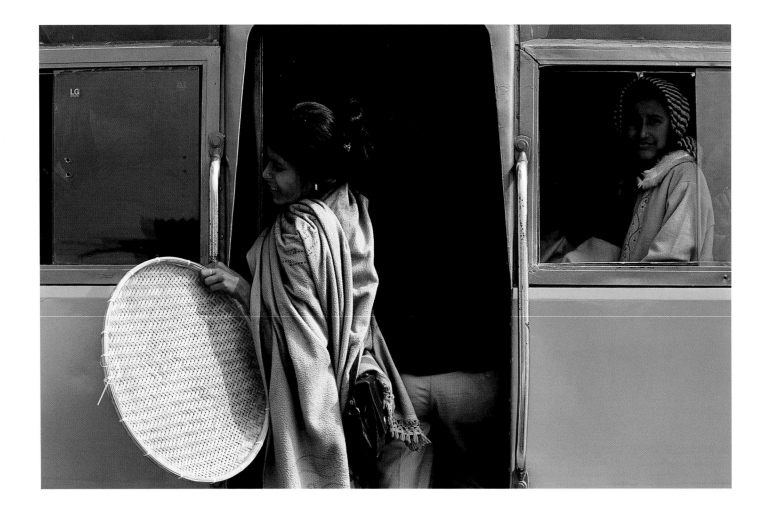

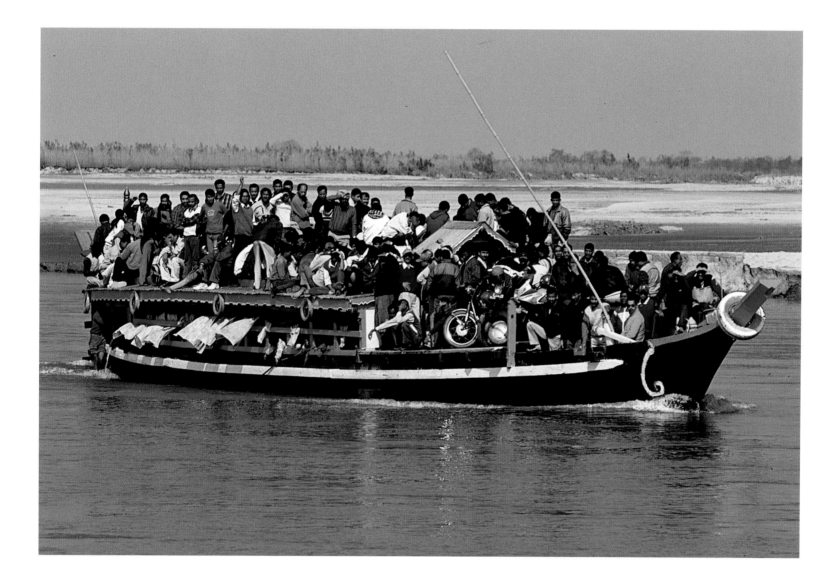

THE 1000-MILE JOURNEY of the Brahmaputra River begins in the high deserts of western Tibet. Along with the Indus and the Ganges, it flows from the sacred lake of Manasarovar in the shadow of Mount Kailash, the holiest mountain of every eastern religion because of its physical resemblance to the mythical Mount Meru, the 'Centre of the Universe'. In Assam, it becomes a vast body of water, like an inland sea. (**ABOVE**) Our ferry was practically identical to this one, and I had the strangest sensation of watching myself going in the opposite direction. (**TOP LEFT**) Our boatman prepares to dock at Majuli Island. (**BOTTOM LEFT**) At the boat station on Majuli, a lady tries to squeeze herself into the sardine can.

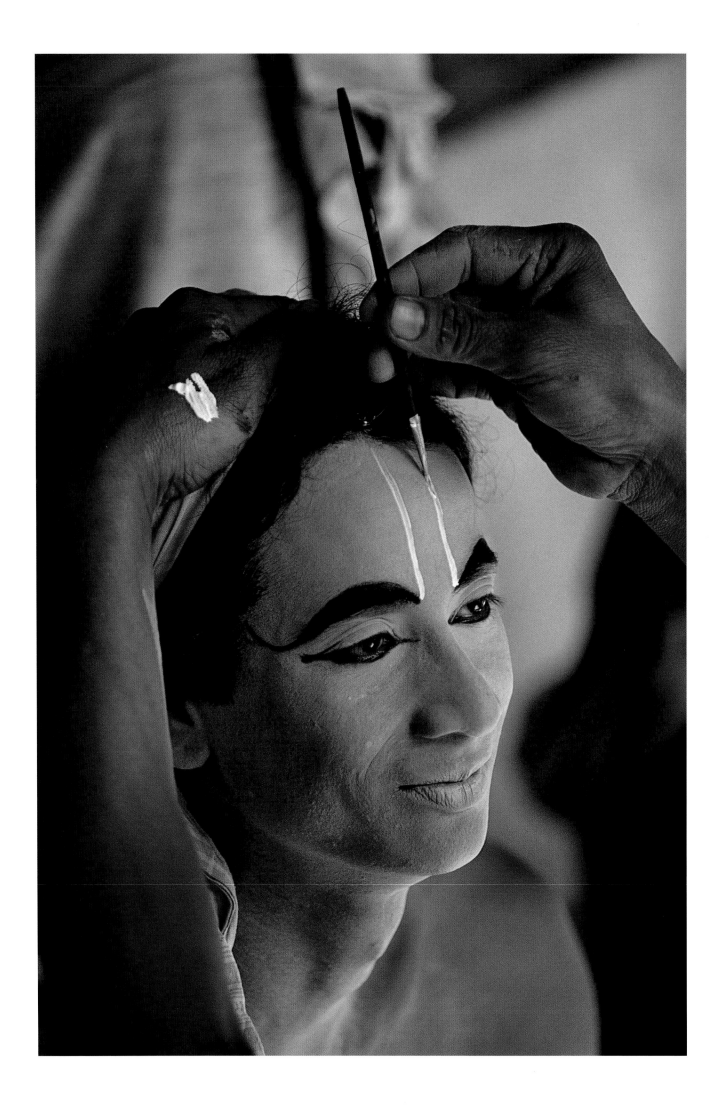

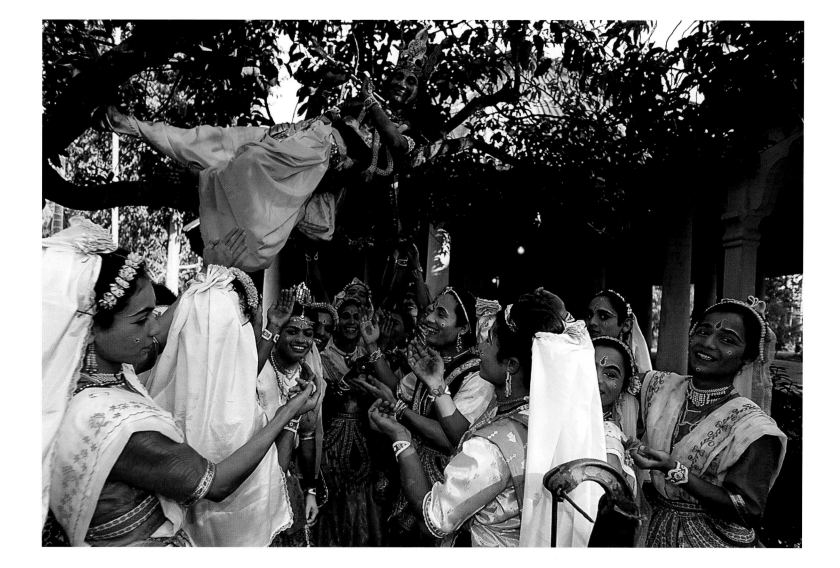

THE MONKS OF THIS SATRA (monastery) in Uttar Kamalabari devote their lives to the worship of Shiva
through dance, drama and music. From the age of six or seven, they begin their rigorous classical
training. By their late teens, the best ones will have the opportunity to travel the world and perform
at arts festivals with the renowned troupe. (LEFT) The dancer playing Krishna is being made up for the
performance of *Rass Lila*, in which handsome boys dressed up as pretty girls play the milkmaids who
all fall in love with Krishna, the 'matinée idol' incarnation of Shiva. (RIGHT) Their spontneous antics in
the garden after the performance brings to mind the song 'Girls Just Want to Have Fun'.

India

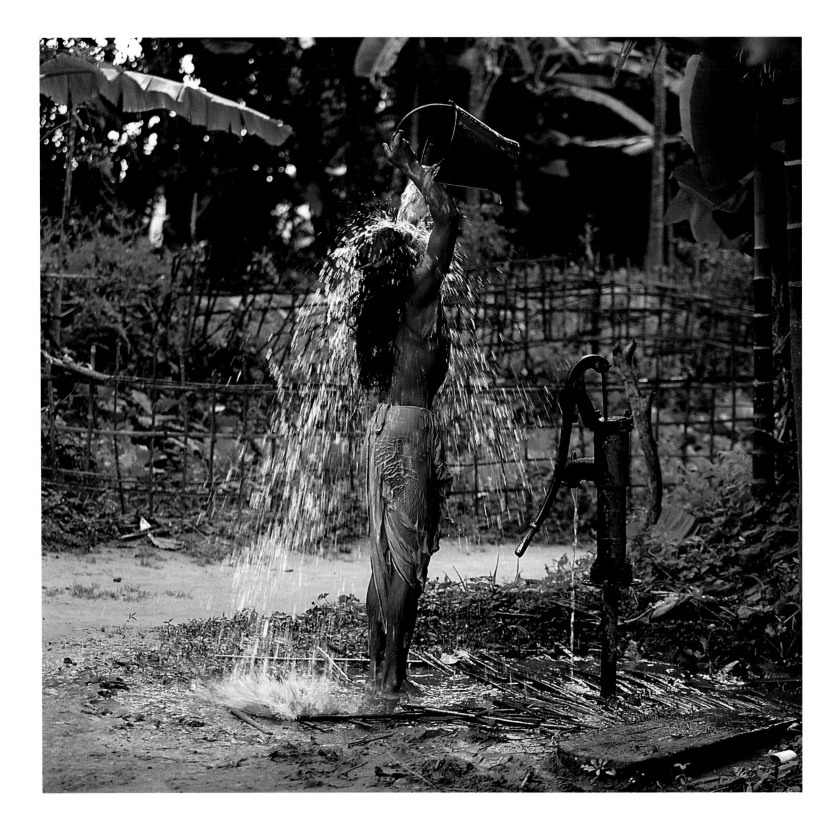

THE INHABITANTS OF THE MONASTERY all took a vow of purity and celibacy on joining this sect of Vishnu followers. So, although they are free to leave the monastery (the children go to local schools) and have normal contact with outsiders, the monks must be thoroughly cleansed when they re-enter the *satra*. **(ABOVE)** A teenage monk taking a cold shower. While just beyond the gates of the monastery, **(TOP RIGHT)** a boy of similar age leads a very different kind of life. A deep sense of serenity and happiness pervades within the compound, **(BOTTOM RIGHT)** where even mundane daily chores can take on an aura of magic.

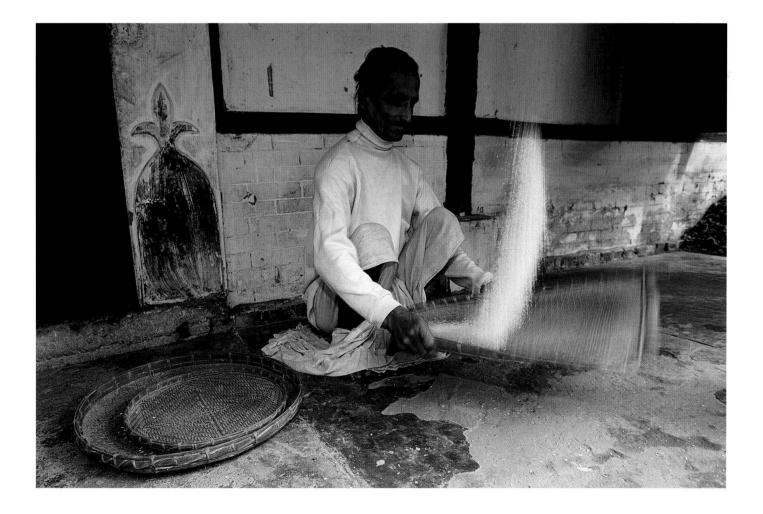

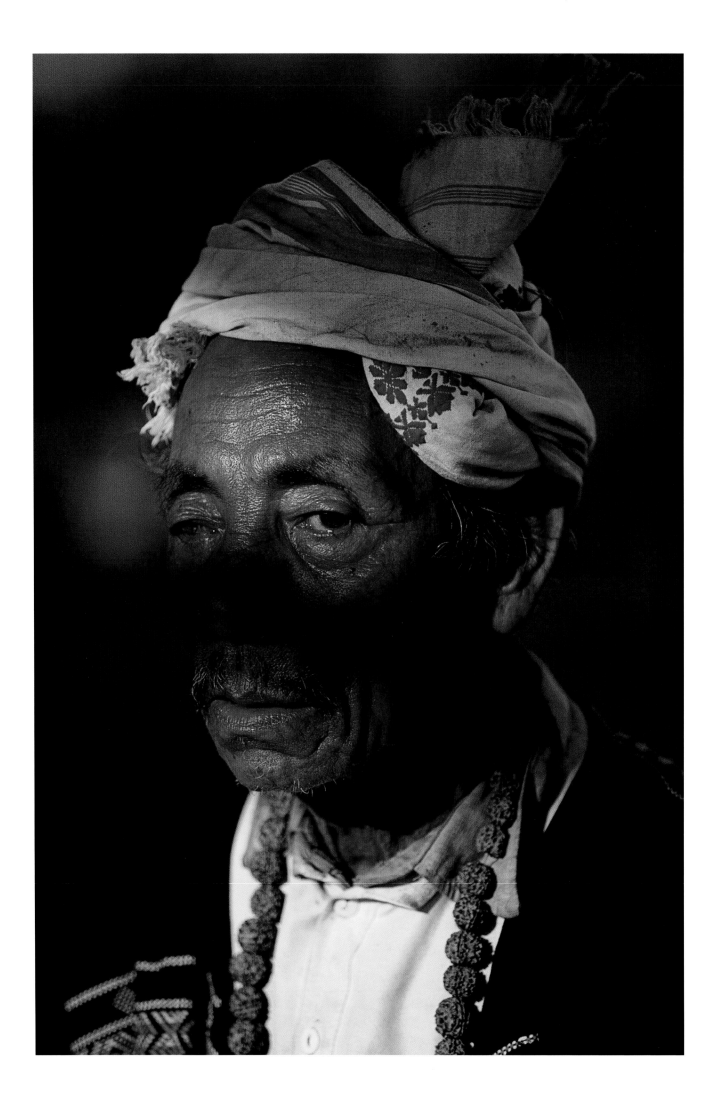

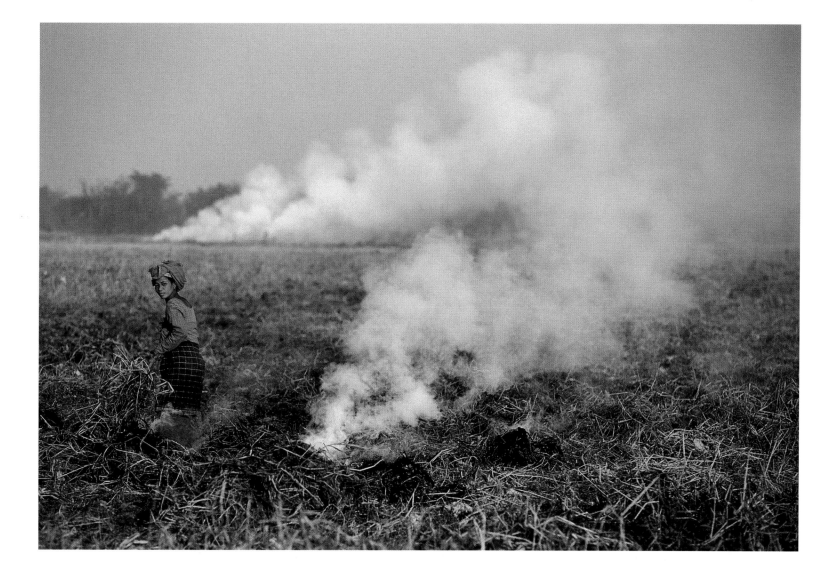

THE MINORITY MISHING PEOPLE on Majuli Island are believed to be the original inhabitants of the Brahmaputra lowlands, who took refuge here to escape religious persecution. They are animists who worship the sun god Donyi and the moon goddess Polo. **(LEFT)** The Mishing shaman keeps an eye on the elaborate ritual being performed to honour the gods, which, to the uninitiated eye, looks like a very complicated way of making chicken soup. **(ABOVE)** At twilight, a woman clears the field with fire in Uttar Kamalabari.

India

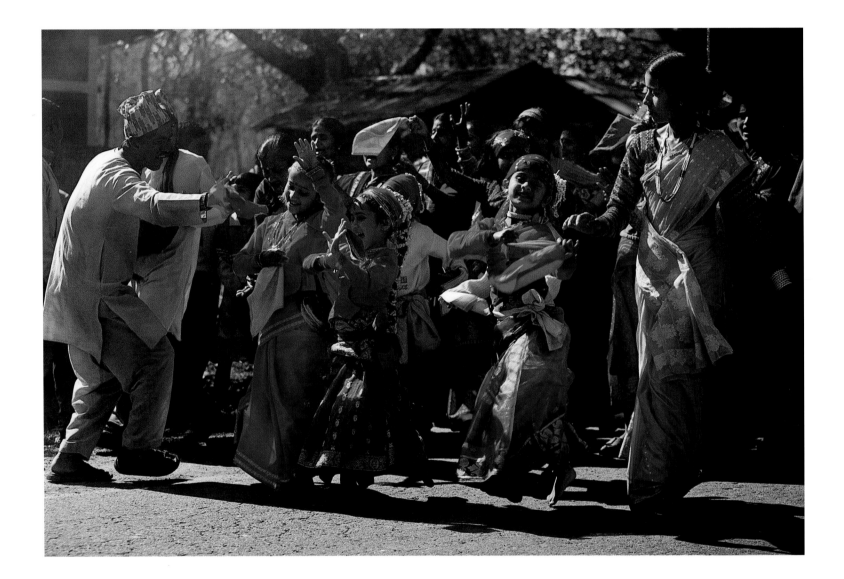

THE ASSAM REGION is known to have the most diverse mix of cultures and ethnic groups in all of Asia, and many of them are represented – in their national party dresses – at the opening ceremony of the 2nd Kaziranga Elephant Festival. **(ABOVE)** The Nepali Dance group, with three irrepressible little girls in the lead, is probably the most energetic participant in the parade. **(RIGHT)** Meet a member of the group called the Kalah Girls, who paraded around the grounds with what looked like terracotta flower vases in their arms.

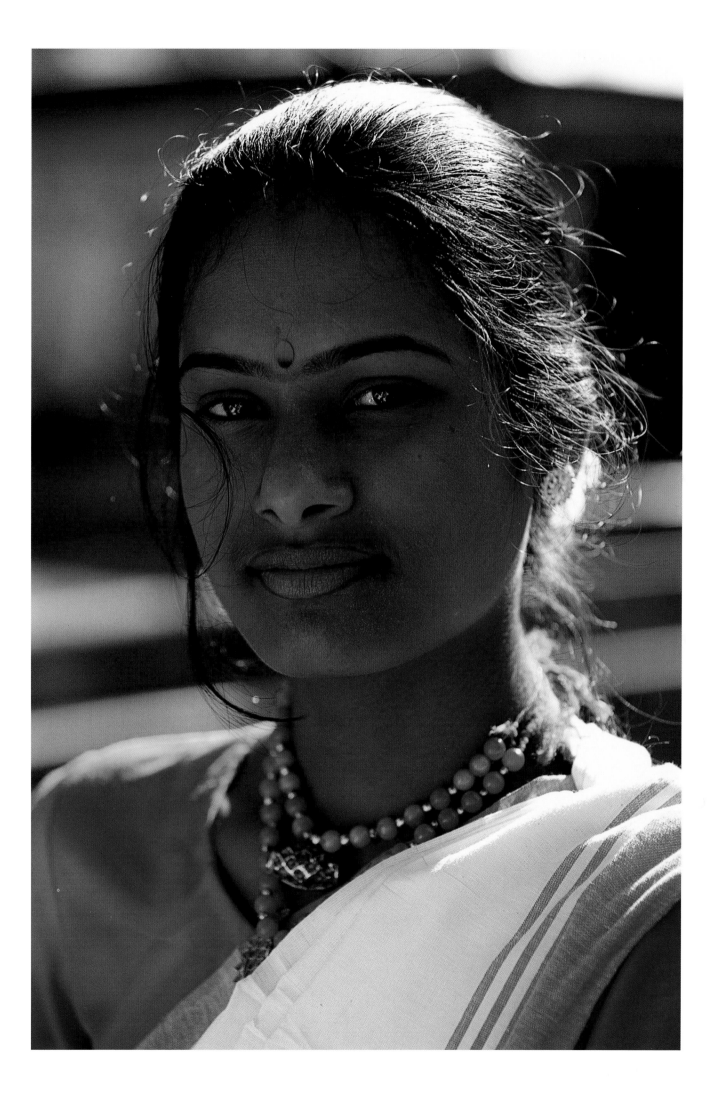

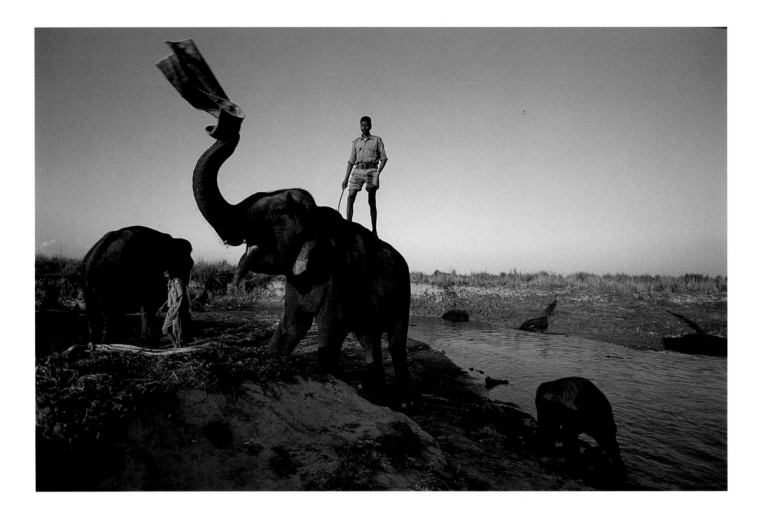

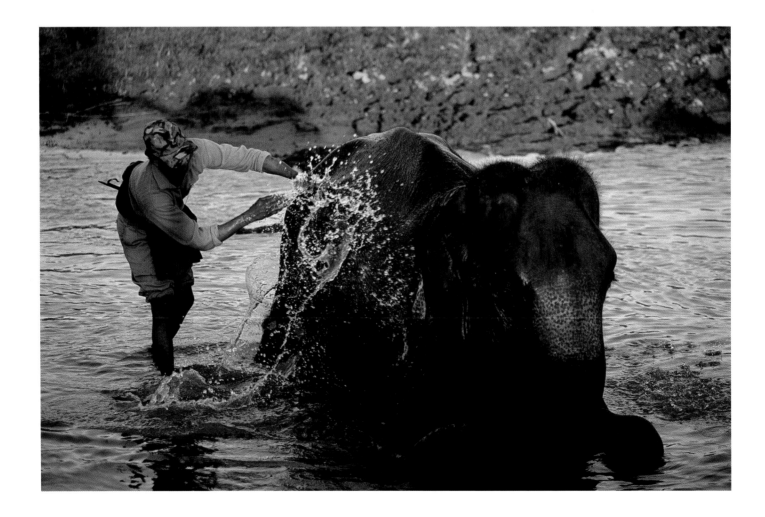

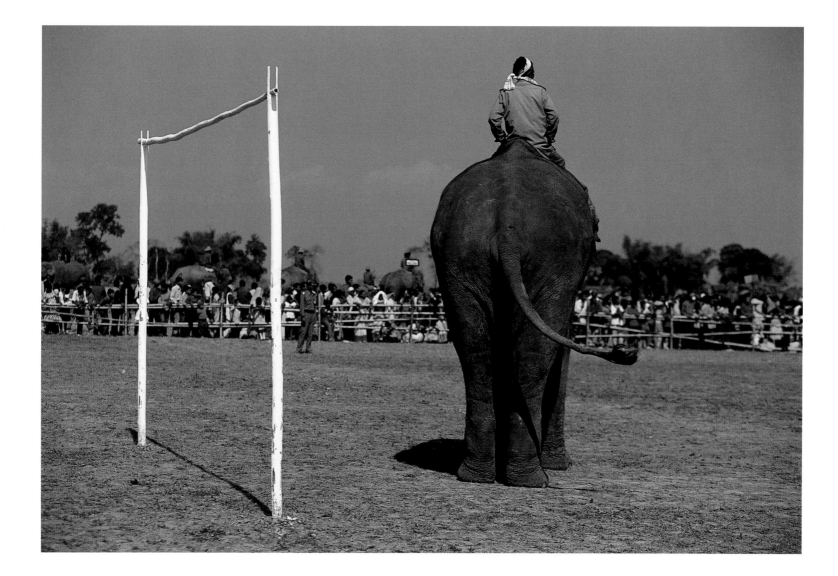

BEING THE GOALKEEPER in an elephant football match **(ABOVE)** is a very lonely job. For a start, none of the gentle giants seems to be able to 'Bend it like Beckham', or indeed do anything else with the ball, except kick it forward in whatever direction they happen to be facing. The game is also marred by the constant interruption of men with wheelbarrows and shovels, who are fighting a valiant but futile battle against the mountains of dung that keep appearing all over the pitch. At dusk, after a long, hot day at the festival, **(LEFT)** the elephants get to enjoy a refreshing bath in the river.

India

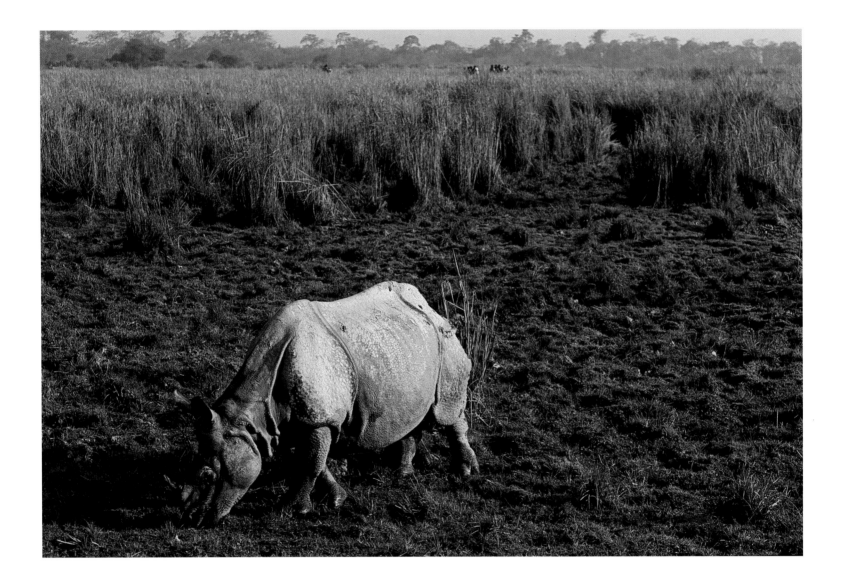

THE KAZIRANGA NATIONAL PARK is a 293-square-mile (759-sq-km) wildlife sanctuary on the banks of the Brahmaputra. The Viceroy, Lord Curzon, first established it in 1916 to save the Indian greater one-horned rhino from extinction. Today, there are over 1500 rhinos, about 70 per cent of the world's population, living in the park. They are protected against poachers by 400 rangers and their only natural predators are the 100 or so tigers who also live here.

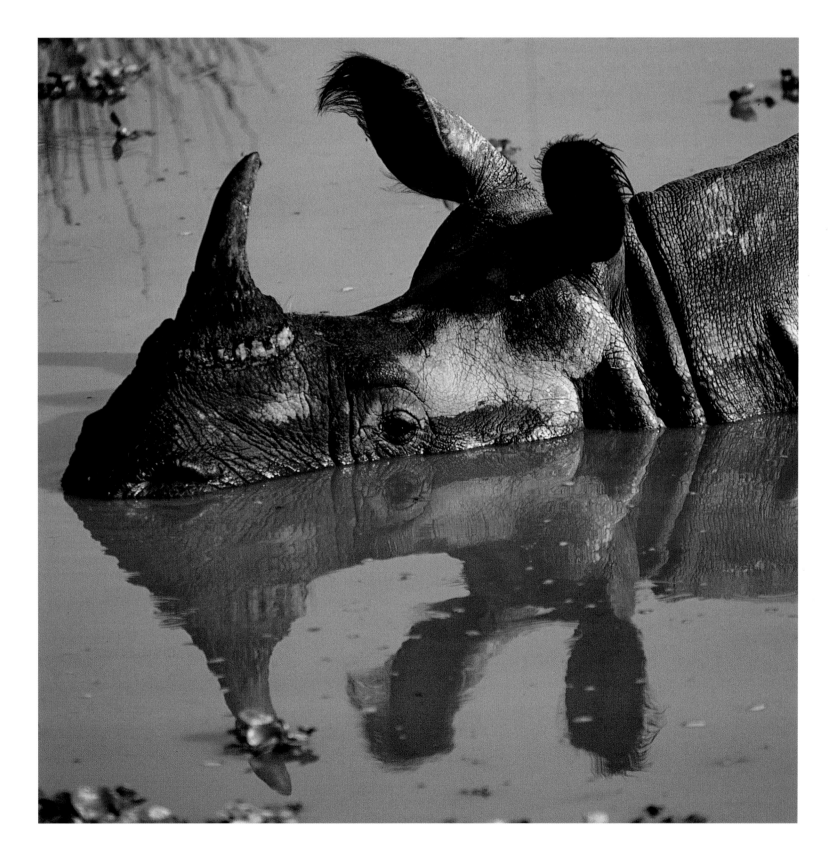

NEPAL

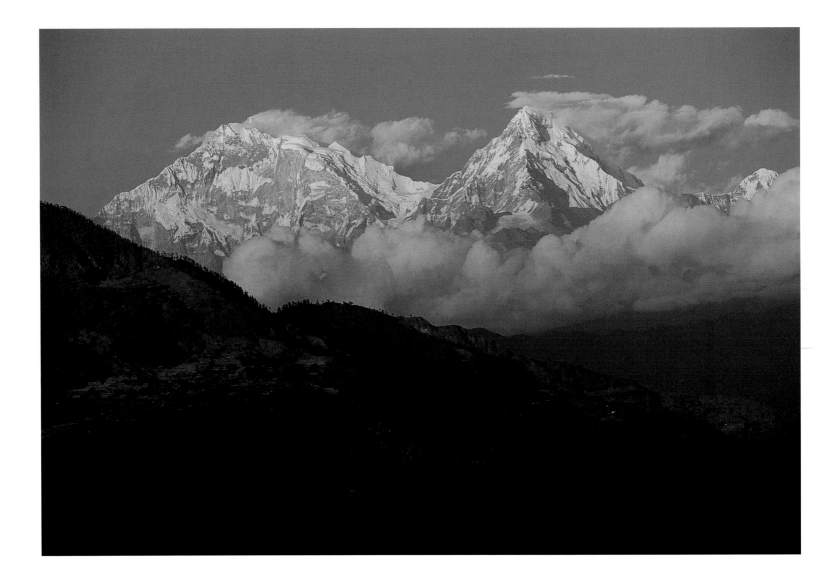

LOCATED SOMEWHERE WEST OF POKHARA and not indicated on any map, the small village of Lekhani is difficult to get to (hours of rutted mud tracks followed by hours of trekking) but beautiful to behold. **(ABOVE)** The view from our campsite at sunset of the peaks of the Annapurna and Macchapuchare. **(RIGHT)** At sunrise, I meet a young girl on her way up the hill to gather feed for the cattle. *(Our visit to Lekhani to film Gurkha recruitment was cut short by the sudden appearance of Maoist insurgents, who abducted the Gurkha officers. They were released a few days later unharmed.)* **(PRECEDING PAGES)** A Lekhani boy mending the bamboo swing.

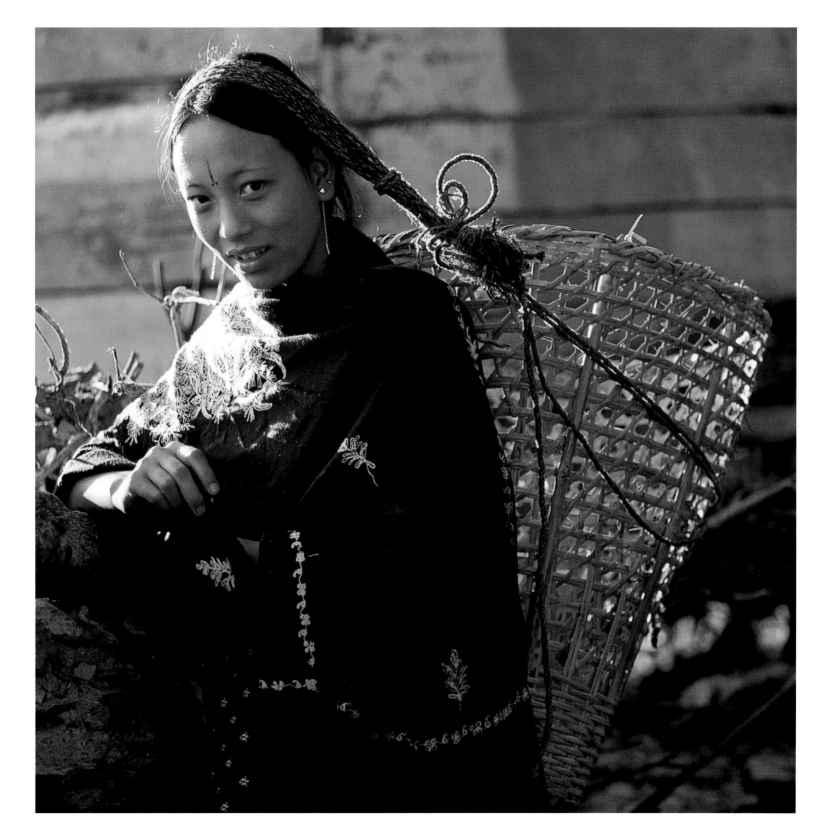

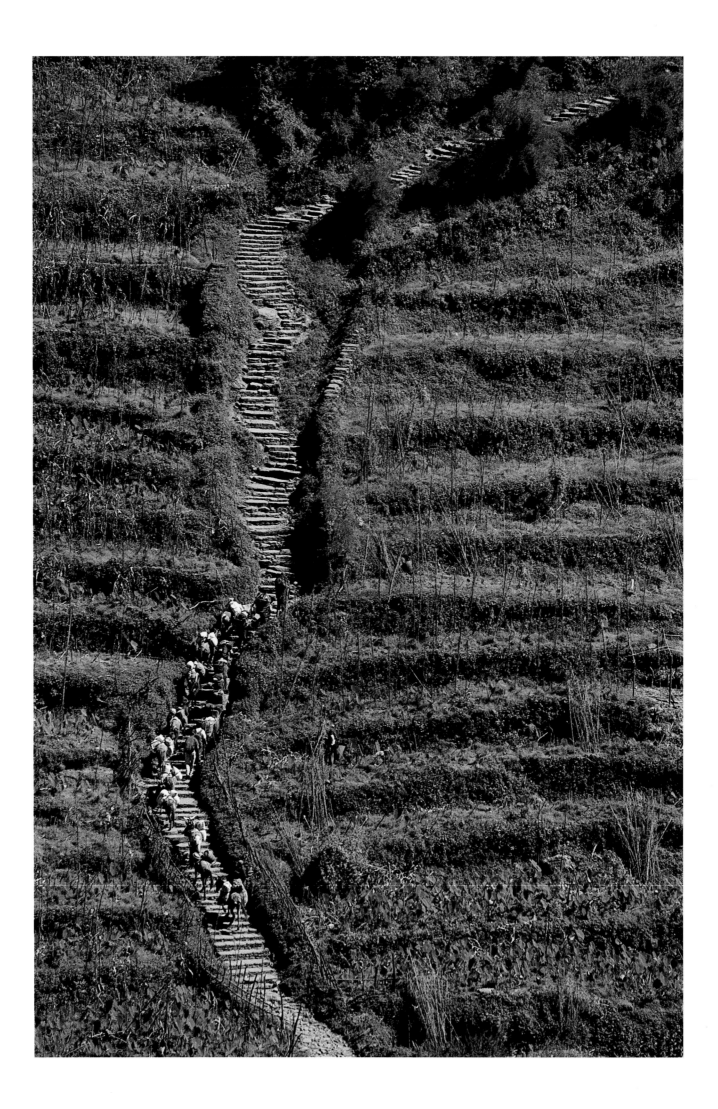

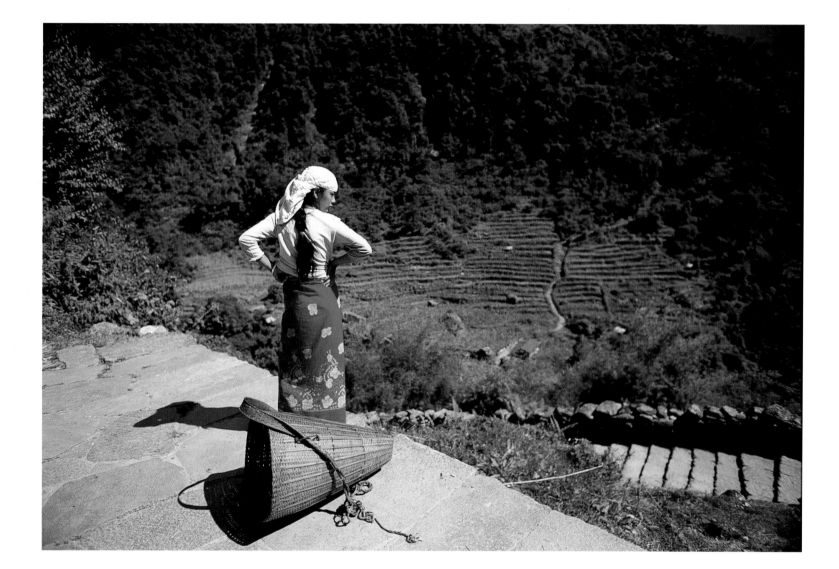

A VILLAGE GIRL from Chomrung looks on (**ABOVE**) as the crew disappears out of sight down the stone steps that lead to the River Modi. I had no idea when I took this picture that the steps go on for miles down to the very bottom of the ravine, before a small bridge takes you across the river to begin the tortuous climb (**LEFT**) up the steps on the other side of the valley. Over the next few days, I get that same sinking feeling every time the trail starts winding down a gorge towards the distant sound of water far below; I know I will have to climb at least twice that distance again in order to gain any altitude towards that illusive goal that is always several thousand feet further up.

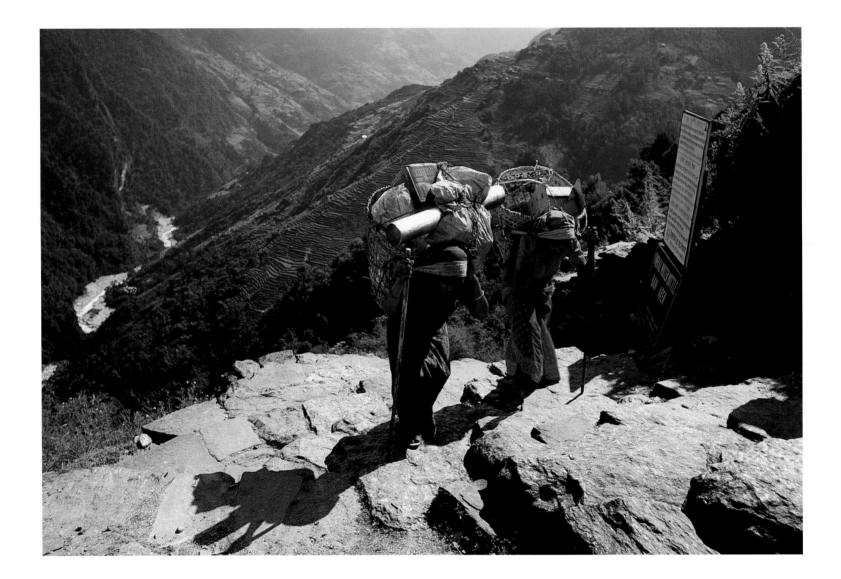

BY THE TIME I took these pictures, on the final assault from Derali **(TOP RIGHT)** to Macchapuchare Base Camp **(BOTTOM RIGHT)**, the flu bug I had picked up in Kathmandu a week earlier had truly kicked in and was in full bloom. Gasping for breath at 13,000 feet (3960 m) and stopping to cough my lungs out every hundred yards, I remembered the road sign back in Chomrung **(ABOVE)**, which listed all the symptoms of 'early' and 'worsening' Acute Mountain Sickness, and, apart from vomiting, I had them all. Alas, it was too late to follow their advice of 'Descend! Descend! Descend!'.

(OVERLEAF) A battered presenter with a mug of hot cocoa at Macchapuchare Base Camp.

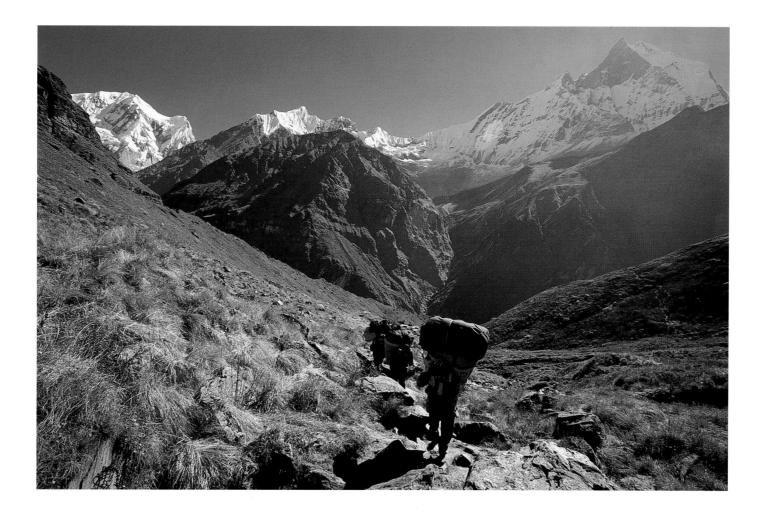

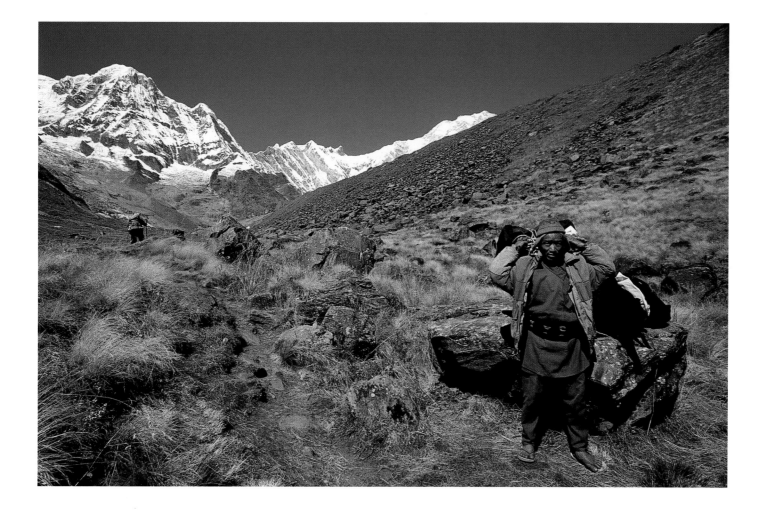

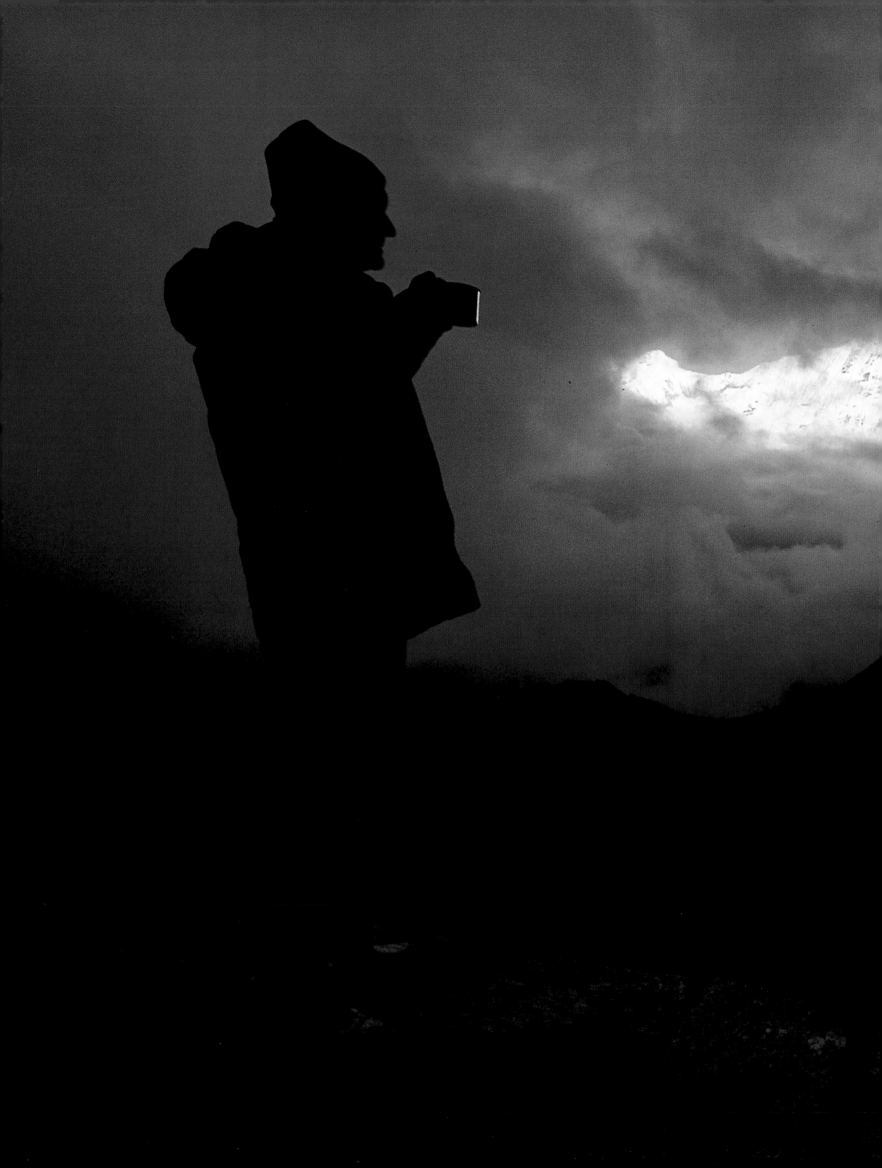

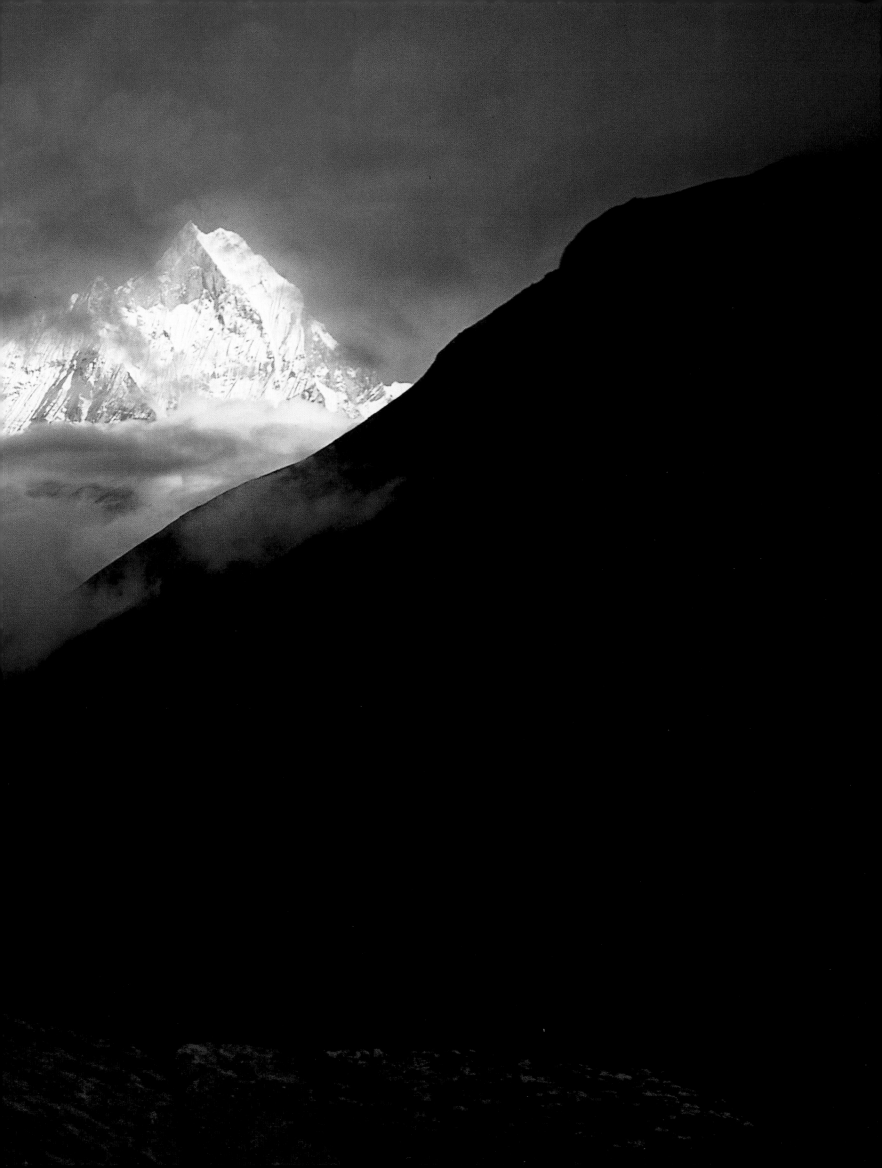

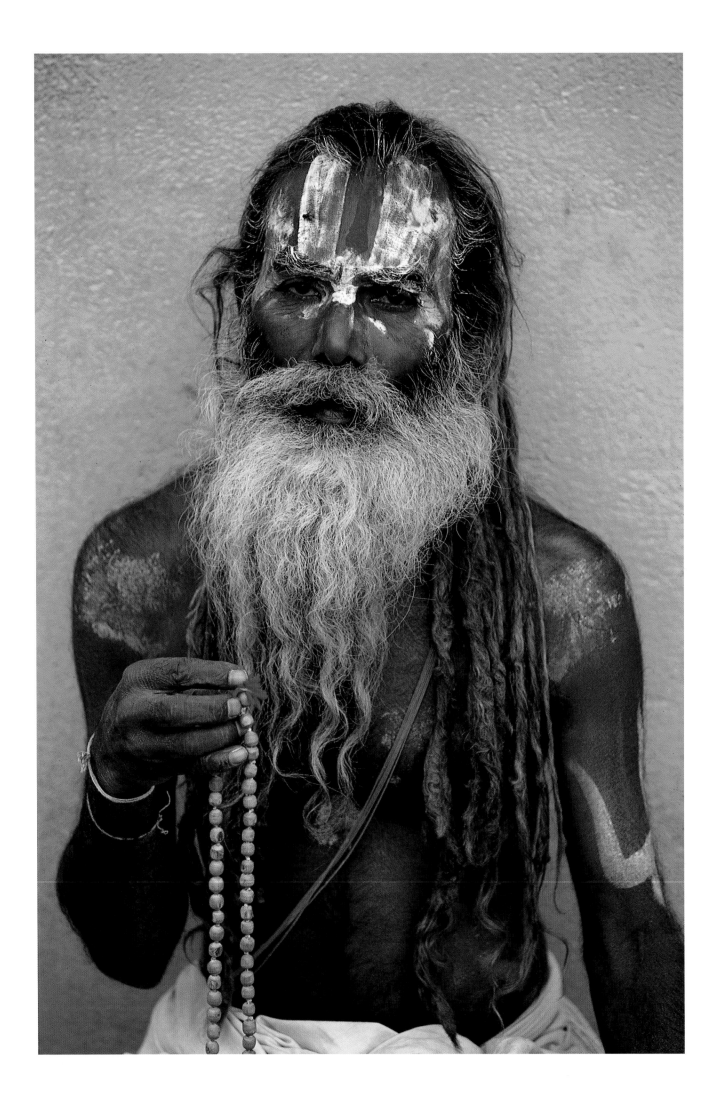

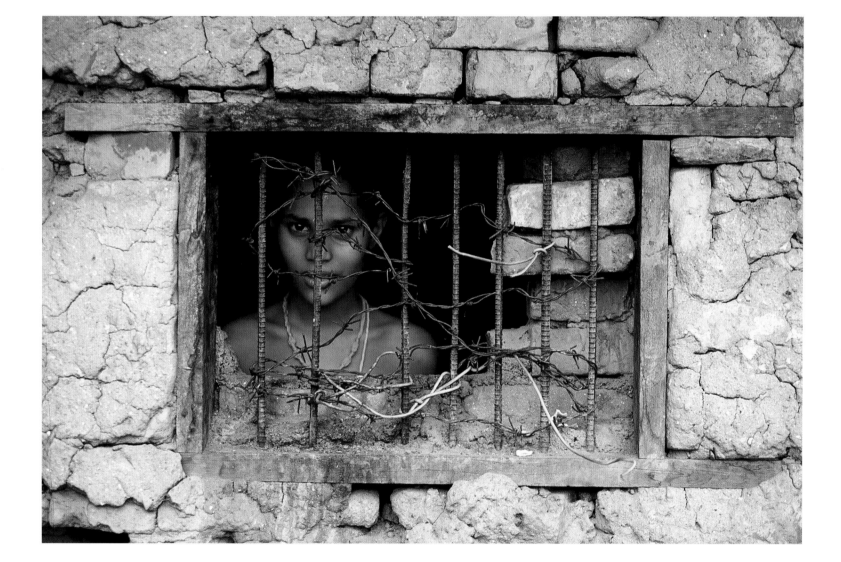

PASHUPATINATH (Lord of all Creatures) is one of the four holiest Shiva temples of Hinduism and has been the royal temple of Nepal for over 1000 years. It is also the favourite haunt of the sadhus **(LEFT)**, the wandering mendicants who live beyond the bounds of 'normal' society, kind of like the Rolling Stones of Hindu spirituality. One particular sect, known as the Aghoris (Fearless), meditate in the cremation grounds at night, and some believe their arcane practices include ritual cannibalism. So it is all the more surprising to find this girl **(ABOVE)** at the window on a back wall of the temple courtyard where the sadhus congregate.

Nepal

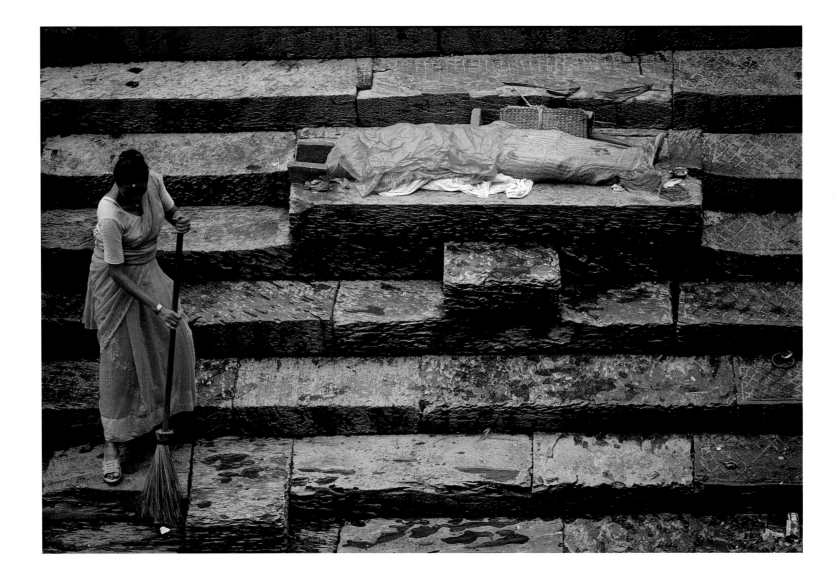

BELOW THE MAIN TEMPLE of Pashupatinath, on the banks of the holy Bagmati River, is the Arya ghat, the traditional cremation ground of the royal family and the high castes. The ancient rituals and the super-charged atmosphere are the same as my first visit 14 years ago, but the times have certainly changed. We observe, from a respectful distance across the river, a particularly poignant cremation ceremony, where a young man is bidding a final farewell to his wife. While he is choking with grief and touching her hennaed feet with his forehead, as if on cue, a western tour group, led by their local guide, file by right next to him, openly gawking at the proceedings with shock and awe.

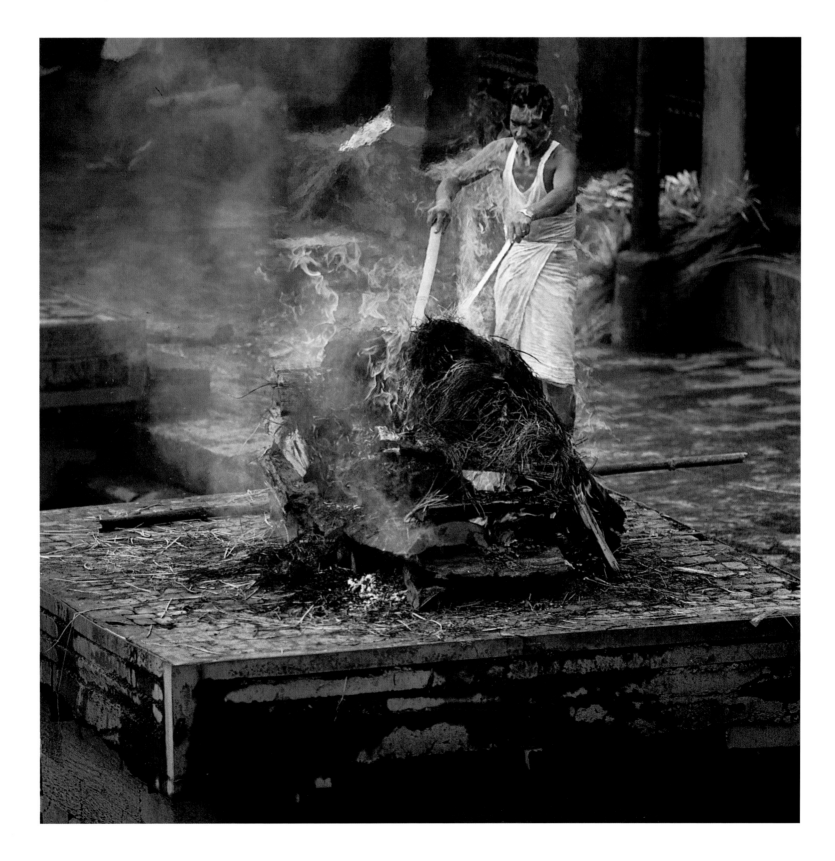

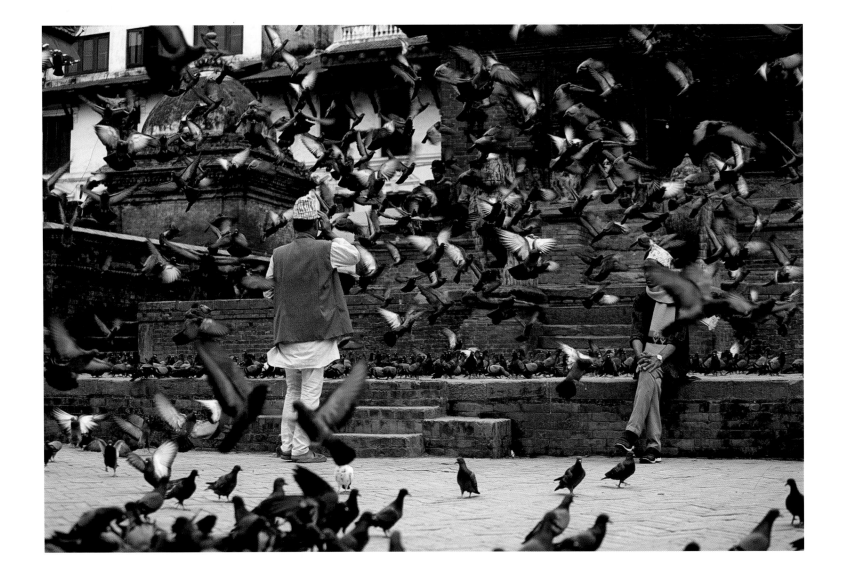

THE KATHMANDU VALLEY is full of architectural wonders, and one of the most famous is Durbar (Palace) Square **(ABOVE)**, which unfortunately you can't see because of all the pigeons. As in other poor countries, tourists and street urchins are like Yin and Yang, an unbreakable symbiosis that thrives in the most beautiful and historic places. **(TOP RIGHT)** A boy searching for coins inside the sublimely carved 'Map of the Universe', set on top of a stone *chaitya* at Pashupatinath. **(BOTTOM RIGHT)** Judging by her accent, our friend Kunda thinks the girl lounging on top of the superb elephant in Bhaktapur is part of a gang of child-beggars imported from India because the begging business is better in Nepal.

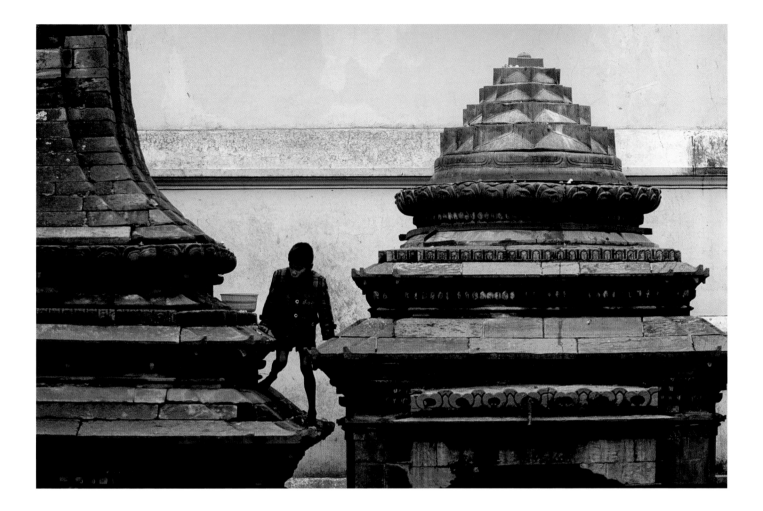

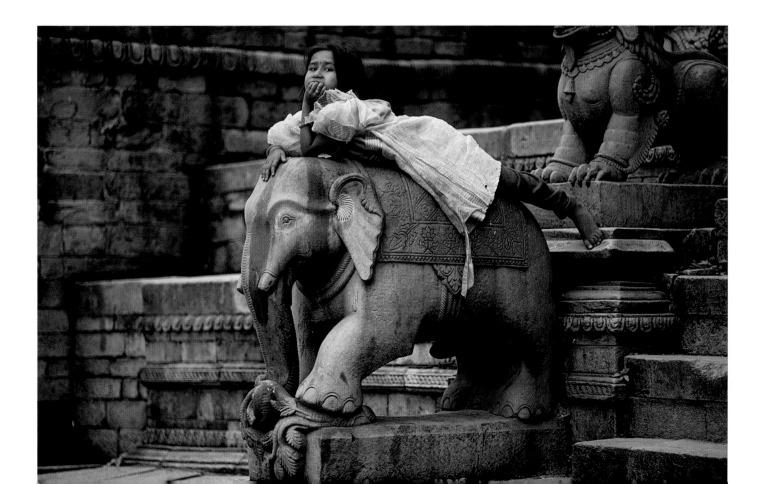

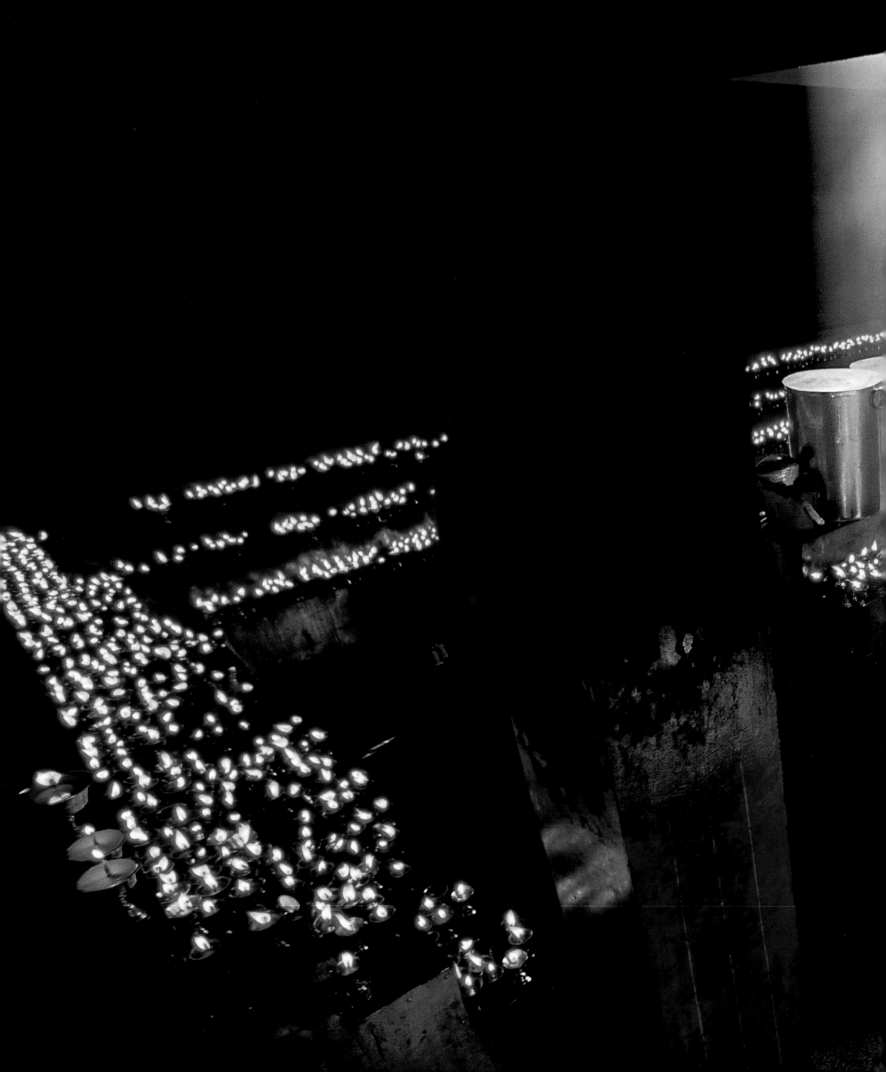

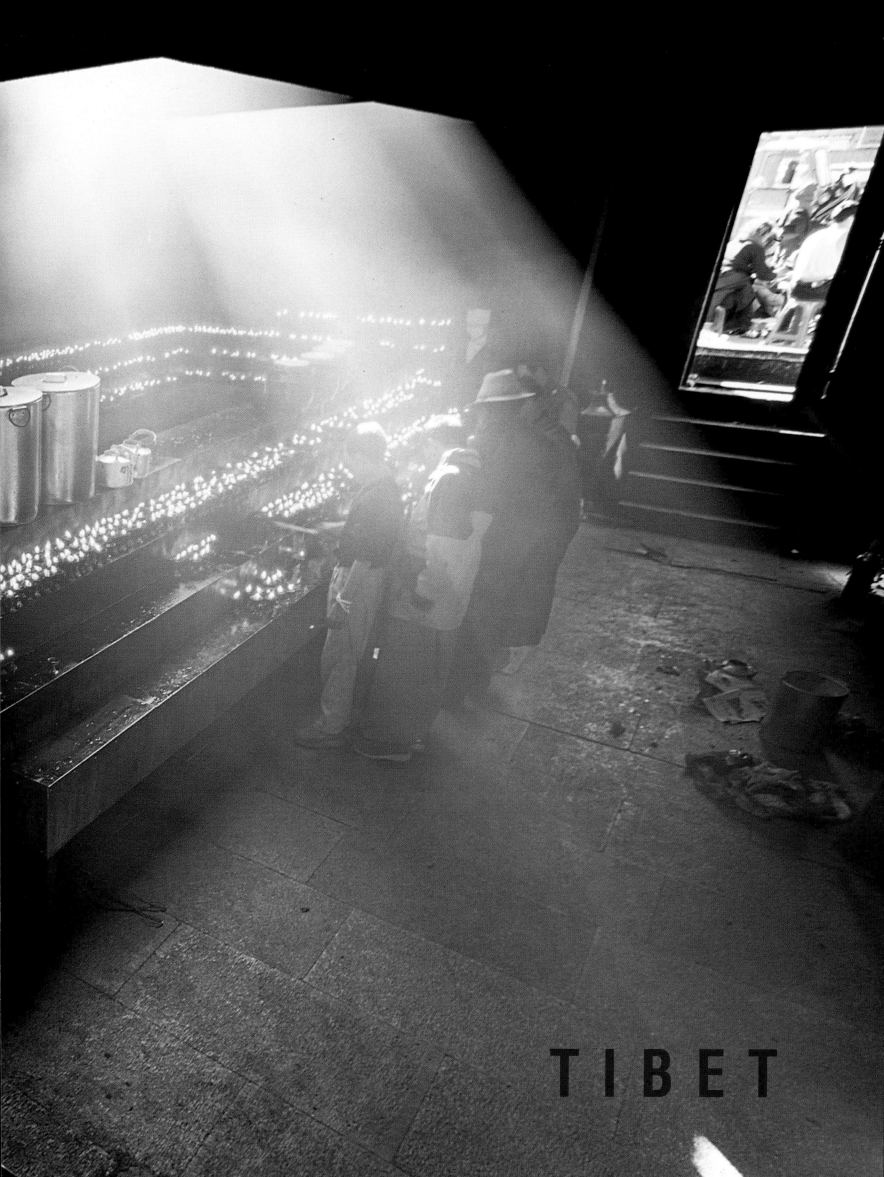

TIBET

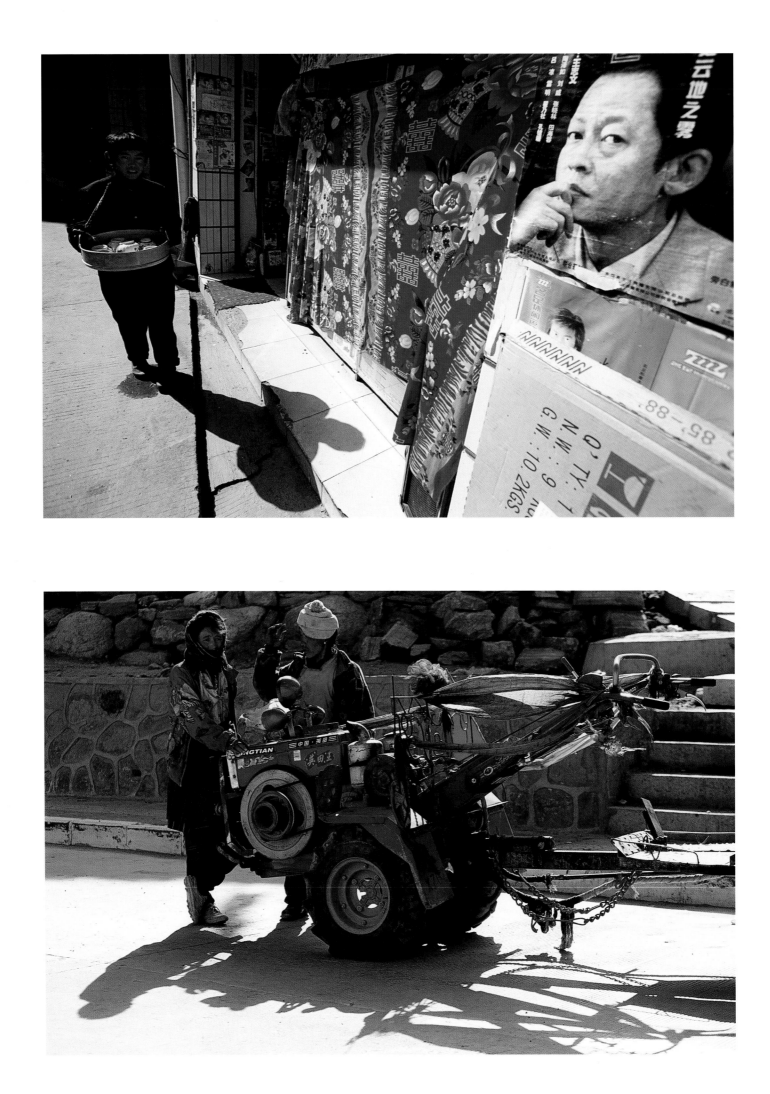

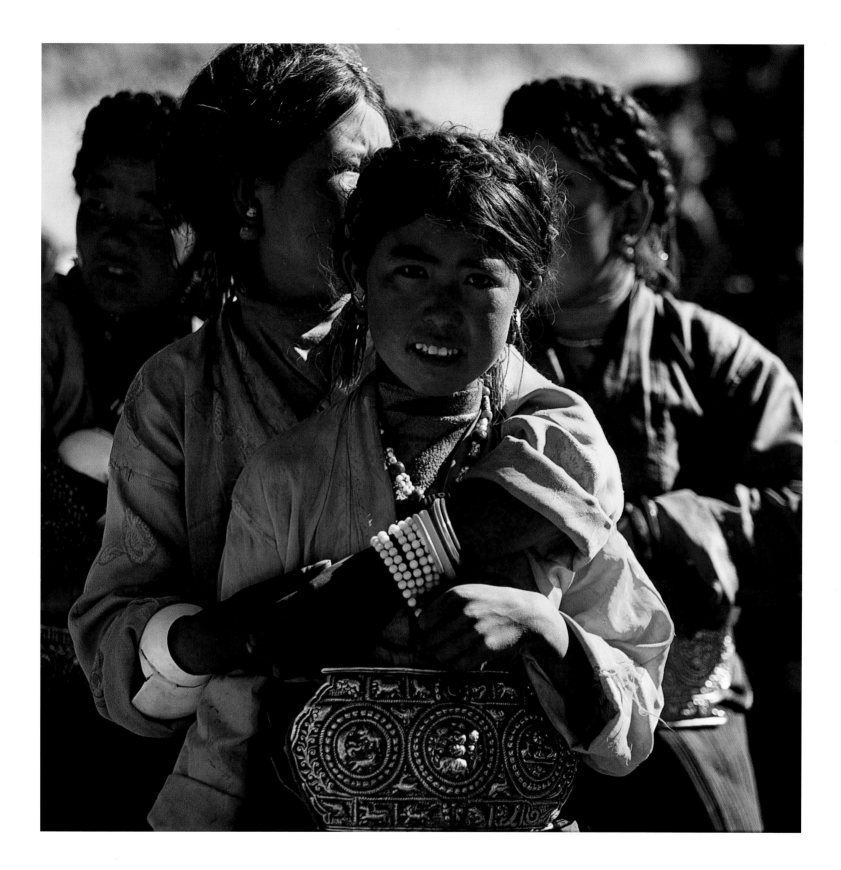

THE BRIGHT SUNSHINE and the sweet smile of the boy vendor **(TOP LEFT)** belie the general nastiness of the town of Xangmu. Perching like a vulture high above the border crossing over the Friendship Bridge at the bottom of the gorge, it is the starting point of the Friendship Highway, which links Lhasa with Kathmandu. At the small town of Nyalam **(BOTTOM LEFT)**, a Tibetan couple try in vain to mend their stalled tractor. **(ABOVE)** In a village dance outside Tingri, young girls are checking out the boys, just like at any dance, anywhere else in the world. **(PRECEDING PAGES)** Butter lamps at the Jokhang in Lhasa.

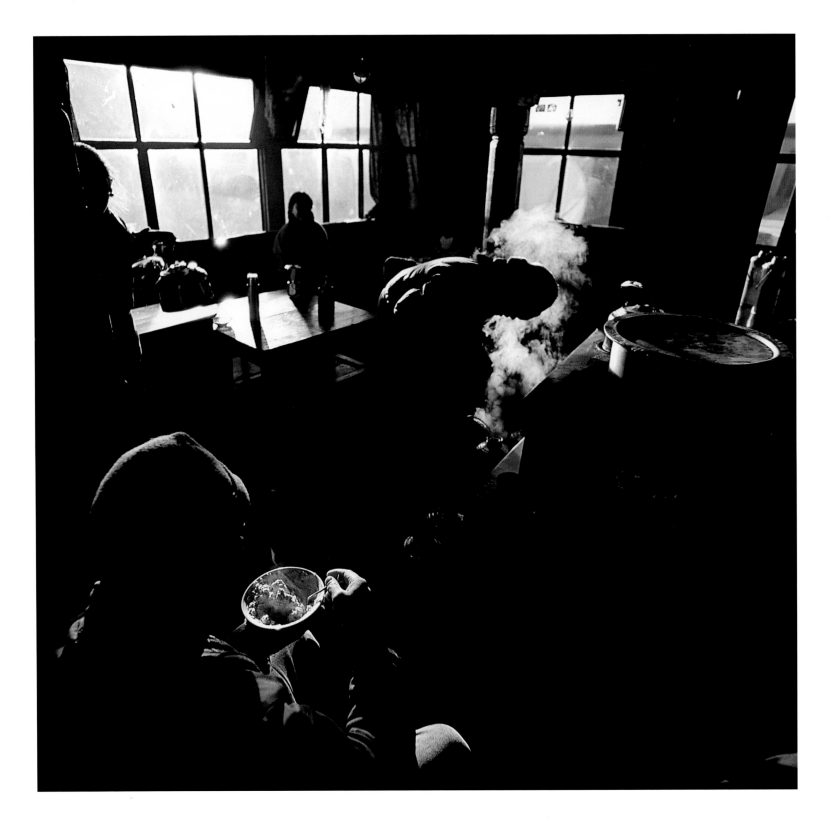

AFTER A LONG DAY'S JOURNEY across the spectacular Tibetan plateau, where we set a new altitude record for Palin's Travels by going over Tong La Pass at 17,000 ft (5180 m) above sea level, we arrive in pitch darkness to spend a sleepless night in Tingri. Early the next morning, guests and staff gather for breakfast in the communal room **(ABOVE)**, which is the only place with any heating in the primitive guesthouse compound known as the Snow Leopard Hotel. **(RIGHT)** A village girl on the road between Tingri and Rongbuk.

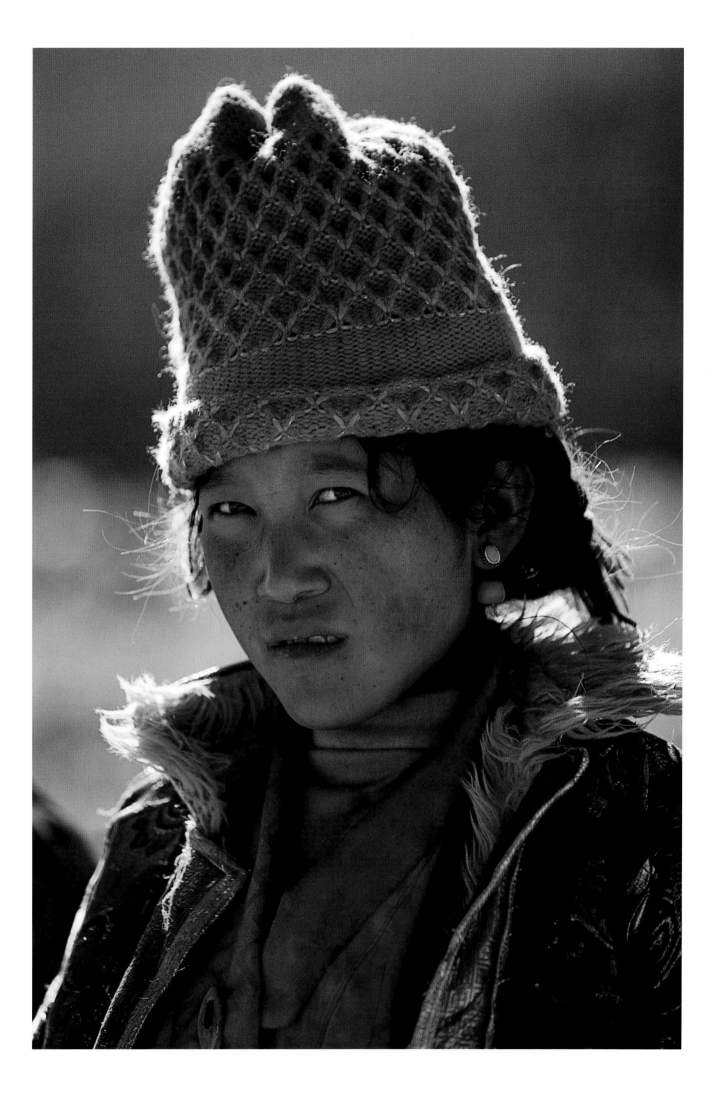

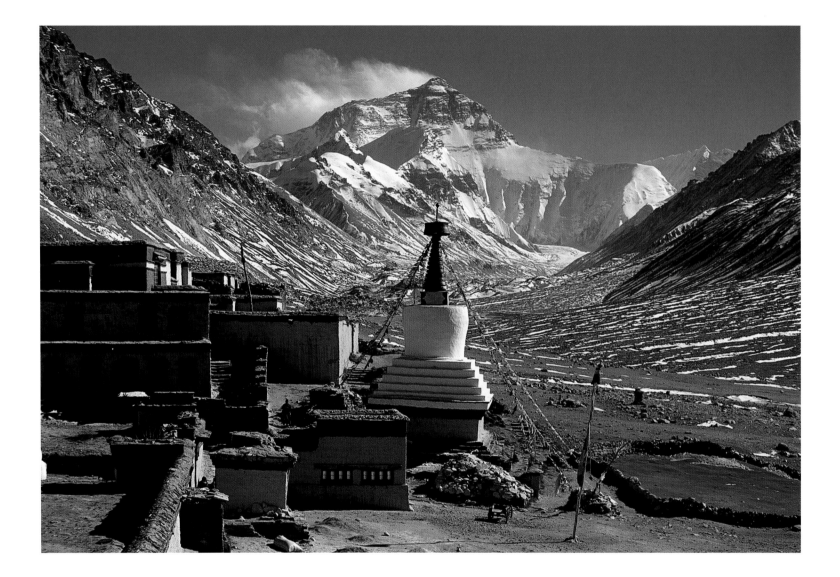

IF THE SNOW LEOPARD HOTEL is primitive, then the Rongbuk Guest House can only be described as a rat-hole with a magnificent view. Just outside the gates of the guesthouse, the residents of Rongbuk village **(RIGHT)** go about their daily activities. The new Rongbuk *gompa* **(ABOVE)**, built 20 years ago to replace the original, which was completely destroyed by Red Guards during the Cultural Revolution, is only eight miles from Everest Base Camp, and, at 16,000 ft (4800 m) above sea level, the highest monastery in the world.

(OVERLEAF) The north face of Everest, or Qomolangma (Goddess Mother of the Universe)

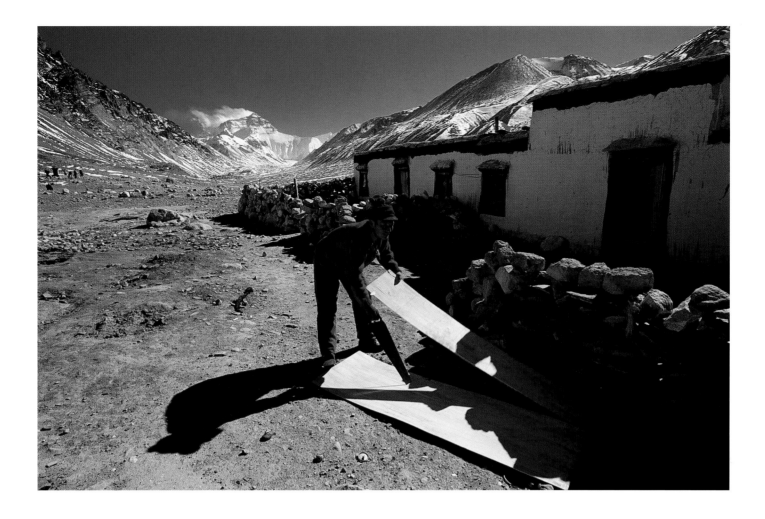

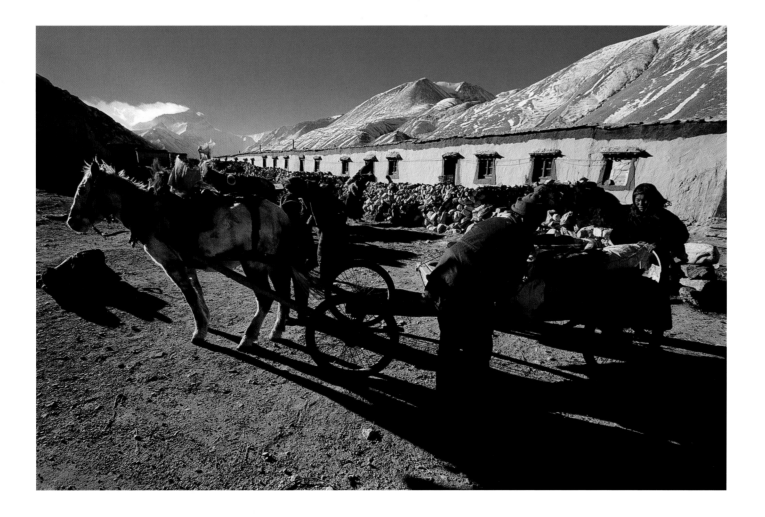

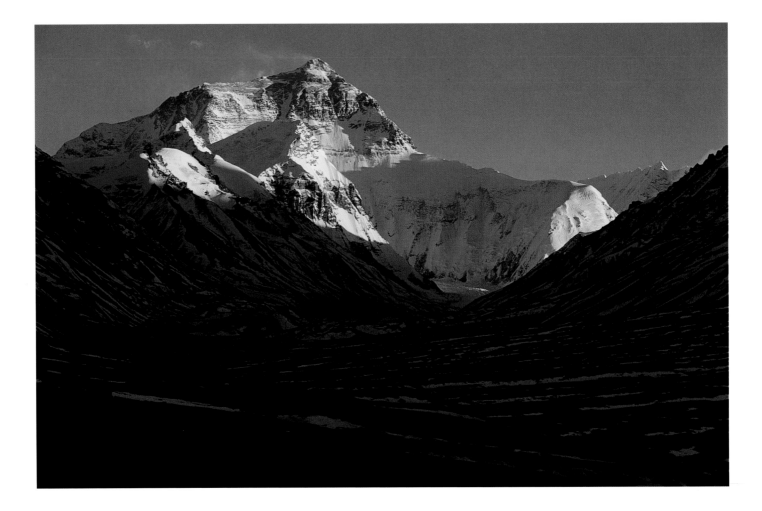

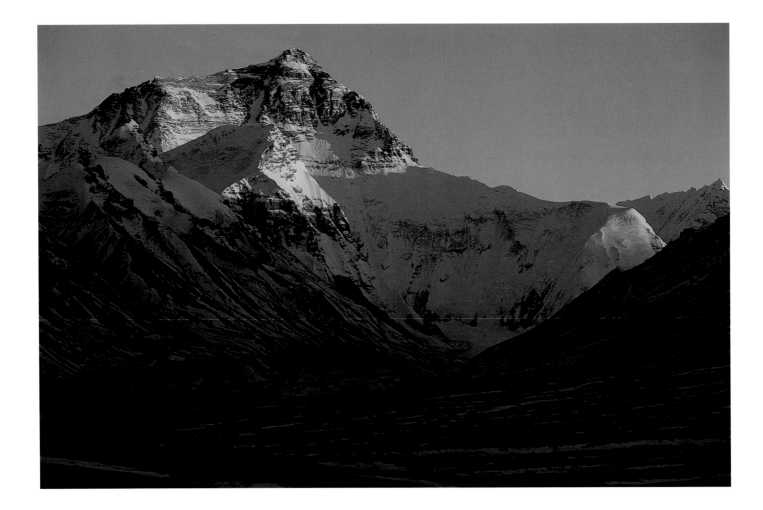

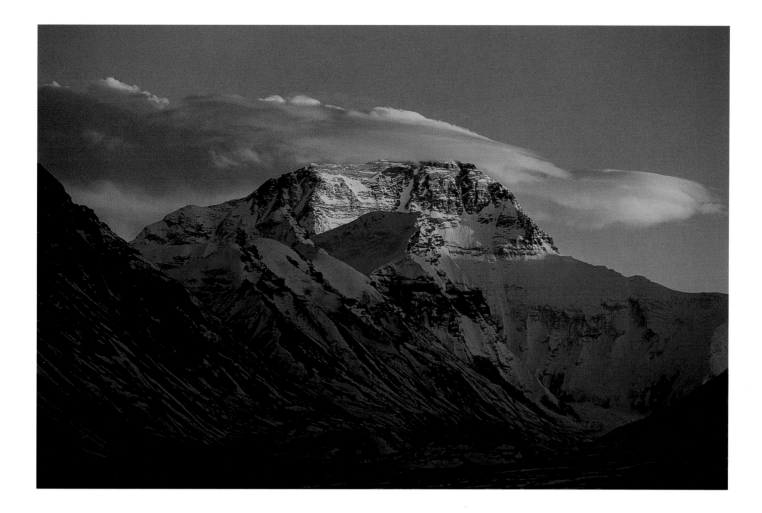

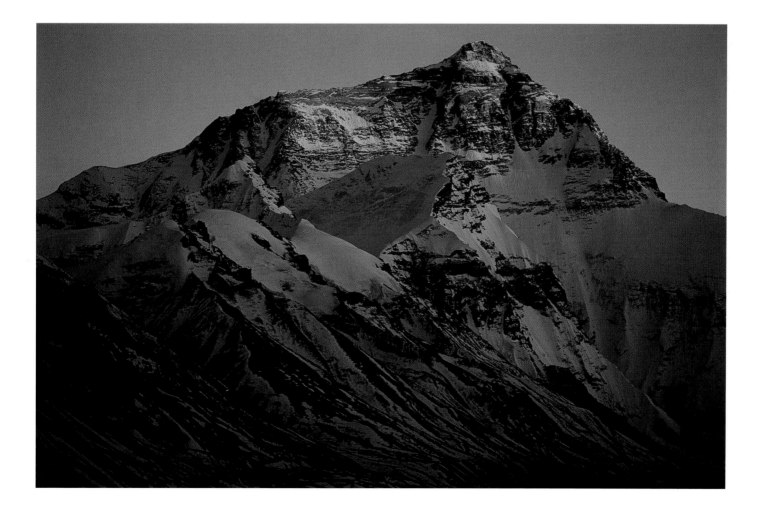

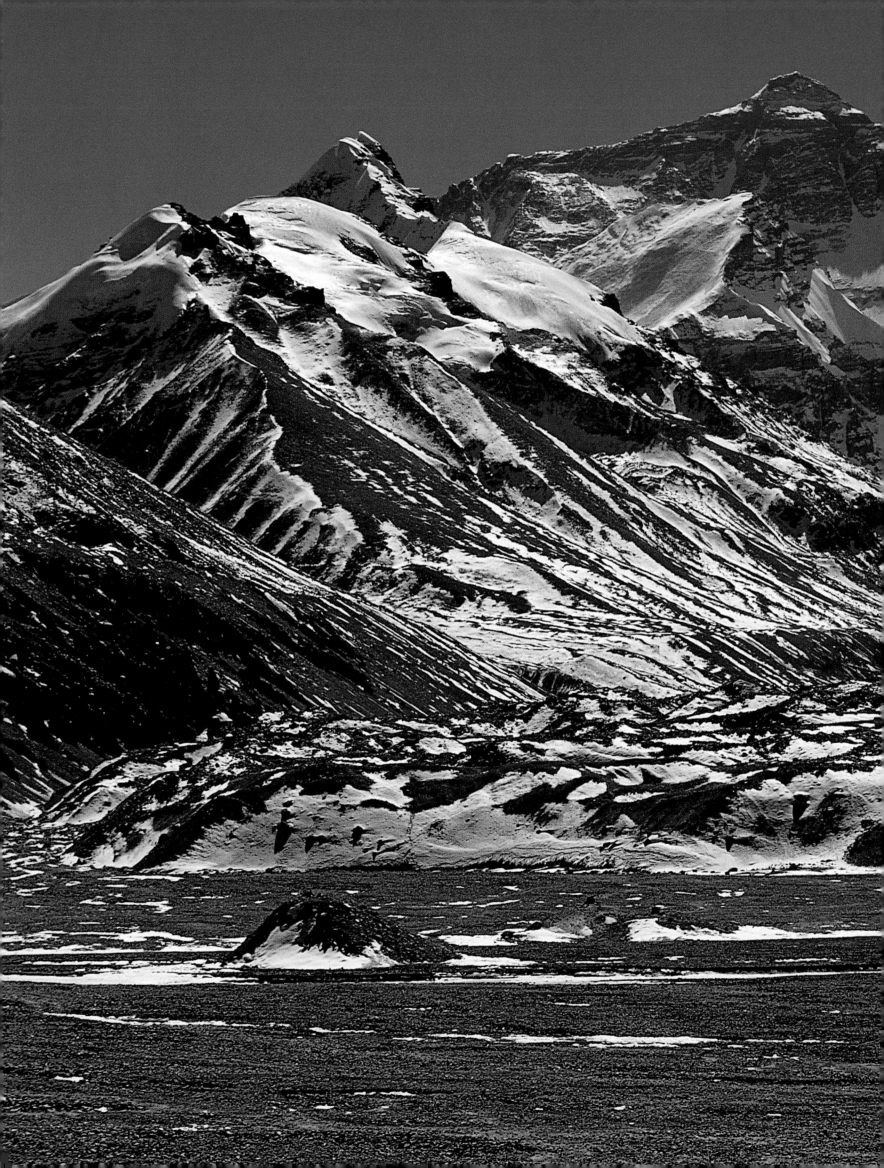

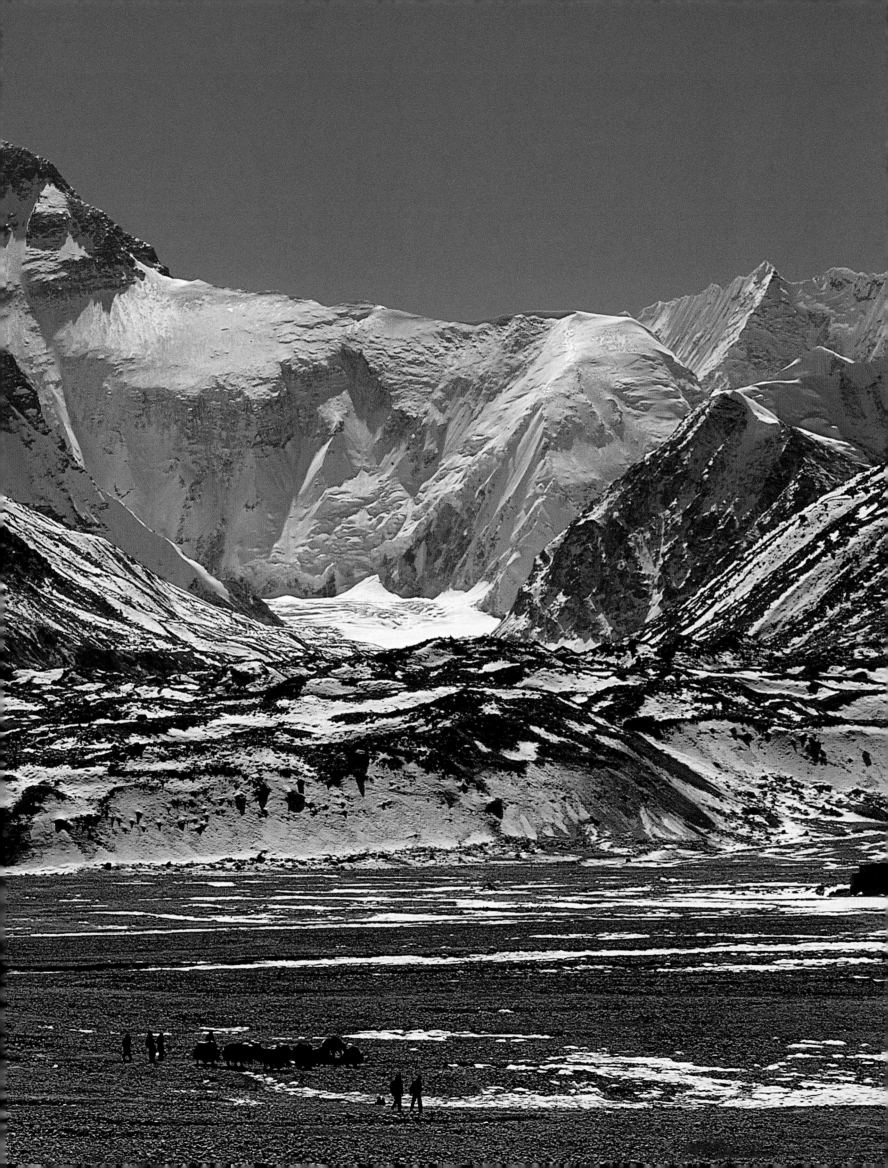

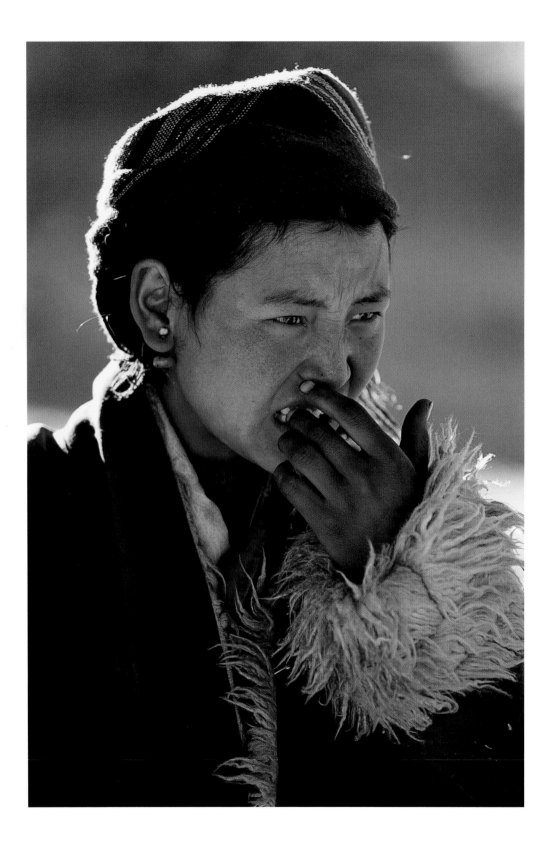

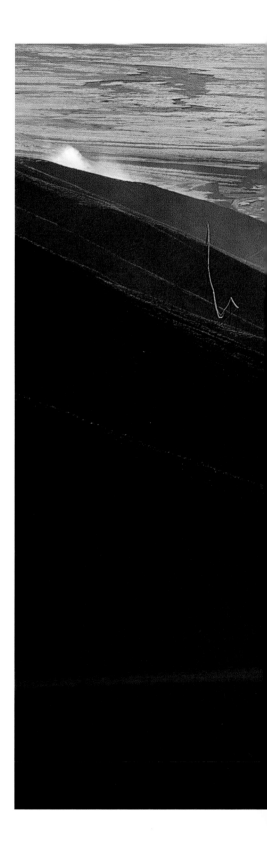

THIS NOMAD GIRL (LEFT) has the loveliest face and the dirtiest hands I've seen in Rongbuk, prompting the title 'Cinderella of Everest'. The scenery along the 200-mile journey to Shigatse **(RIGHT)** is no less spectacular than our drive up to Everest Base Camp. Plus, we are finally descending. **(PRECEDING PAGES)** Mount Everest and the Rongbuk Glacier, as seen from Everest Base Camp.

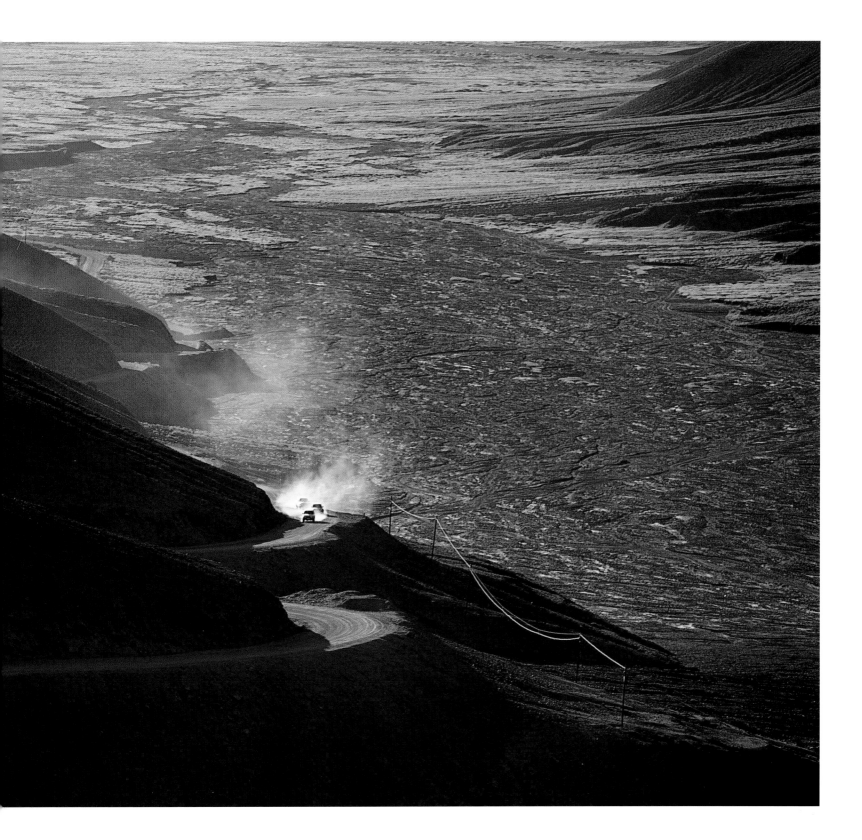

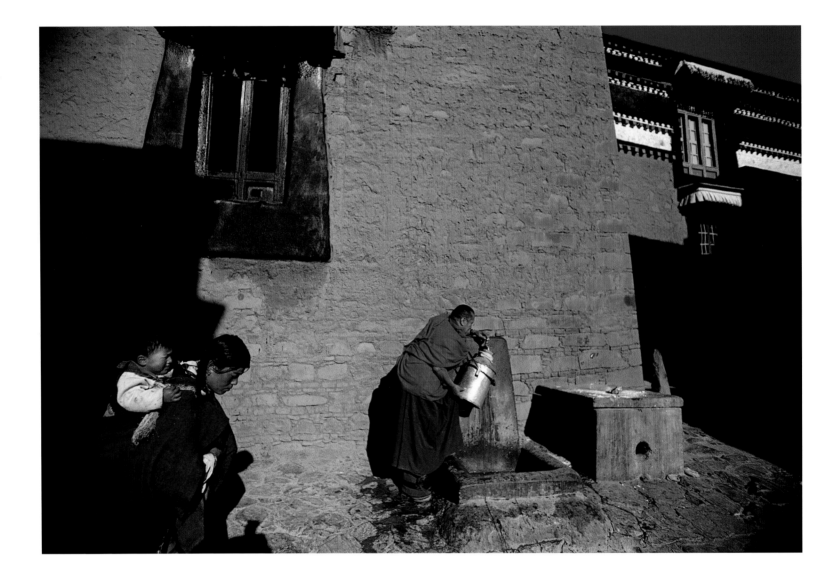

THE TASHILUNPO is the traditional seat of the Panchen Lama, the second highest reincarnation in Tibet after the Dalai Lama. This medieval city of temples and monasteries on top of the hills in Shigatse is also the stage for an unresolved drama of treachery and intrigue surrounding the current incarnation. After the passing of the last Panchen Lama, a boy was found in Northern Tibet and was recognized by the Dalai Lama. The boy was swiftly arrested by the Chinese. Soon afterwards, Beijing presented their own candidate, who was enthroned at Tashilunpo. The mystery is nobody seems to know where either of the boys are, since the 'official' Panchen Lama is seldom seen in Shigatse.

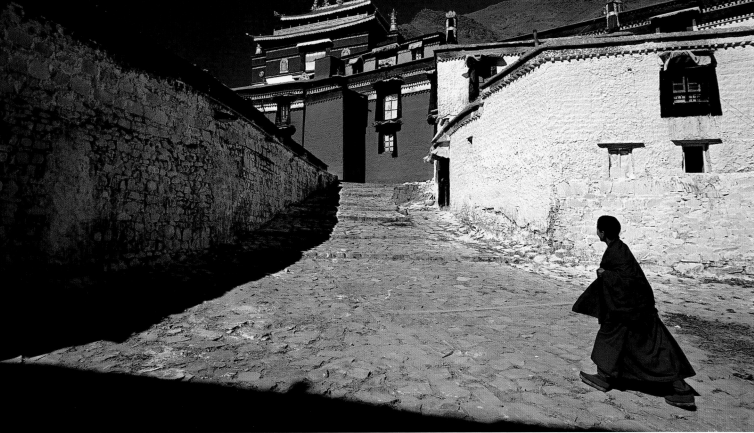

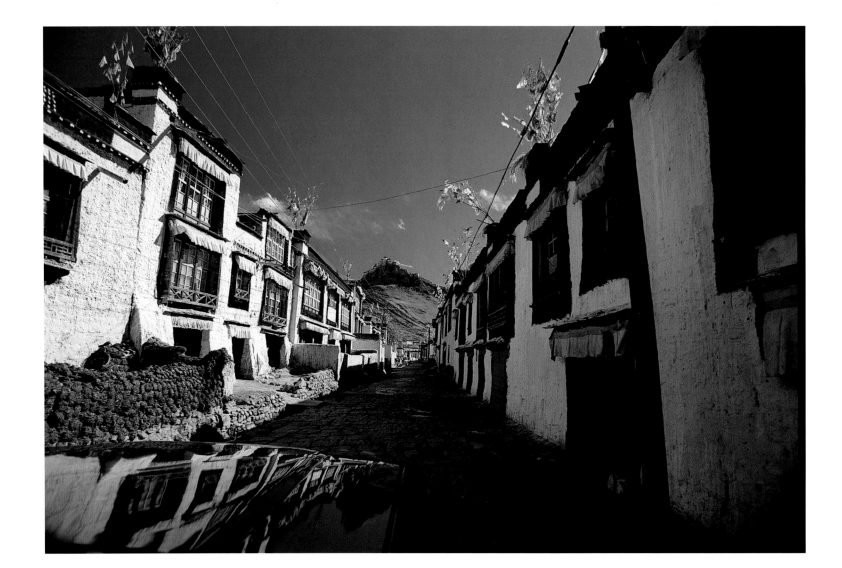

GYANTSE IS A MAJOR CROSSROADS that lies on the east-west axis between Lhasa and Shigatse, with Bhutan to the south. It was once the key trading centre between Tibet and India. Much of what prompted earlier editions of guidebooks to describe it as 'a charming old Tibetan town' has been destroyed to make room for 'progress'. However, rare glimpses of the past are still possible, **(ABOVE)** like this back street of traditional houses, which leads up to the Gyantse Dzong (Fortress). **(RIGHT)** One of the most common and yet still touching and beautiful images of Tibet.

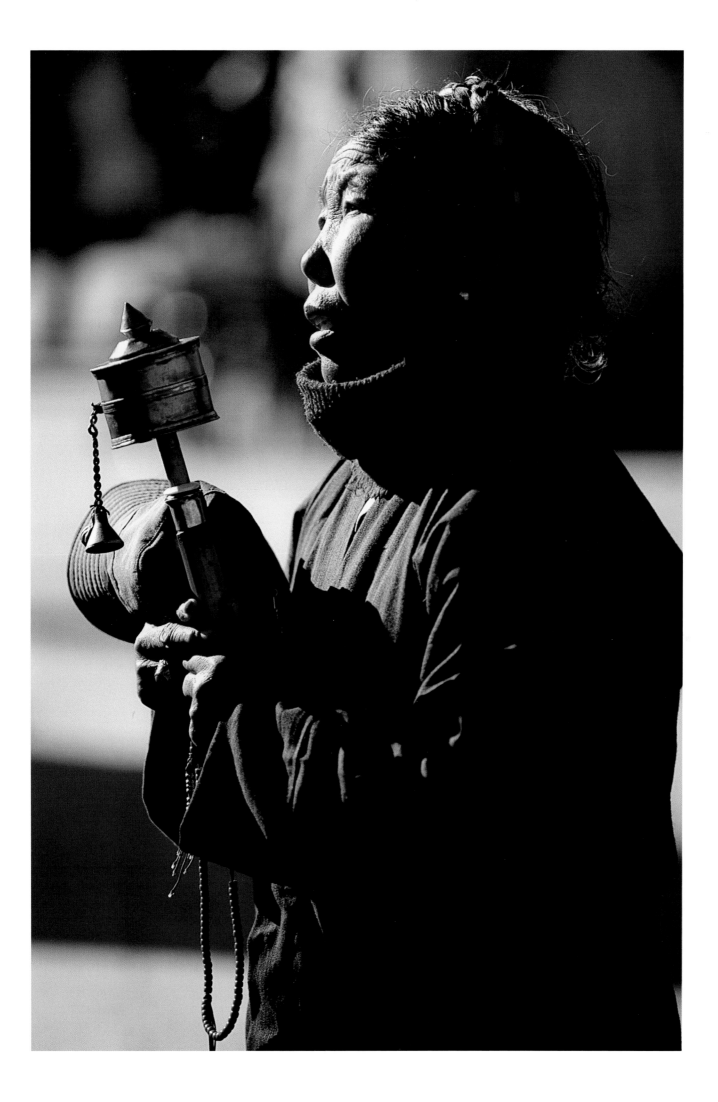

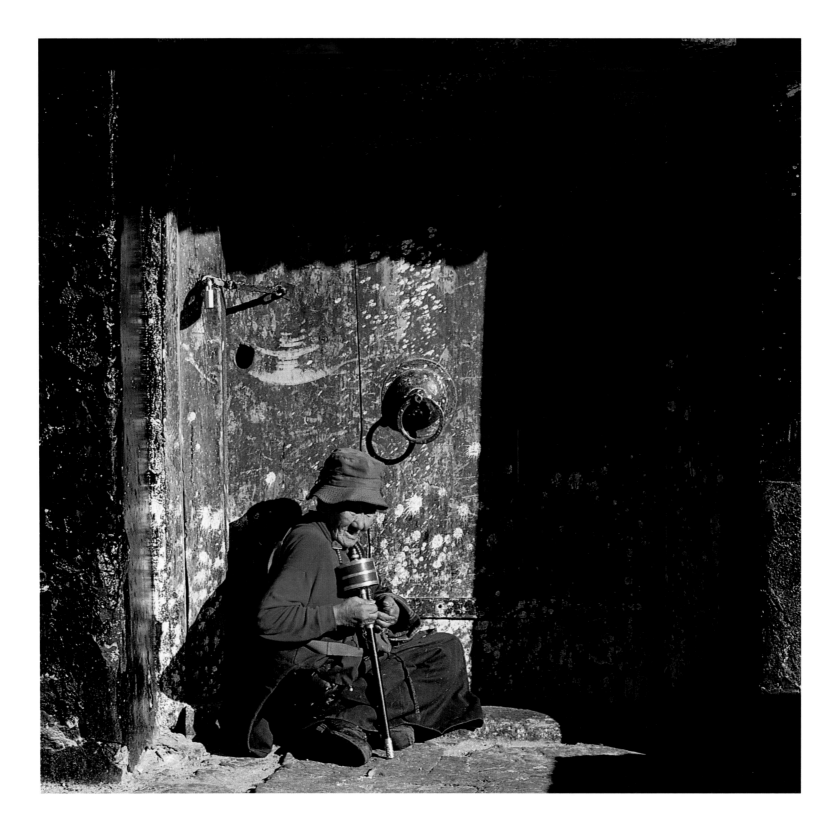

THE RESILIENCE OF THE TIBETAN FAITH can be truly awe-inspiring. It has survived over half a century of ruthless persecution by the madness of Chinese revolutions. Though the Han now have political and economic control, the power of devotion in the Tibetan spirit remains indomitable. And in no other place is this faith more manifest than at the Jokhang in Lhasa. **(ABOVE)** An old lady fixes her prayer wheel in an inner courtyard. **(TOP RIGHT)** Tibetans believe that the rising smoke from burning juniper bushes creates a medium through which the Buddha spirit can descend. **(BOTTOM RIGHT)** The four stages of a full prostration, as demonstrated by these ladies outside the main entrance.

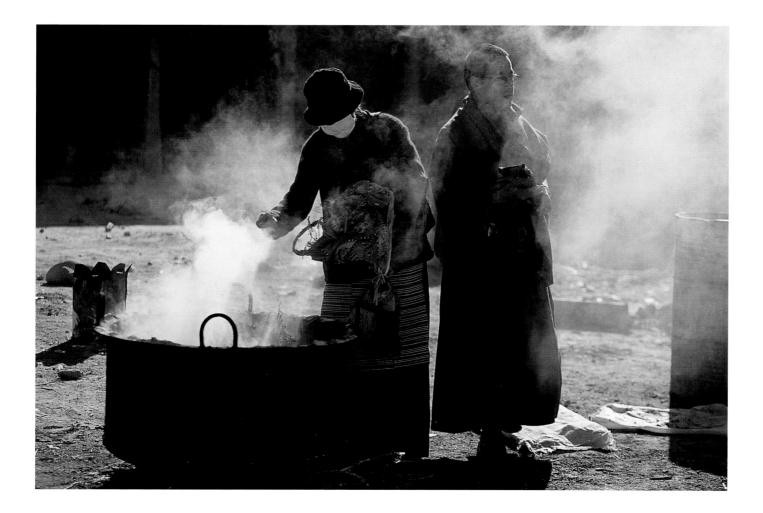

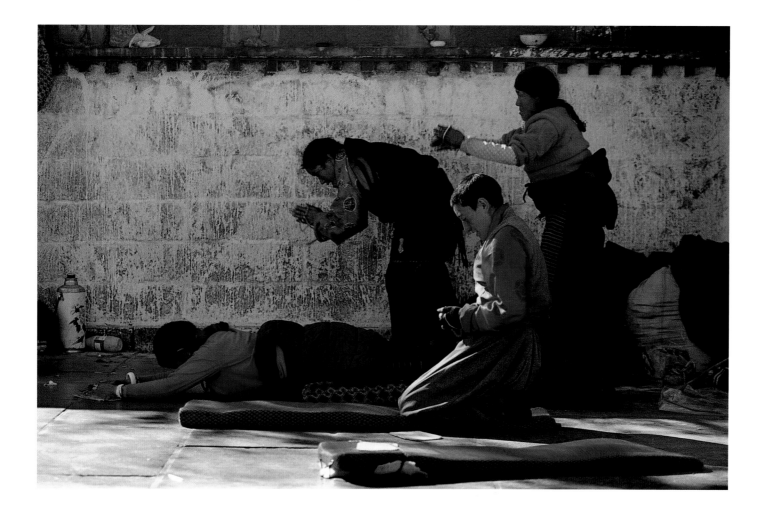

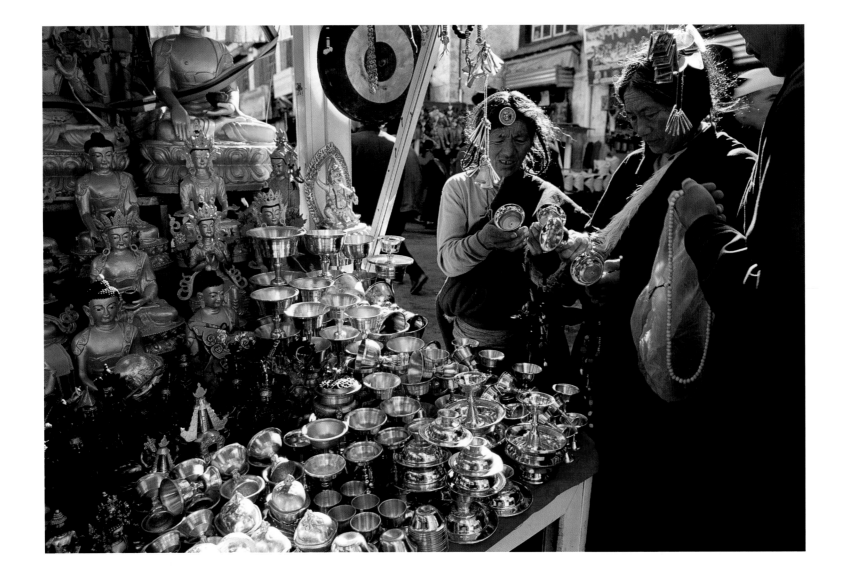

THE JOKHANG (House of Sacred Mystery) was originally built in the 7th century by King Songsten Gompo, a devotee of the animist Bon religion, who had taken, for political alliance, two Buddhist wives. His first wife, Queen Bhrikuti of Nepal, paid for and supervised the construction of the Jokhang to house the sacred Buddha images brought by the second wife, Tang Chinese Princess Wengcheng. The temple and Barkhor (**ABOVE**) that surround it, remain the religious and commercial heart of Lhasa's old city today. (**RIGHT**) Potala Palace, the architectural wonder that was once the tallest building in the world before the invention of skyscrapers, photographed from Potala Square, the soulless architectural blunder that was once a beautiful lake and a thriving old town.

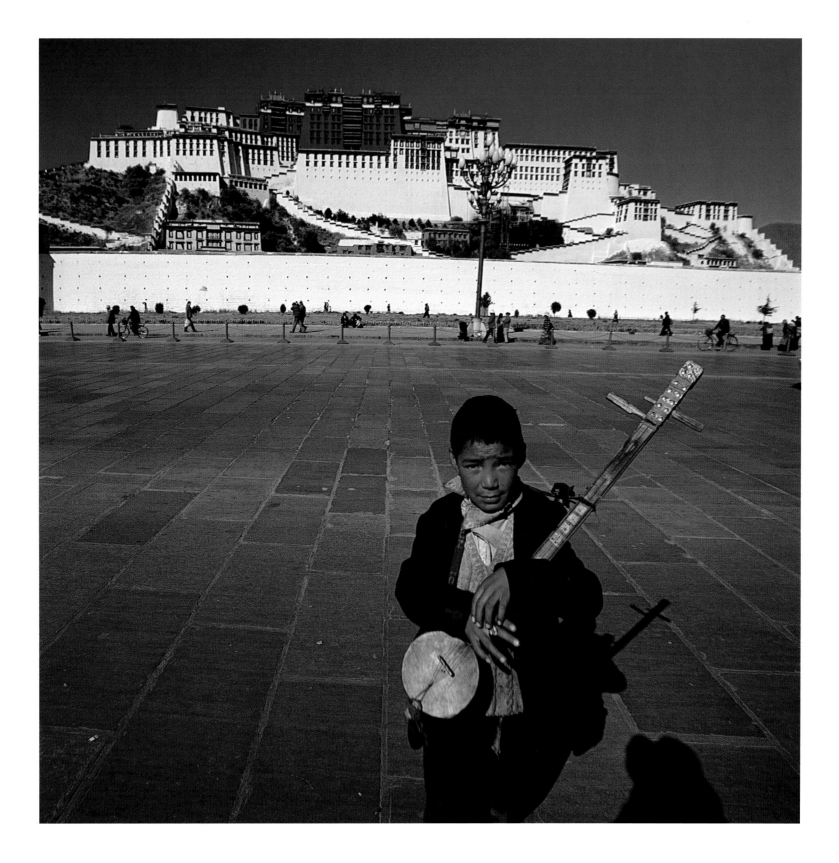

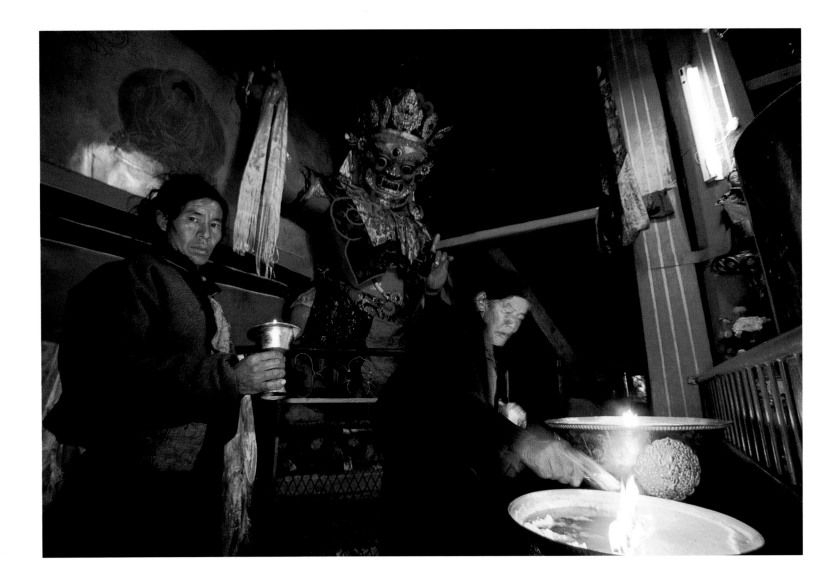

FROM THE SUBLIME TO THE RIDICULOUS. Dawn finds us at the Drepung, the biggest monastery of the Dalai Lama's Gelugpa sect; in the 17th century, with 10,000 monks in residence, it was the largest monastery in the world. **(ABOVE)** In the Buddhas of Three Ages Chapel, pilgrims from Amdo region light butter lamps for the statues of the past, present and future Buddhas. Night finds us back in Potala Square inside the JJ Disco. **(TOP RIGHT)** On stage, a quasi-Vegas-style floorshow with 'Tibetan flavour' drags on interminably in front of a balsa wood replica of the Potala Palace. **(BOTTOM RIGHT)** I find myself wandering into dressing rooms backstage, looking for a decent shot.

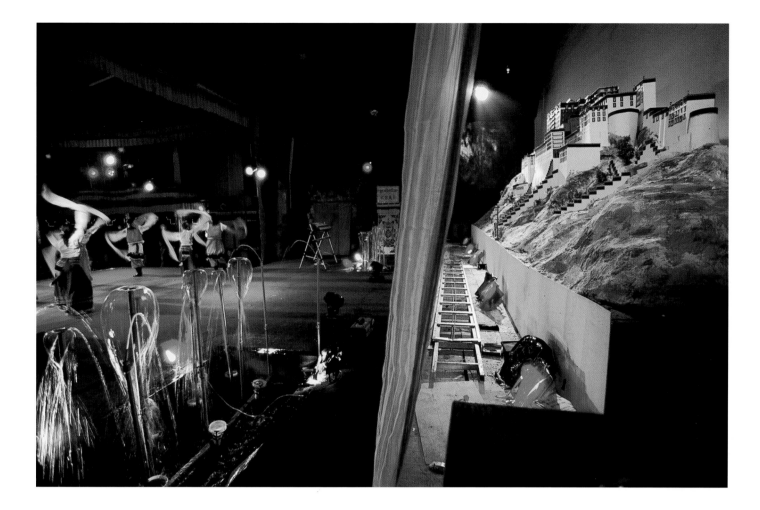

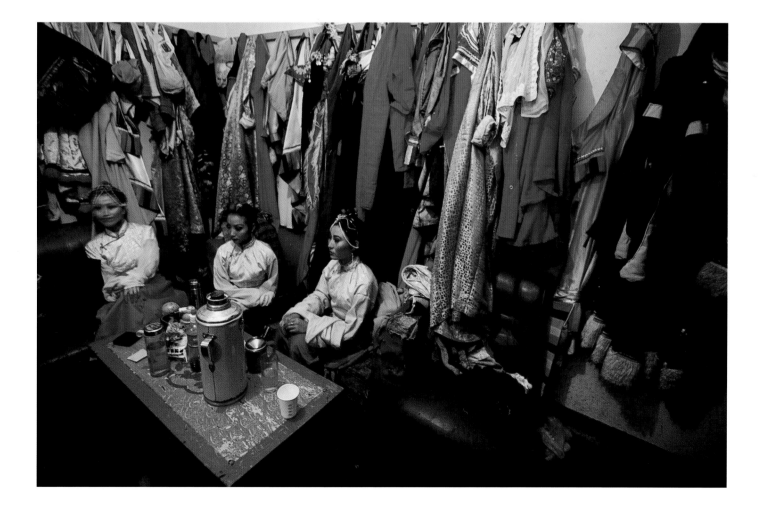

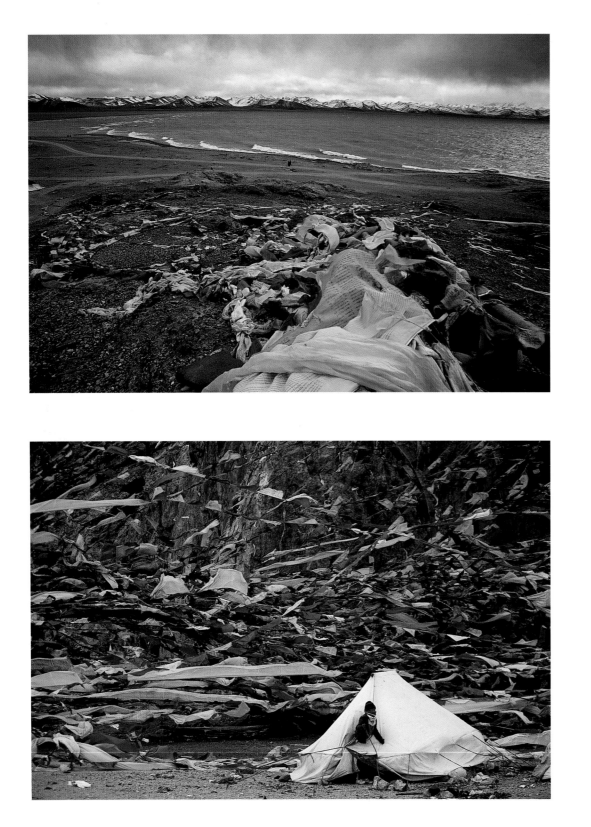

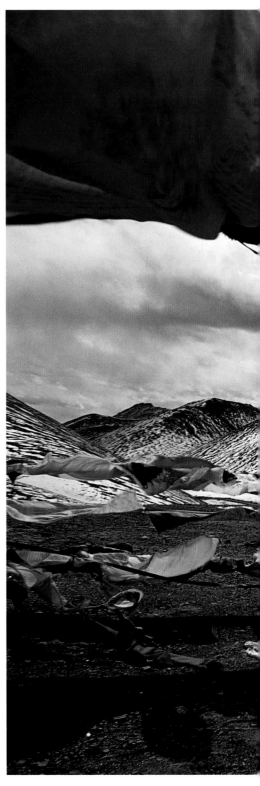

A SNOWSTORM BREWS OVERHEAD as we cross the 16,700-ft (5090-m) Lhachen La Pass **(RIGHT)** en route to Namtso Chukmo, the second largest saltwater lake in Tibet and a sacred site for both Buddhists and Bon pilgrims. **(LEFT)** The storm is raging at Tashido, the cave hermitage where some of the most important lamas and famous holy men in Tibetan history had their retreats.

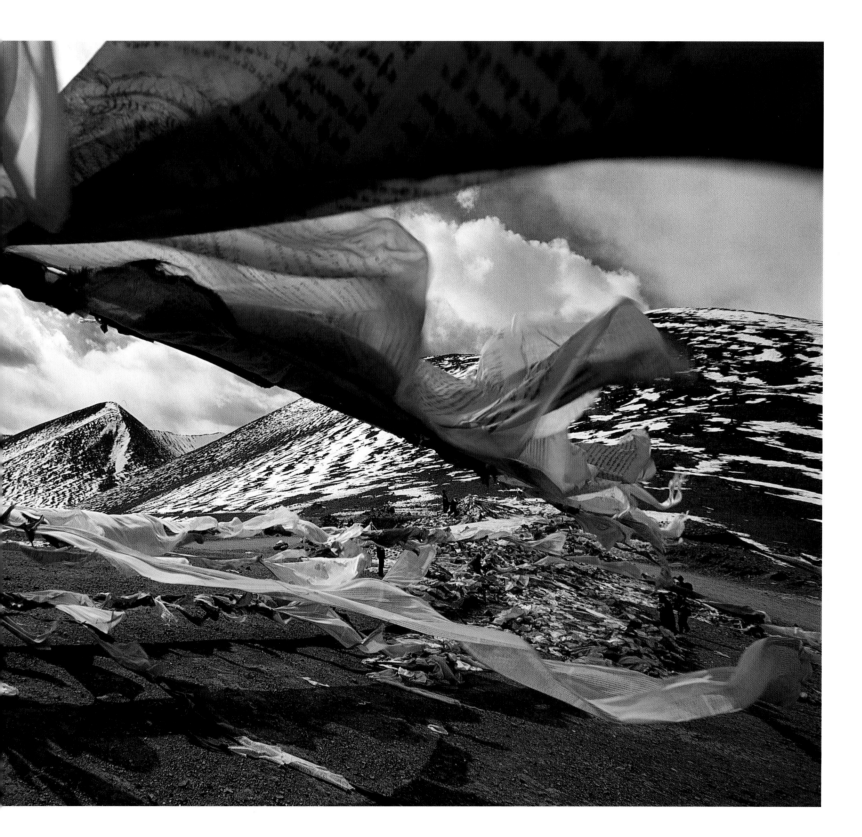

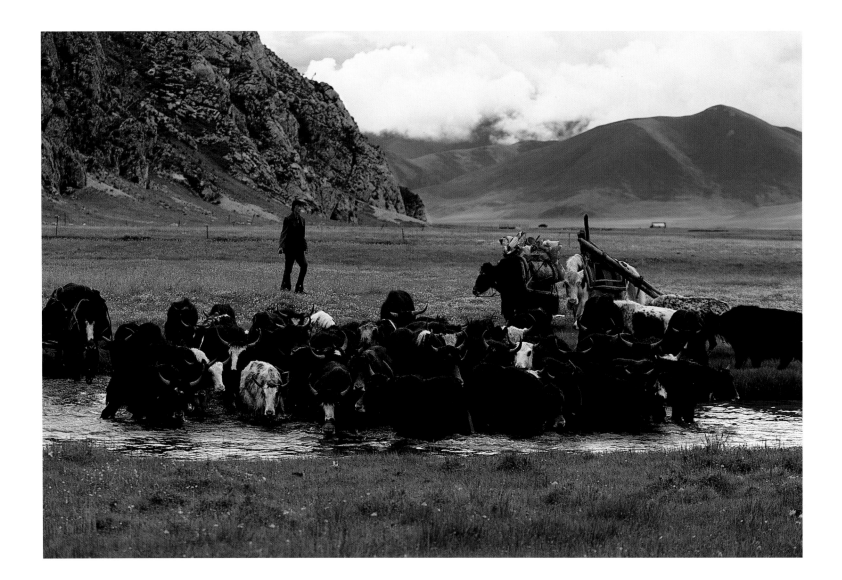

HISTORICALLY, to be exiled by the Chinese emperor to the no-man's-land now called Qinghai was a punishment more severe than death. In more recent times, the name has become synonymous with gulags. But this part of the Tibetan plateau is also the reservoir of East Asia, containing the source of the Yangtze, Mekong, Salween, Irrawaddy and the Yellow River. **(ABOVE)** Sonam, our Yak farming friend, moves his herd to summer pastures. **(TOP RIGHT)** A nomad girl is stunned by the sight of foreigners. **(BOTTOM RIGHT)** The *chortens* of Gyanak Mani, the temple reputed to have the largest collection of Mani stones (stones inscribed with mantras or prayers) in Tibet.

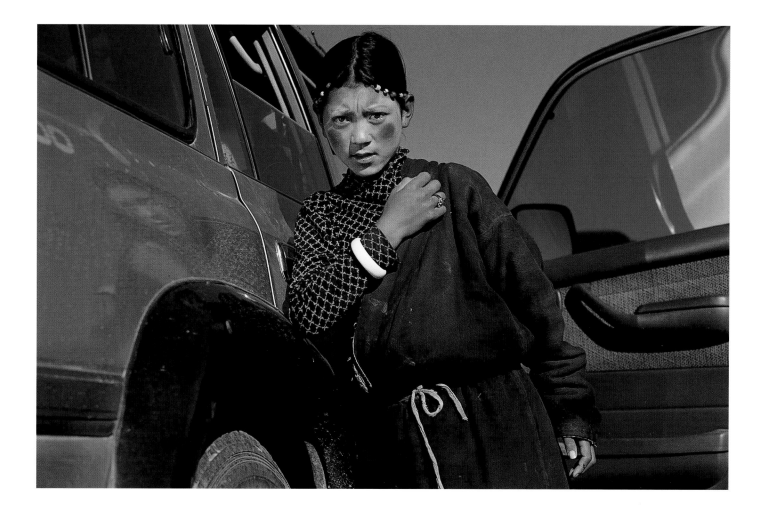

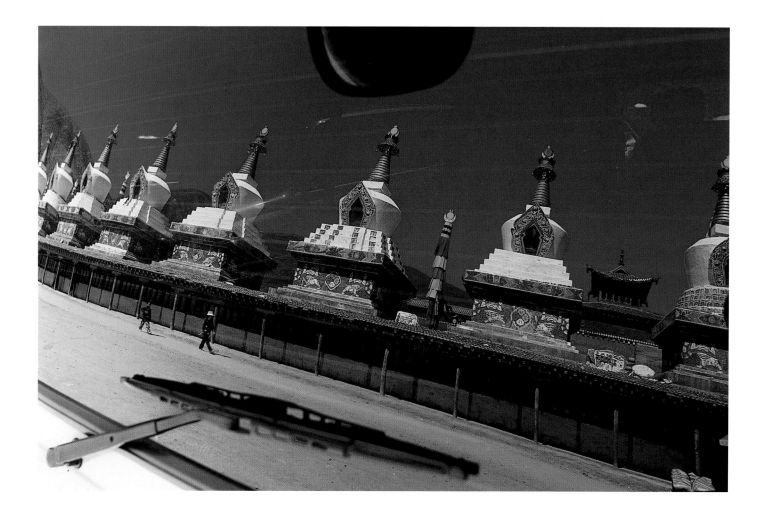

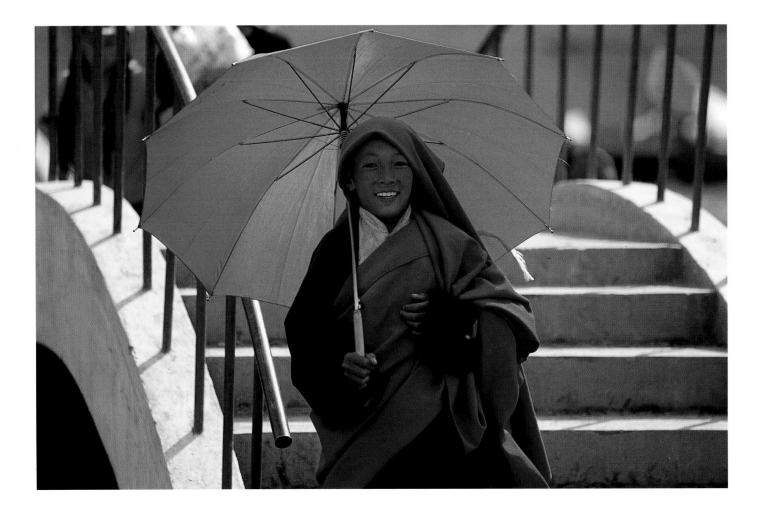

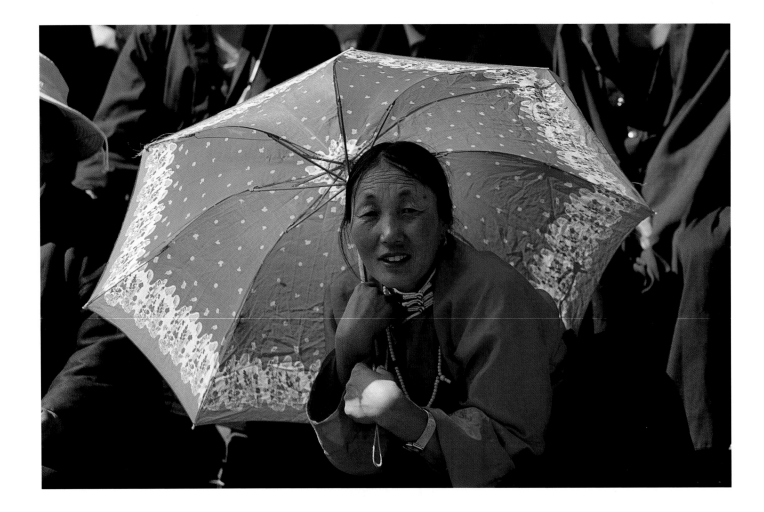

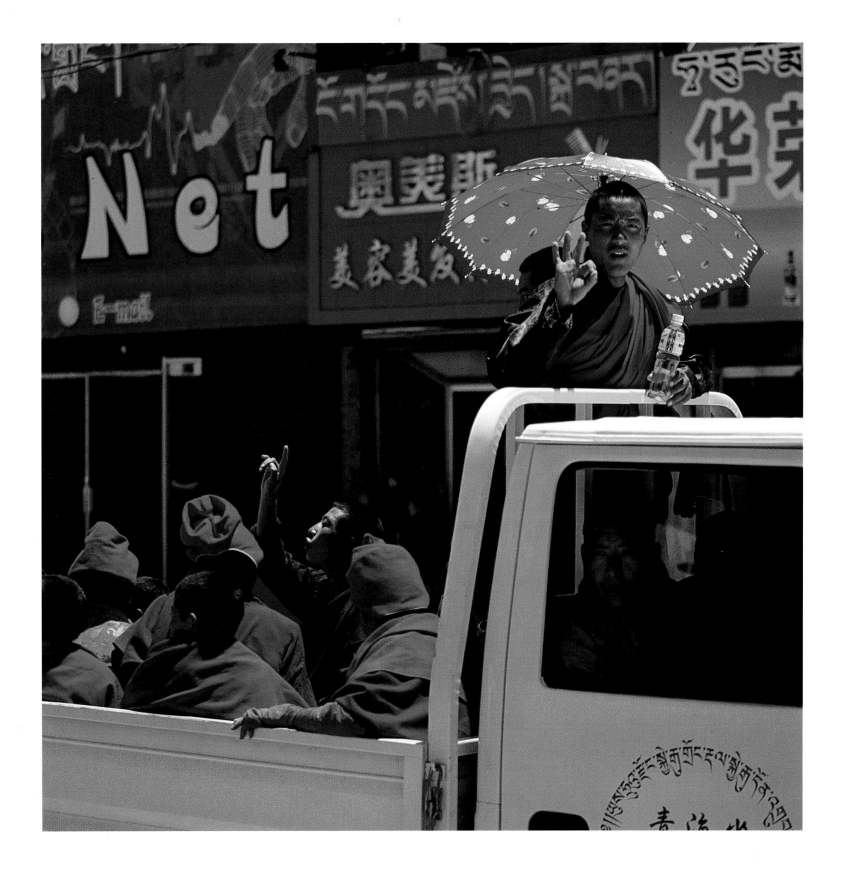

TIBETANS ARE BOLD with their colours; **(LEFT)** whether it is in their paintings or statues of deities, their clothing, headgear, jewellery or umbrellas, their choice of colour is decisive, to say the least. And at the Yushu Horse Festival, where thousands of them are dressed up to the nines for the week-long party, the effect can be quite hallucinatory. **(ABOVE)** A truckload of monks drives past a row of internet cafés in downtown Yushu on their way to the festival grounds.

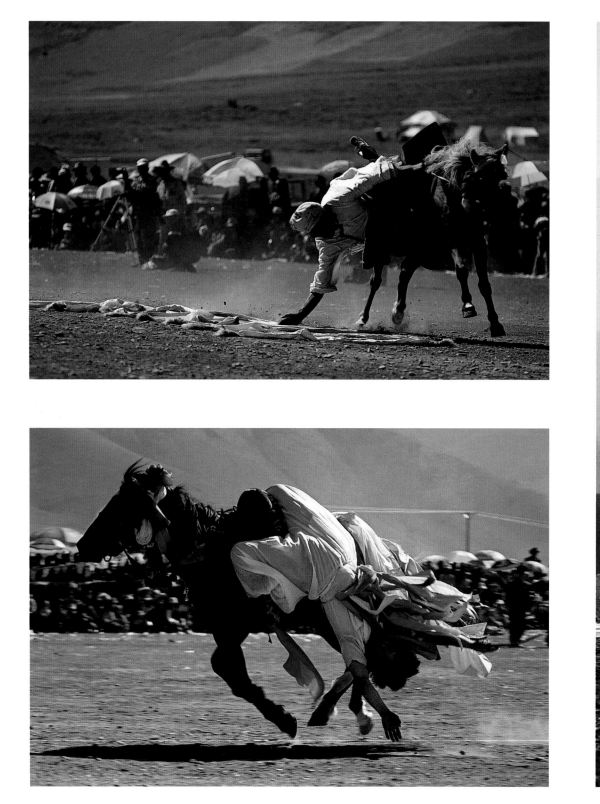

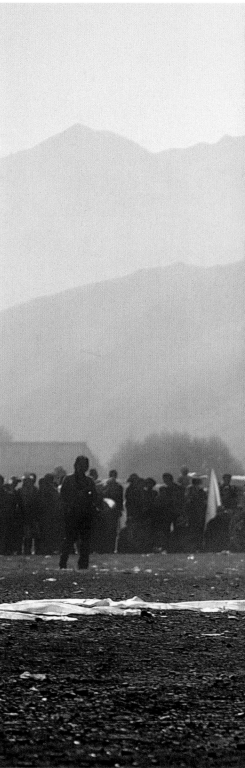

HORSEMEN from far and wide across the Tibetan plateau come to Yushu to show off their skills in a variety of competitions. They range from (TOP LEFT) picking up as many *katas* (white silk scarves) as possible on a galloping horse, and (BOTTOM LEFT) performing acrobatics on a galloping horse, to (RIGHT) just plain going really fast and kicking up a lot of dust on galloping horses.

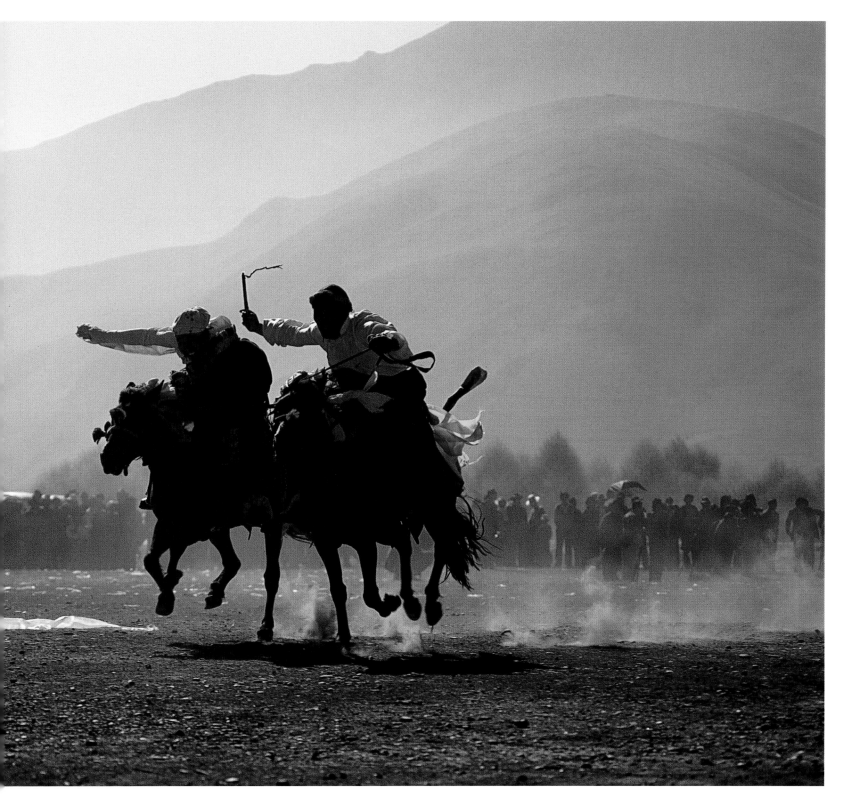

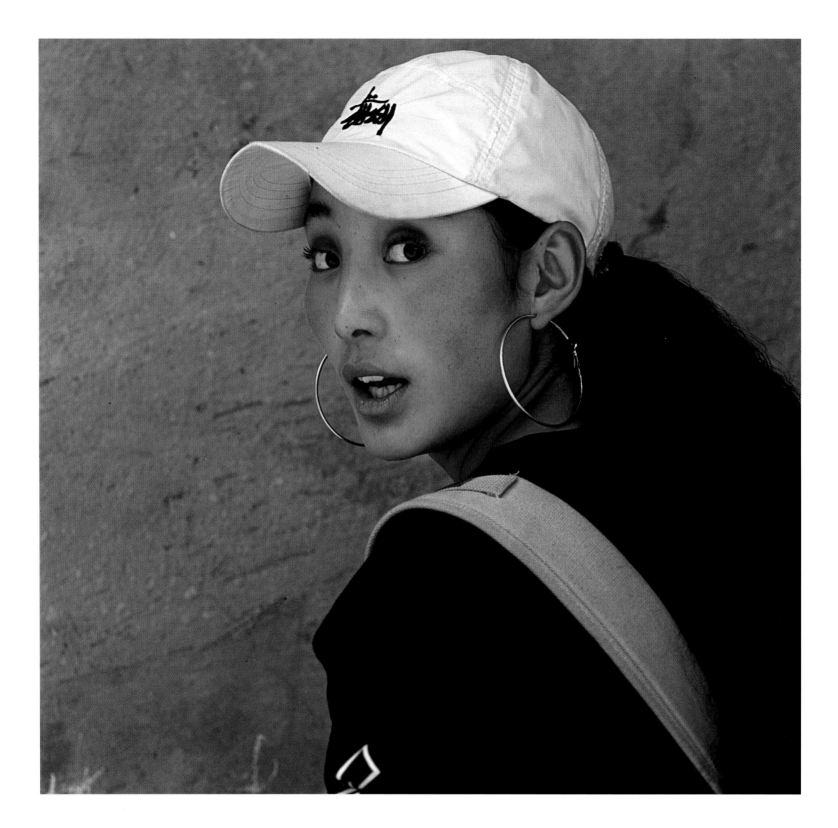

MY ENCOUNTER with this beauty (**ABOVE**) was like a Haiku. I spotted her in a crowd fighting its way up into the grandstand, and managed to get myself into a position to quickly squeeze off three frames. I tried to slow her progress by asking her where she was from in Mandarin, fully expecting her to say Shanghai or Chengdu. 'I'm from Yushu...' she shouted back and disappeared into the crowd. It was a truly memorable 30 seconds. (**RIGHT**) This lady at Gyanak Mani confirms my belief that although western influences have penetrated into these remote mountains, tradition will always live on.

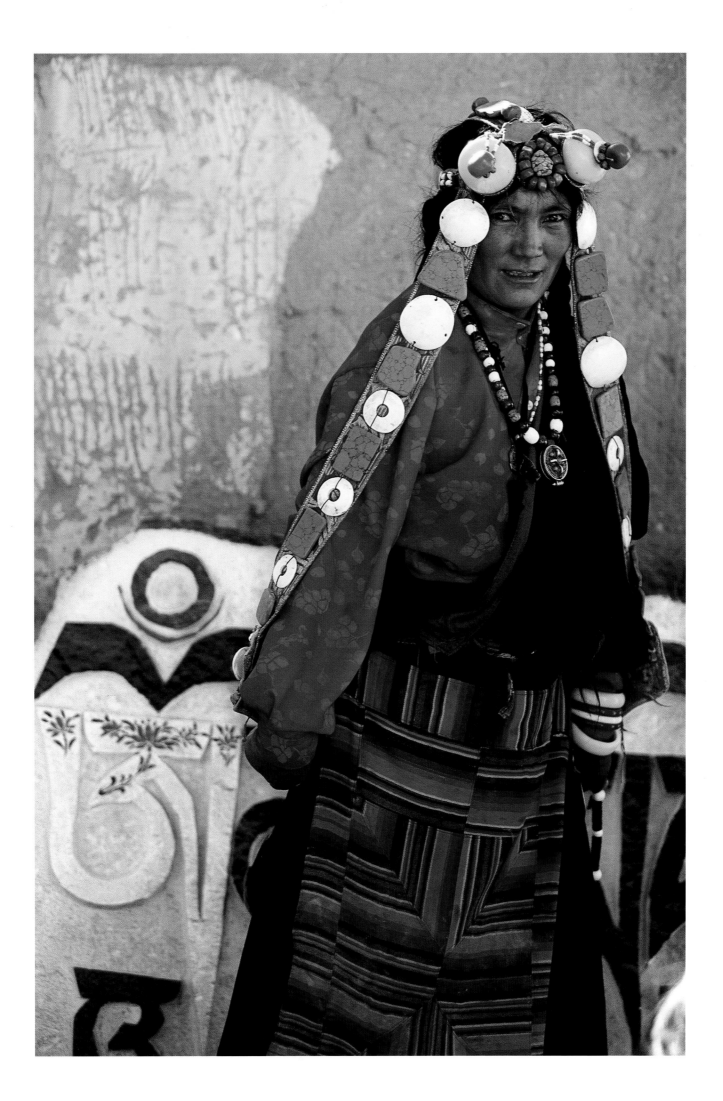

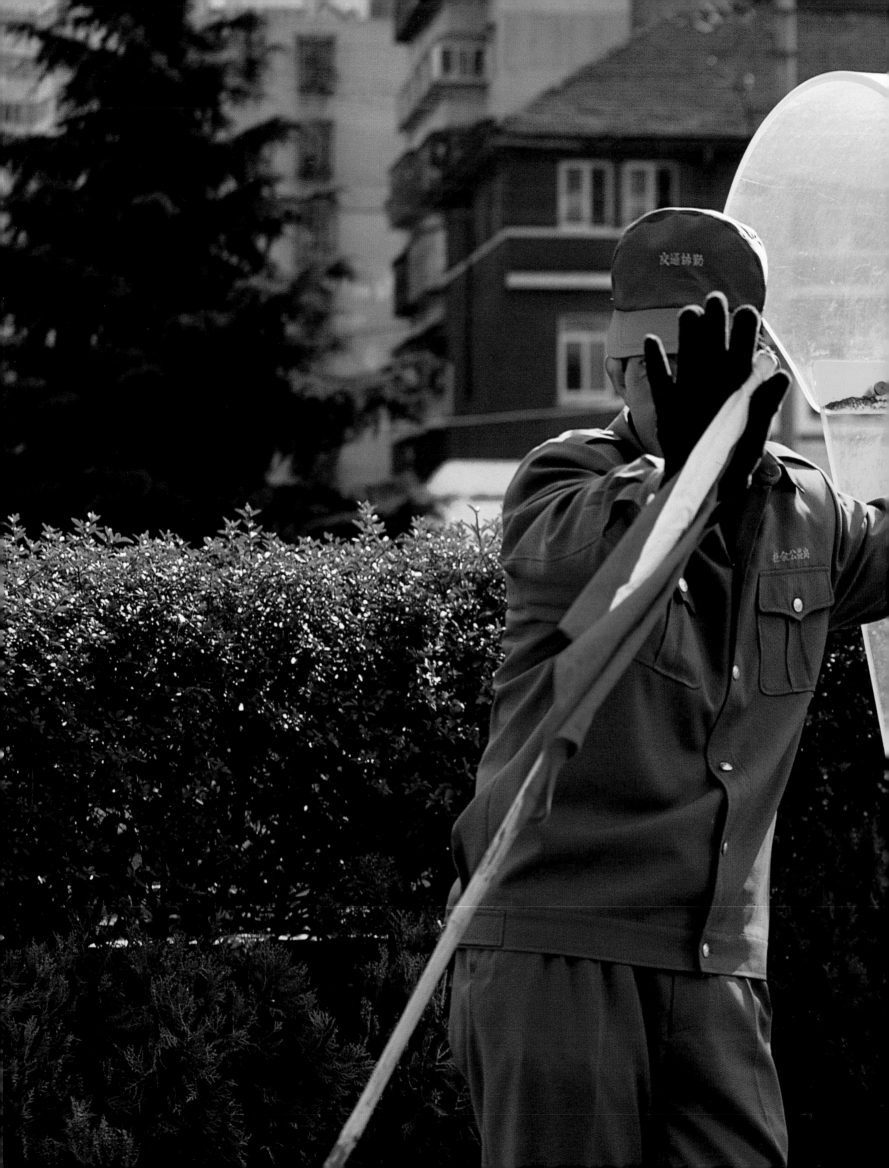

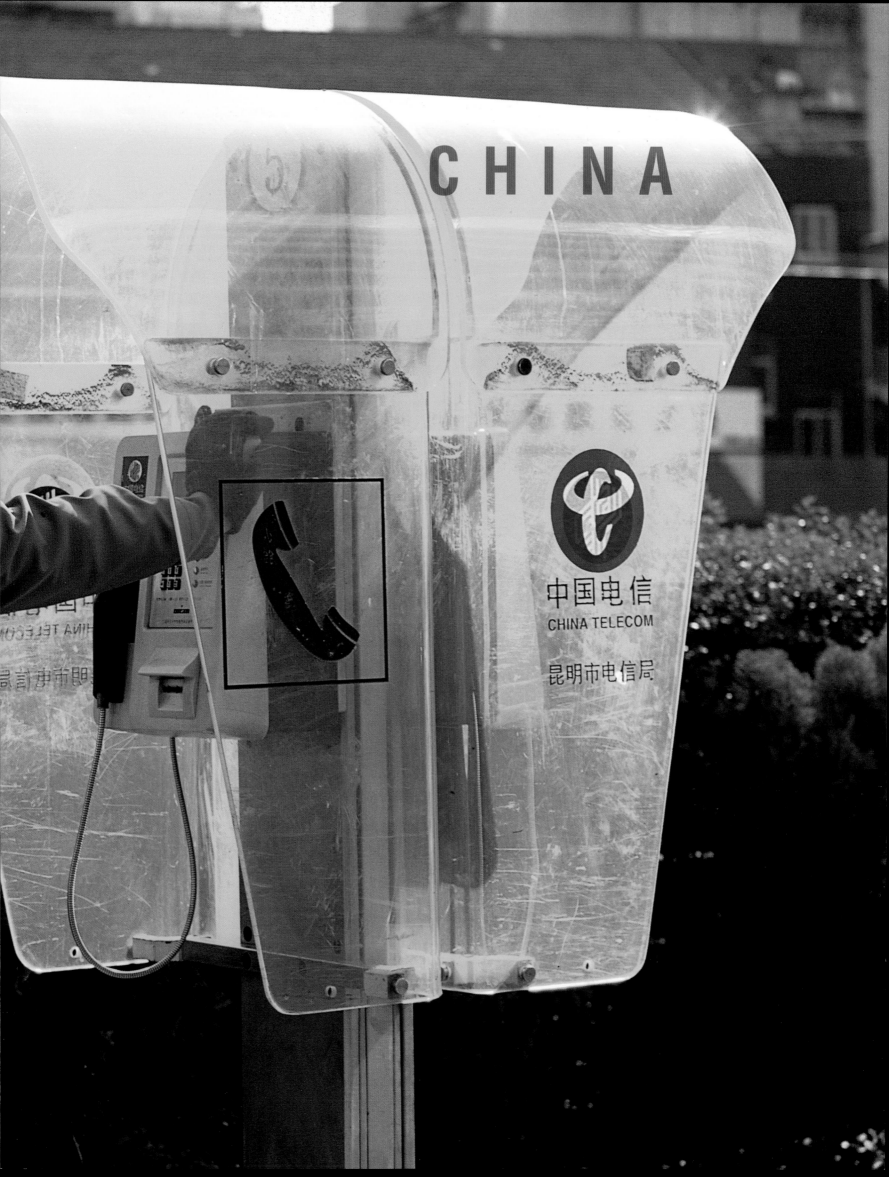

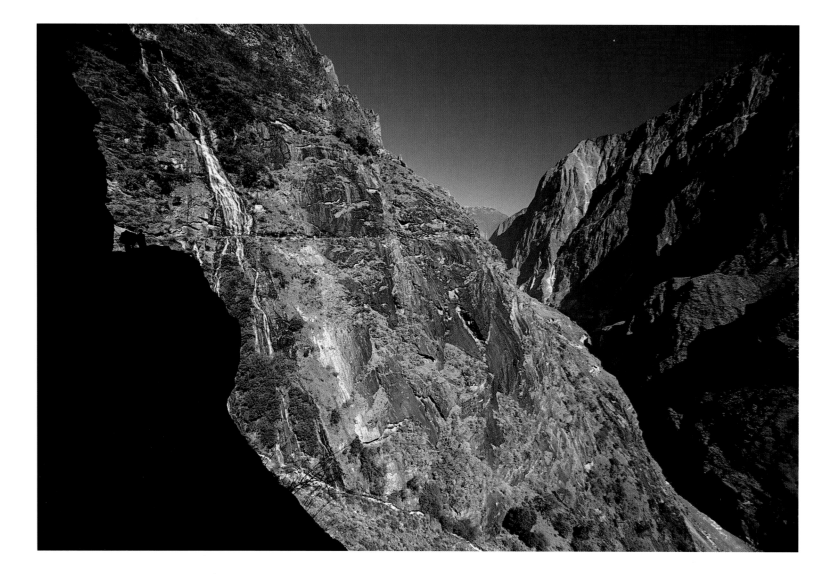

TIGER LEAPING GORGE is but a tiny wrinkle on the eastern edge of the Himalayan range, where the immovable Eurasian Plate finally forced it to turn south 50 million years ago. But for the Chinese, it is the wrinkle that spawned a civilization. This is where the Yangtze made a dramatic U-turn and headed northeast towards the Yellow Sea. The massive alluvial plain it left behind became the cradle and rice bowl of the Middle Kingdom. (**ABOVE**) A porter and his packhorse negotiate the treacherous stony path at the north end of the gorge. (**TOP RIGHT**) A teahouse on top of the gorge, 4000 ft (1220 m) above the river. (**BOTTOM RIGHT**) Porters regroup at the foundations of a suspension bridge, which is part of the new road through the gorges. (**PRECEDING PAGES**) A traffic warden in Kunming.

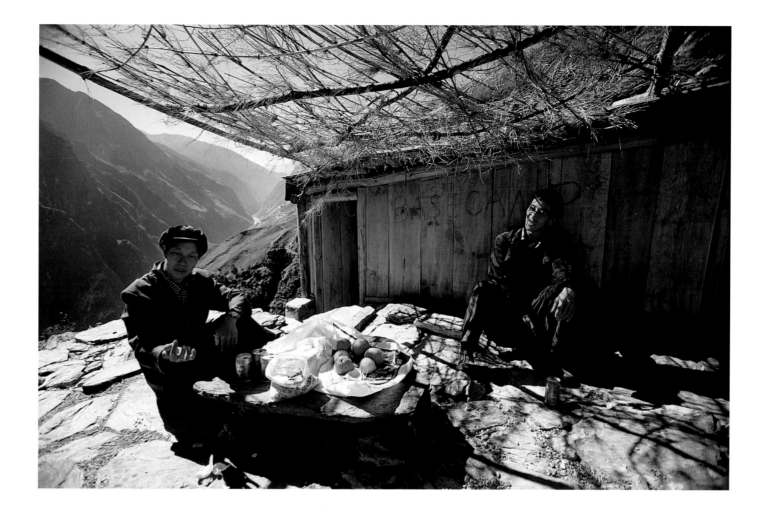

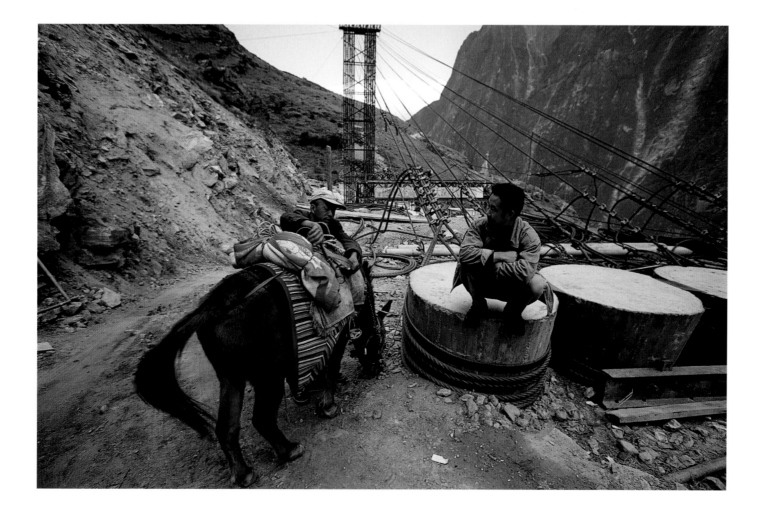

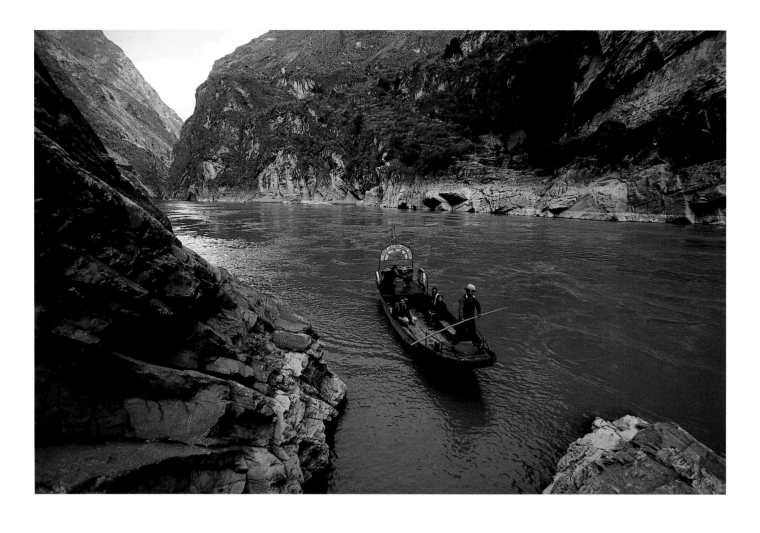

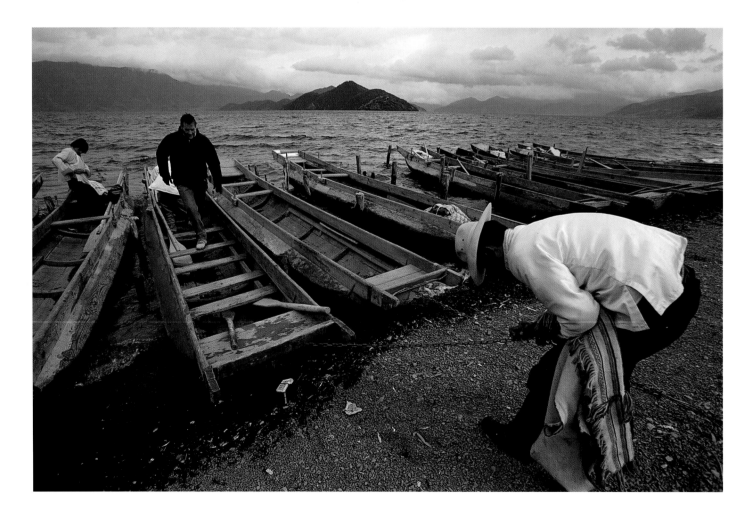

FROM YANGTZE TO LUGU. Michael crosses the Yangtze River (TOP LEFT) at one of its narrowest points (30 feet across) on a small boat aptly named the Tiger Leaping Gorge Ferry. Yunnan province is home to at least 26 ethnic minority groups, including the 36,000 Moso people, a relative of the Tibetans. (BOTTOM LEFT) Mike arriving at Lugu Lake, the homeland of the Moso. (ABOVE) A strong onshore wind, coupled with scattered showers and the lack of tourists, finally forced this Moso lady to pack up her wares and abandon the lake for the day.

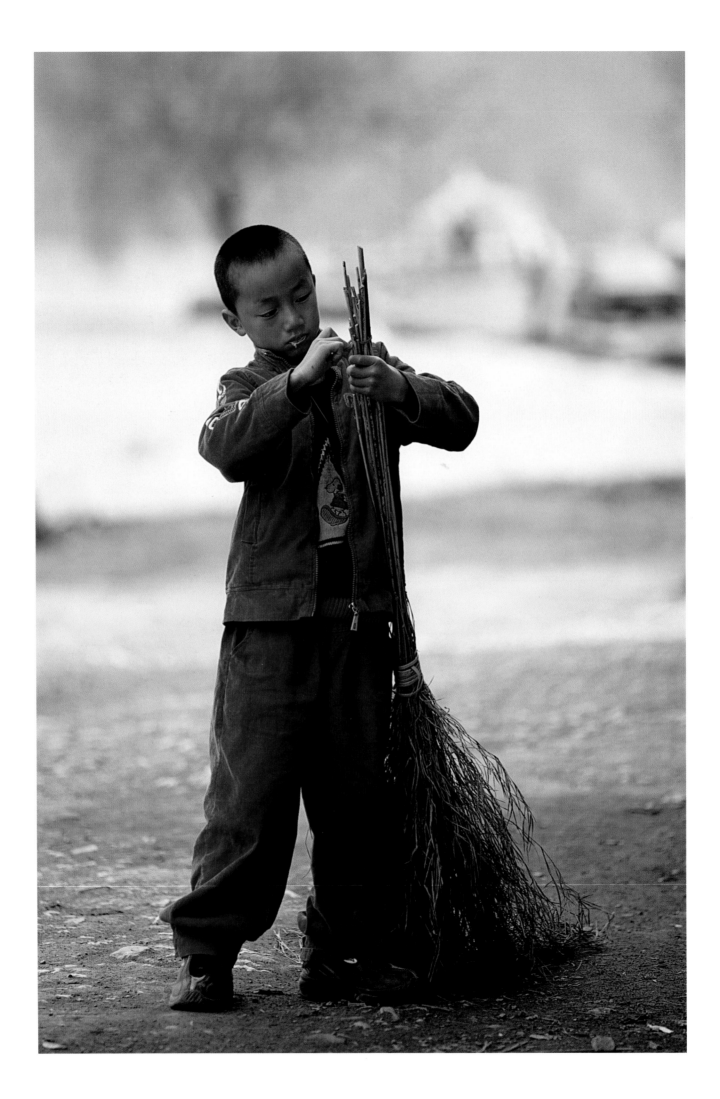

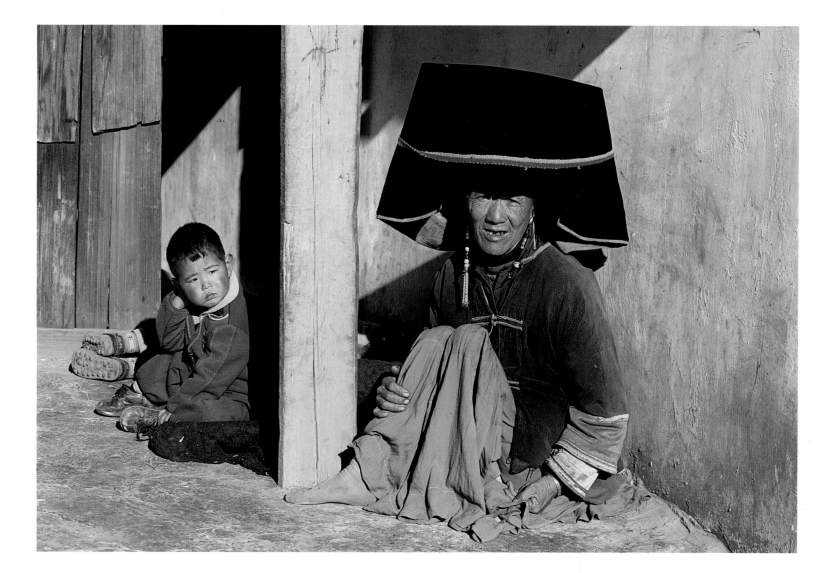

LUGU LAKE sits on the border of Yunnan and the densely populated Sichuan province. And its quiet shores have become major tourist destinations. Weary city dwellers from both provinces, desperate to escape the pressure and the pollution, come in search of clean air and pristine water. Others, however, come for sex. Lured by the false impression that Moso women are 'easy' because of their matrilineal tradition, they arrive only to find imported Han prostitutes in Moso costumes. **(LEFT)** By the lake, a boy makes a broom out of branches with rubber bands. **(ABOVE)** A woman of the Yi minority on the road between Lugu Lake and Lijiang.

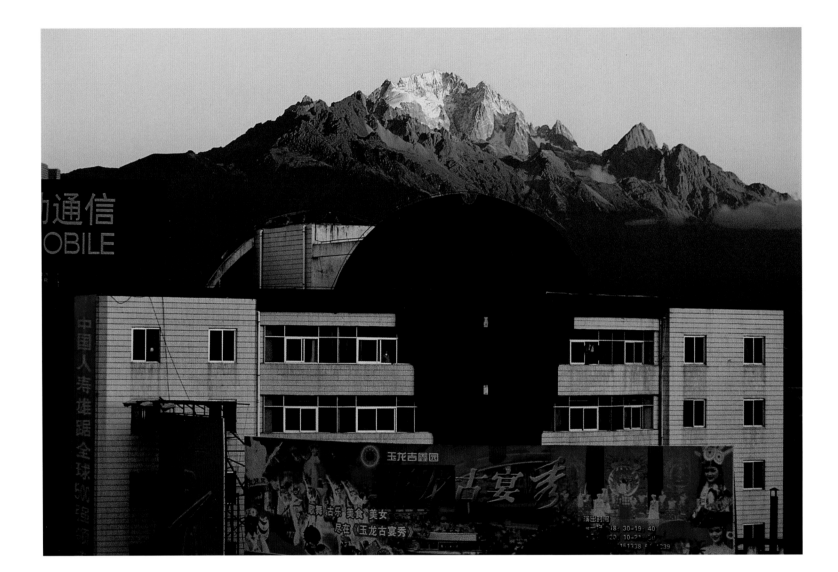

THE CITY OF LIJIANG nestles in the shade of the Jade Dragon Snow Mountain, the easternmost range of the Himalaya. Since the powerful 1996 earthquake, which killed 300 and injured over 16,000, the sleepy Naxi town I first visited 15 years ago has been transformed into two cities. At dawn, (ABOVE) the peak of Shanzidou seems out of place sitting over the new city's commercial centre. (RIGHT) The winding, cobblestoned streets and the historic buildings of old Lijiang are still there, but they have been polished to a shine. And with an average of three million tourists a year, it has taken on an amusement park-like veneer that renders it almost beyond recognition.

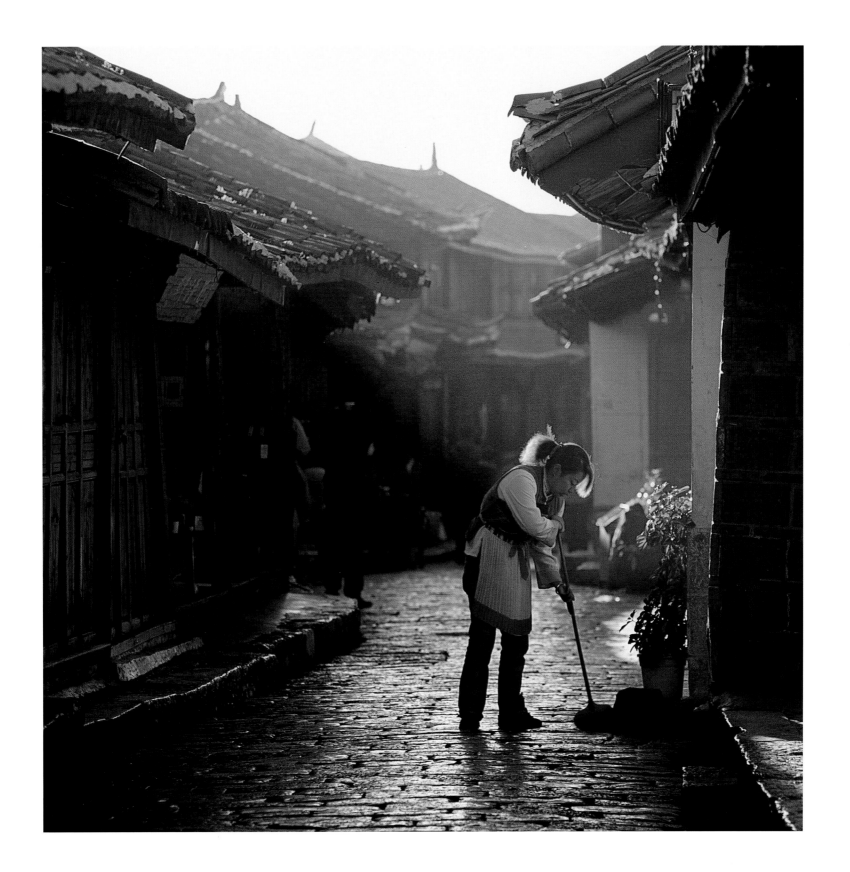

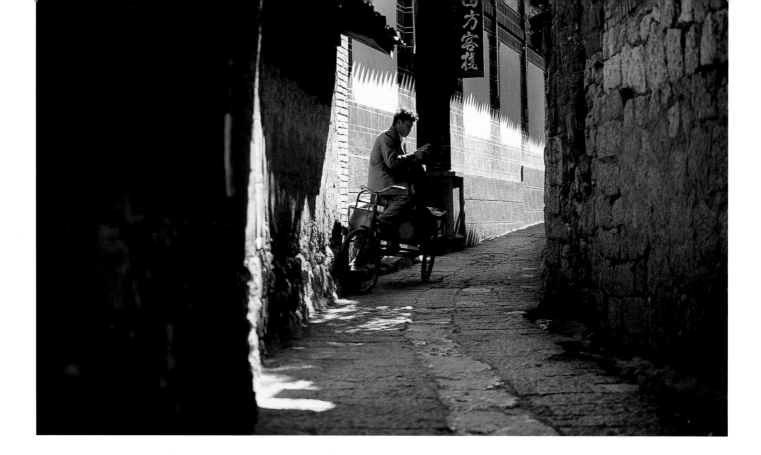

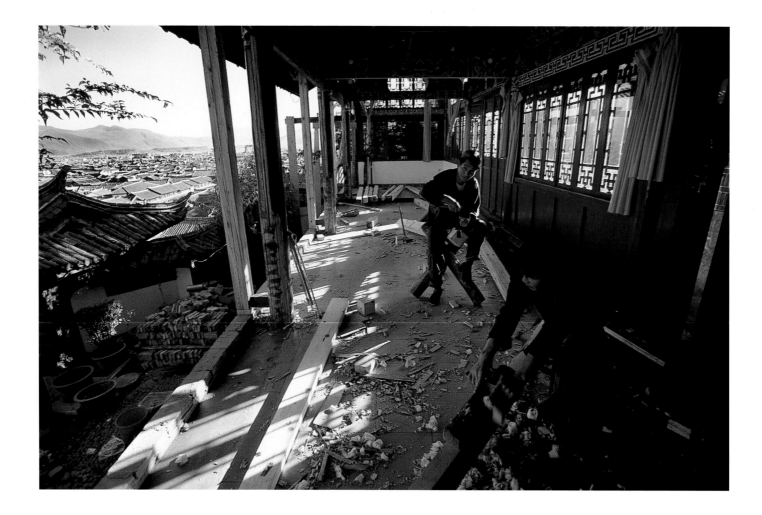

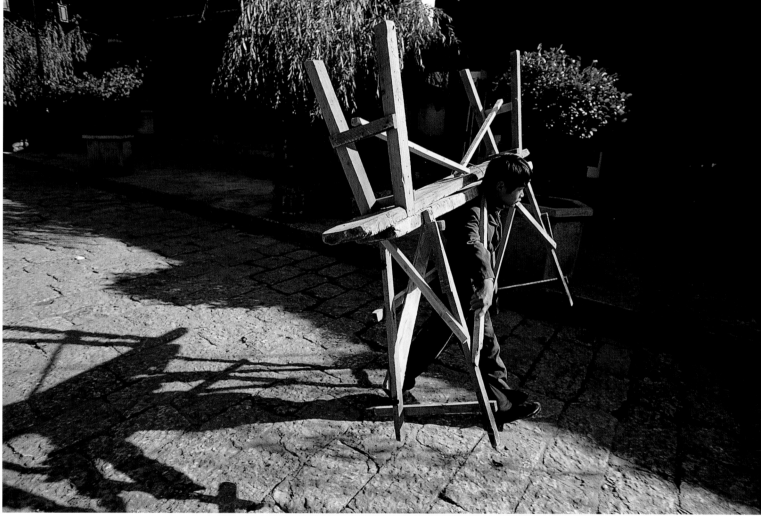

IN THE NEW OLD TOWN of Lijiang, the line between the past and present are often blurred within the sharp edges of the harsh shadows. **(TOP LEFT)** In a quiet corner on a back street, a deliveryman is text-messaging his friends on his mobile phone. Meanwhile, on top of the hill **(BOTTOM LEFT)**, carpenters are using traditional skills and antiquated tools to transform an old temple complex into a new boutique hotel. **(ABOVE)** A young apprentice transports the primitive wooden 'painter's platforms' (which are used for gaining height, and also as legs for a worktable) over to a new location.

China

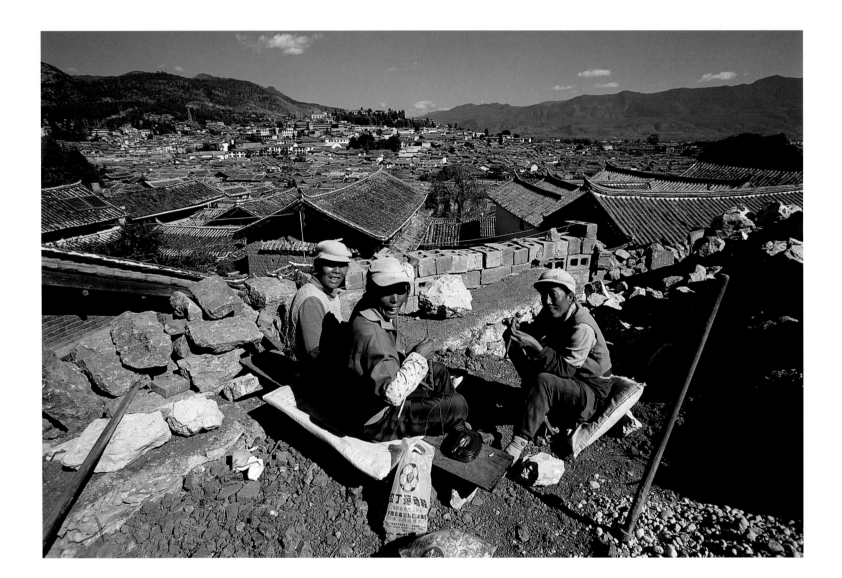

AMONGST ALL THE MINORITIES, Naxi women are renowned for being the (much) stronger of the two sexes. These ladies, at a construction site on top of Lion Hill, demonstrated that reputation by teasing me mercilessly in a mixture of Naxi dialect and impenetrable Mandarin. I eventually got this picture only because they had to stop and catch their breath from all the laughing. The prevailing attitude of the majority Han people towards the minorities in China is drawn in sharp relief at the Yunnan Nationalities Villages in Kunming **(RIGHT)**, where the cultural heritage of the minorities is reduced to the level of Micky, Minnie and Goofy in a Disneyland without the rides.

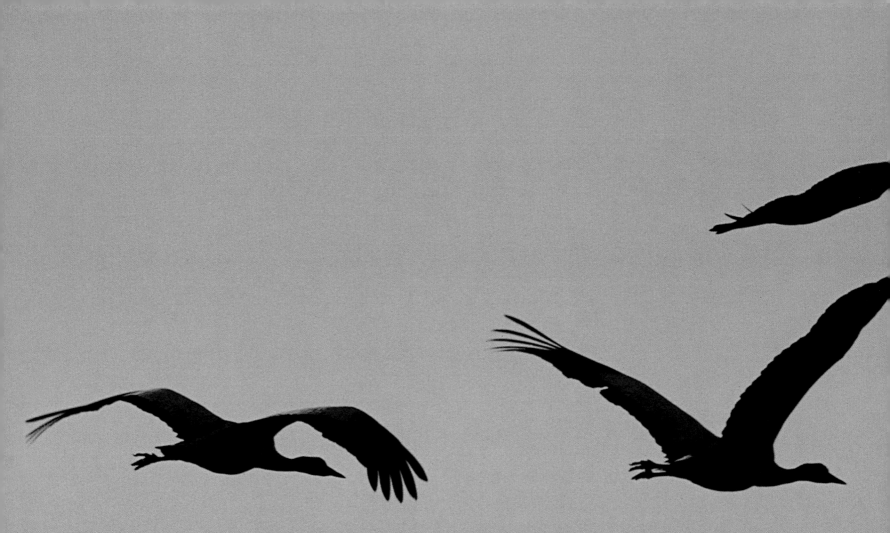

BHUTAN

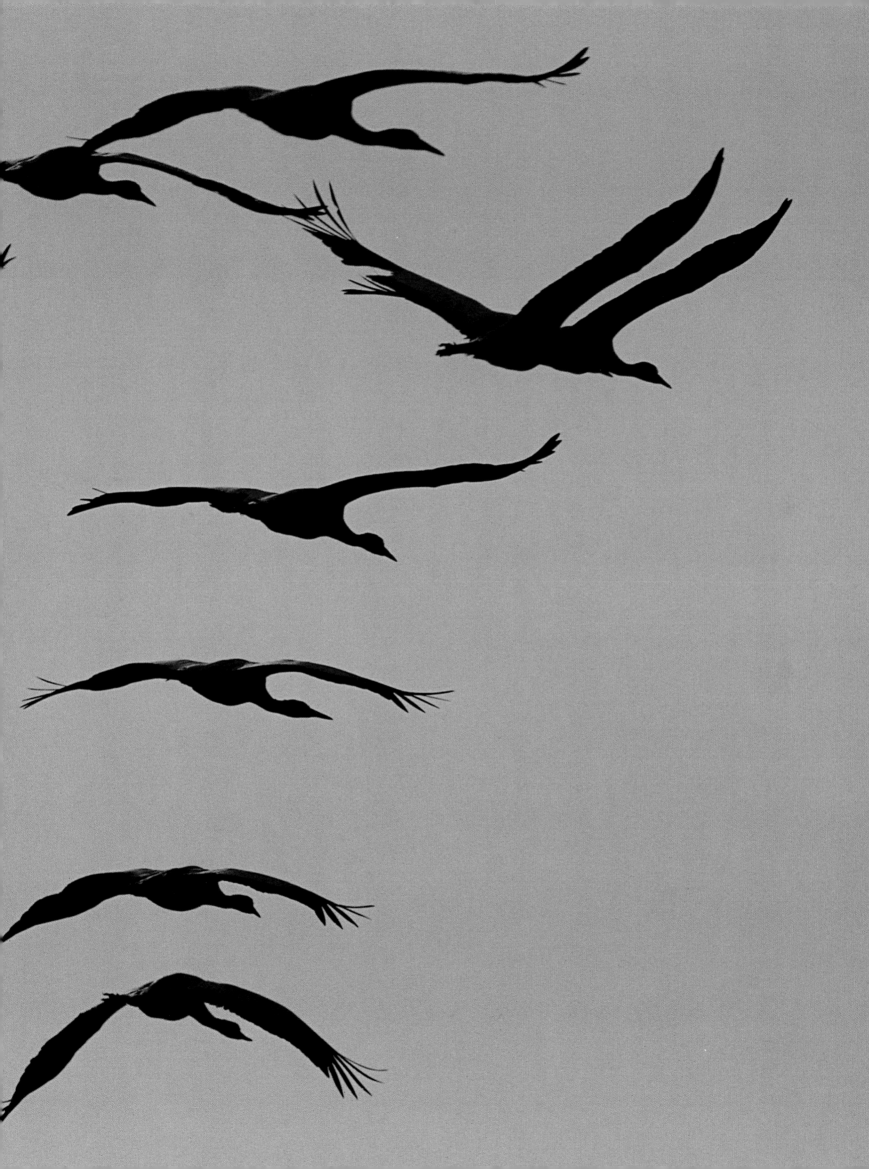

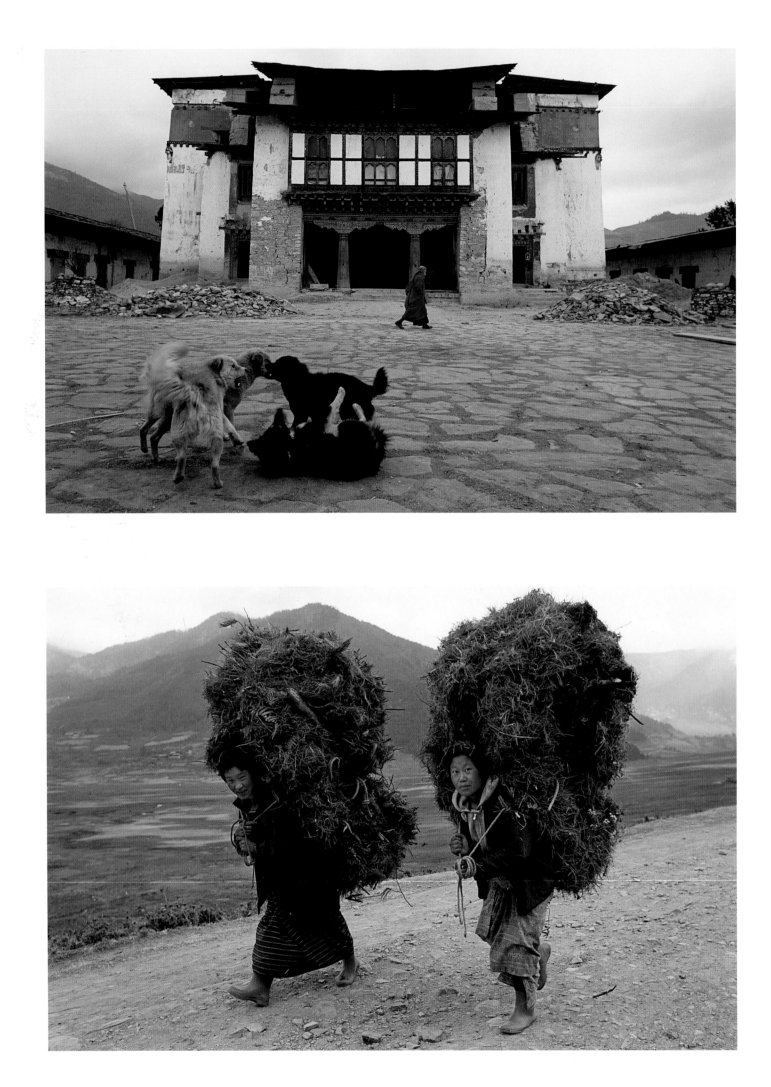

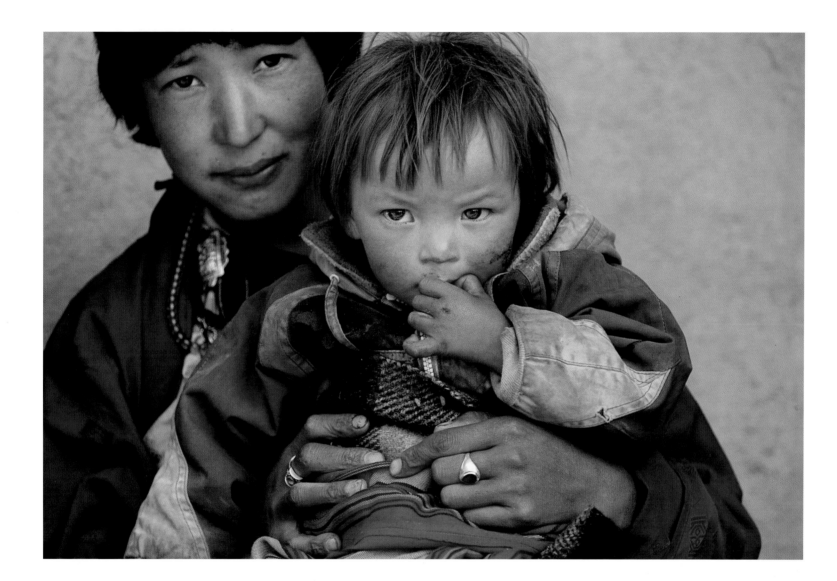

THE PHOBJIKHA VALLEY in the Black Mountain National Park is considered one of the most important wildlife sanctuaries in Bhutan. Every year, between late October and mid February, black-necked cranes, one of the rarest birds in the world, gather here from all over the Tibetan plateau. (TOP LEFT) In the village of Gangtey, the once splendid *gompa* (monastery) looks rather forlorn with the major renovations. (BOTTOM LEFT) Down on the valley floor, girls from Phobjikha return from the mountain, loaded down with feed for the cattle. (ABOVE) One cannot help but wonder what this little Gangtey boy is seeing through those amazing eyes. (PRECEDING PAGES) Black-necked cranes over Phobjikha Valley.

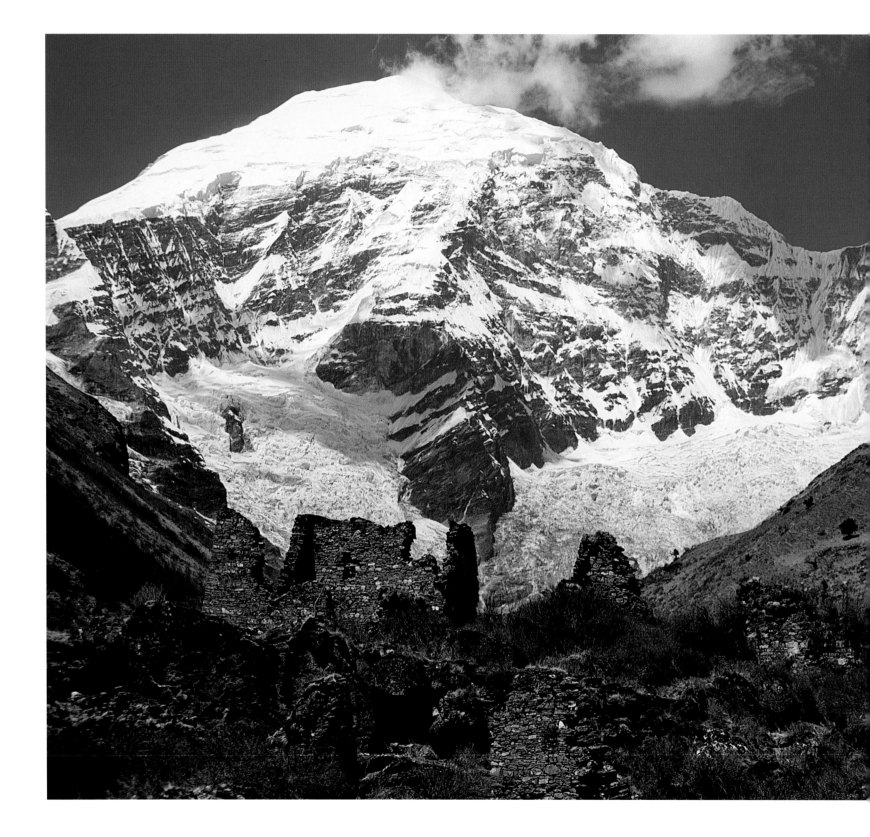

JOMOLHARI is the abode of the Goddess Tsheringma, who sits on a white lion and holds the vase of longevity in her left hand, a very popular guardian of wealth and cattle in Tibetan mythology. It is also, at 24,000 ft (7315 m), one of the tallest mountains in Bhutan. Tibet is just over on the other side of the high passes, through which trade and invasions have come and gone for centuries. And if you

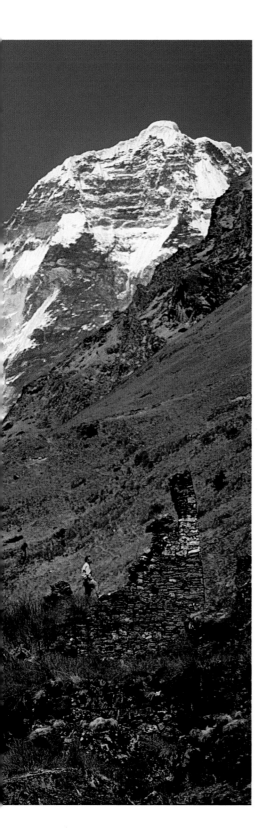

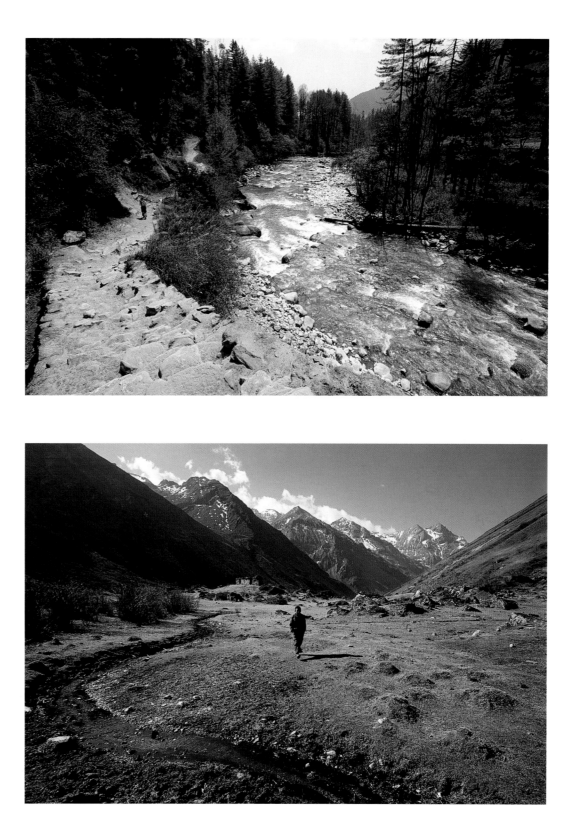

go due north from the fortress ruins (**LEFT**) in front of our campsite, you will eventually come to Gyantse. Regardless of how idyllic the scenery may look (**TOP RIGHT**), the trek to Paro (or any other trek) will always be remembered as a 'nightmare' in my book. (**BOTTOM RIGHT**) A boy from the village of Jangothang approaches to check out the new visitors at the Jomolhari Base Camp.

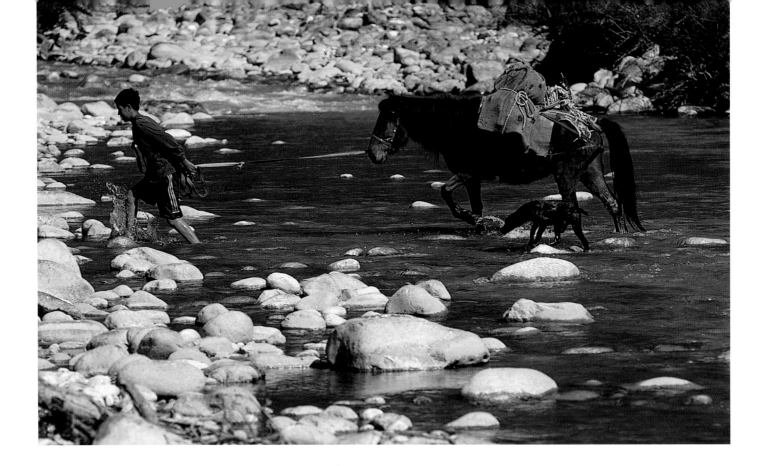

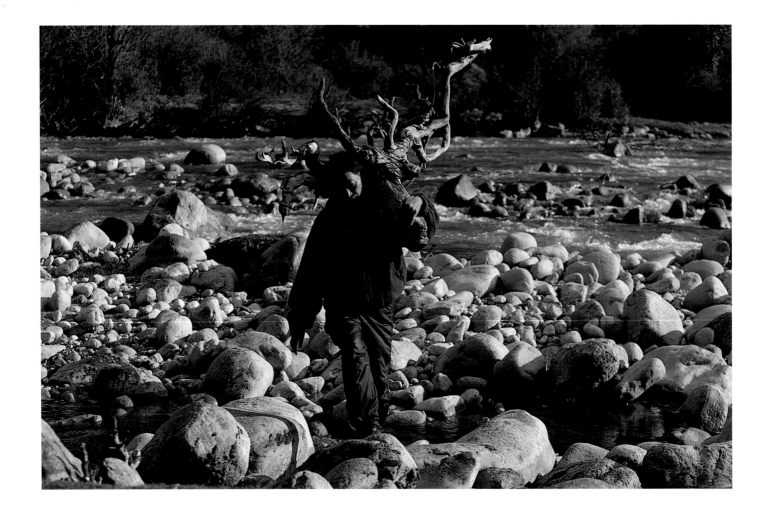

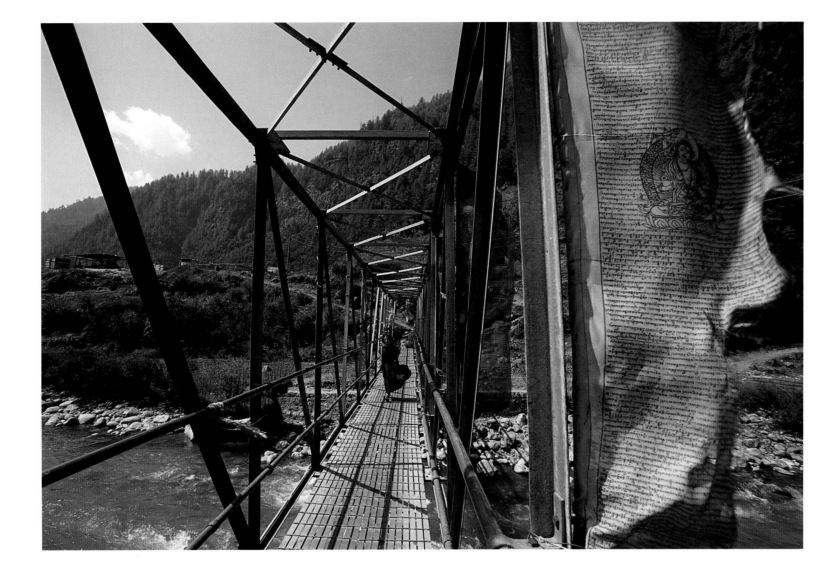

TWO DAYS AND 23 MILES from the Jomolhari Base Camp, we arrive at a campsite on a grassy meadow by the Paro Chhu (River) near Sharma Zampa. For the first time, I begin to feel a touch of optimism. Perhaps it is the knowledge that by the next evening, I shall wake up from this nightmare in a warm bed inside a room that I don't have to crawl into, but more likely, it is because the setting **(LEFT)** reminds me so much of Márquez's mythical Macondo. **(ABOVE)** Crossing this bridge to the army post at Gunitsawa marks the beginning of the end. By late afternoon, we shall arrive at the ruins of Drukgyel Dzong, the 17th-century fortress built to guard the entrance to the Paro Valley.

Bhutan

159

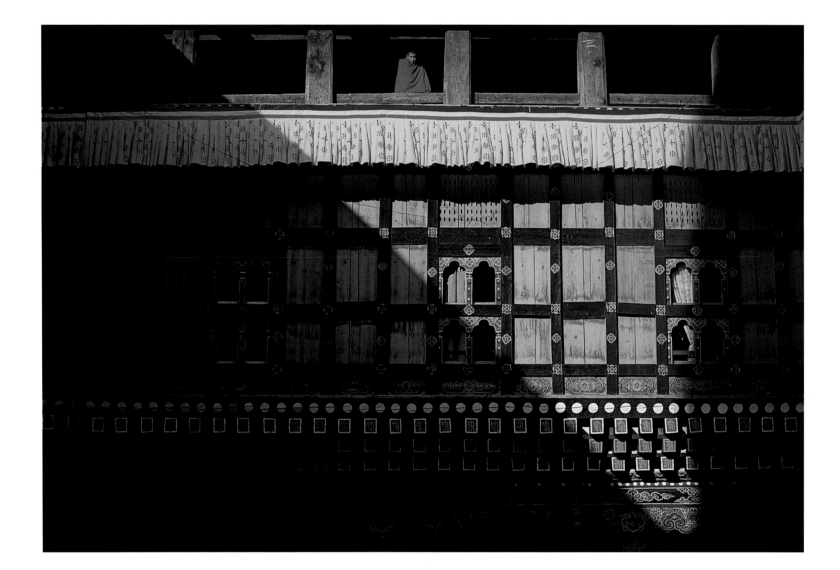

THE FORTRESS ON A MOUNT OF JEWELS (Rinpung Dzong) is what the Bhutanese call the Paro Dzong. I had spent a lot of time in the *dzong* during the filming of *Little Buddha*, and as I retrace the familiar steps through the dark tunnel of the entryway at dawn, I can still hear distant echoes of Bernardo shouting 'Azione!' in the upper courtyard beyond. But all is quiet in the lower courtyard, an eerie calm before the impending storm, where, apart from a few early birds like us, only the younger monks of the *dzong* (ABOVE & RIGHT) are up and about. Within the hour, the courtyard will be jam-packed with a cast of thousands for the start of the Paro Tsechu, the most important festival of the year.

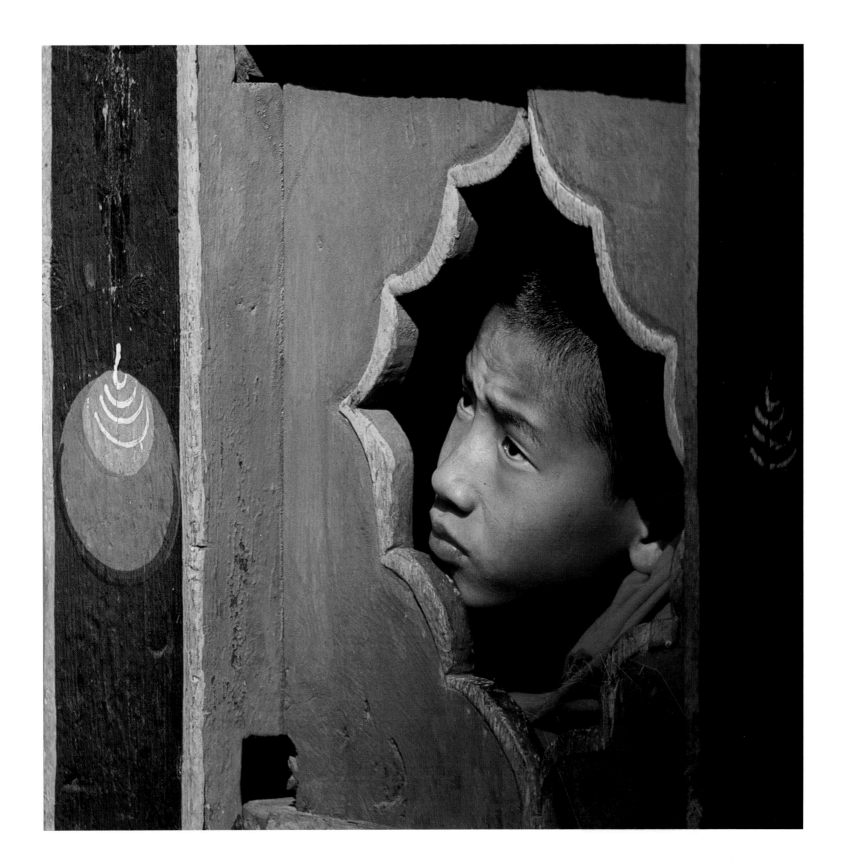

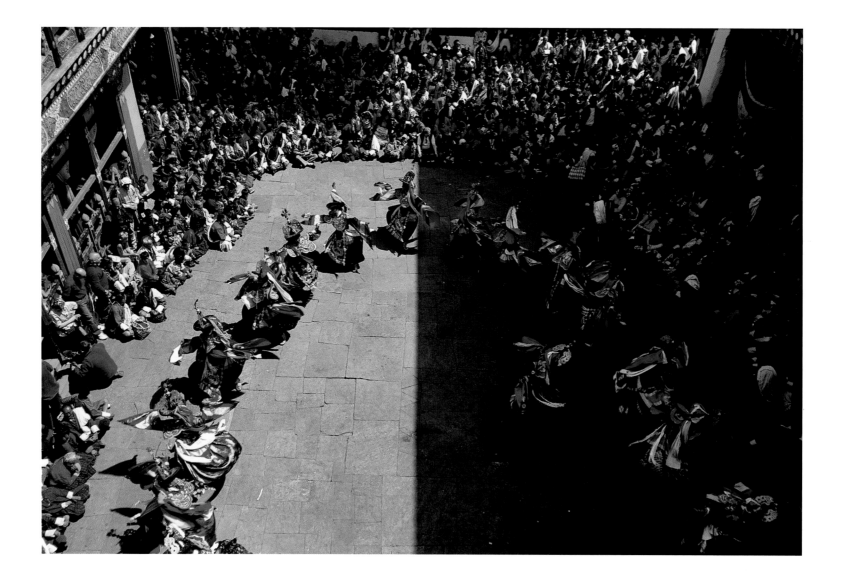

THE TSECHUS, which take place at different times throughout the year in all the major *dzongs* in the country, are festivals honouring Bhutan's patron saint Guru Rinpoche (Precious Teacher). He was a Tantric mystic from Swat, who invented Tibetan Buddhism by combining elements of Bon and esoteric tantric rituals into the doctrines of Buddha. The Black Hat Dance (**ABOVE & RIGHT**) was originally a tantric ritual for the consecration of grounds prior to building. The dancers first 'draw' a Mandala with sacred hand gestures (*mutras*) and 'steps of the thunderbolt' with their feet. Then they slice the invisible cosmic diagram apart like a pizza by spinning across the ground, slaying the demons and clearing the way for the Buddha spirit to take possession of the earth in the process.

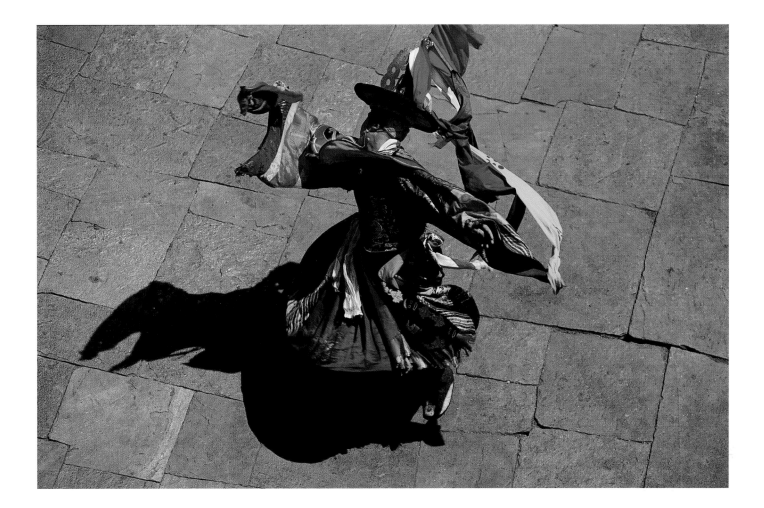

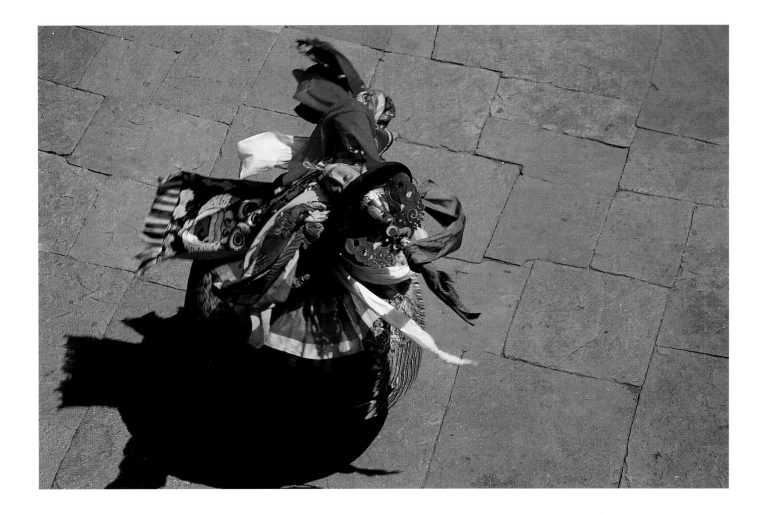

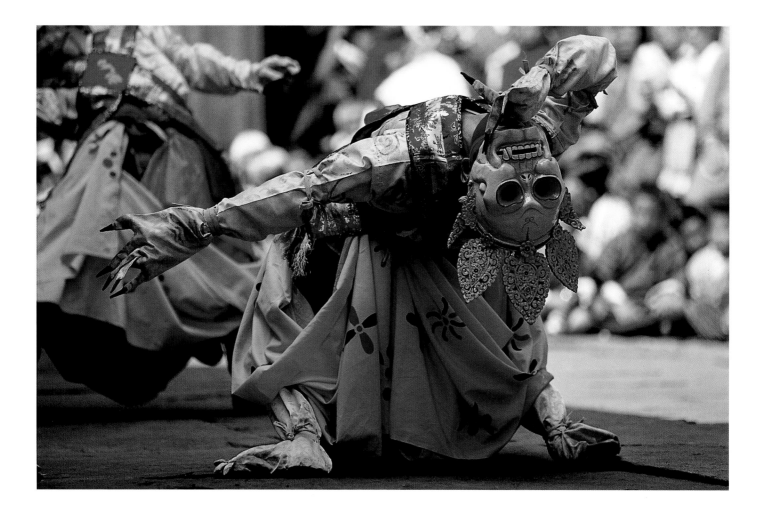

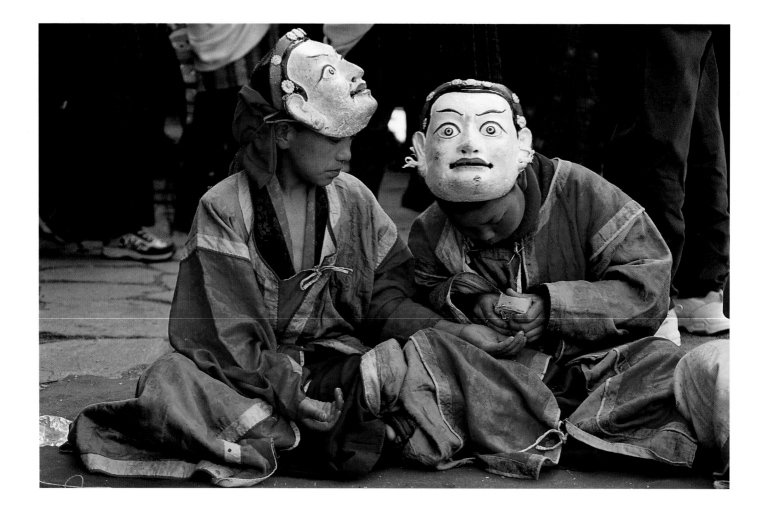

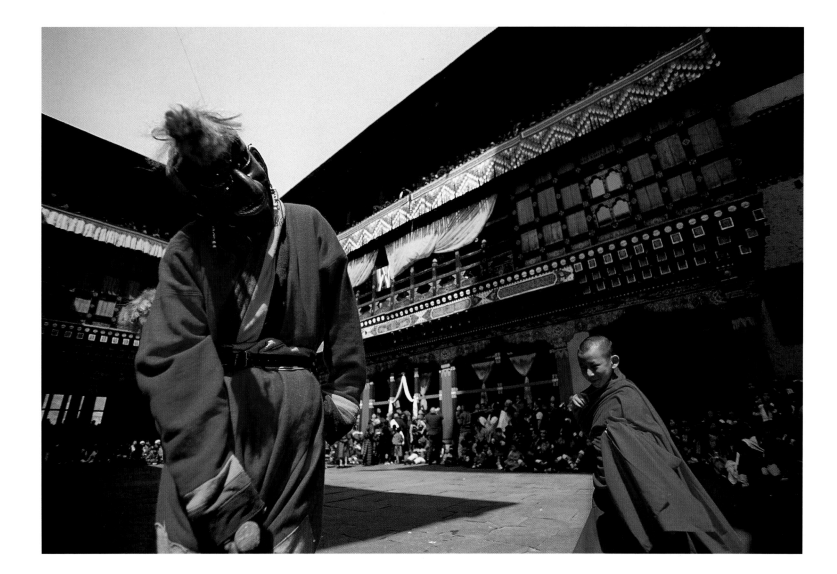

MASKS are often used in the rituals of animist cultures. But in the religious dances of Tibetan Buddhism, where the guardian spirits have been enlisted as protective deities of the faith, the masks have evolved into an important art form, encrypted with sophisticated symbolism. (TOP LEFT) The Skull Mask of the Durdag – Dance of the Lords of Cremation Grounds. (BOTTOM LEFT) Two boys with Lhakarp (White God) masks, sharing a drink in a quiet moment during the epic Dance of the Judgement of the Dead. (ABOVE) The Atsaras (jesters) are given carte blanche to run amok for the duration of the festival. They entertain the crowds with salacious jokes and antics, and wield their phalluses like nightsticks to beat back tourists who get too close to the dancers.

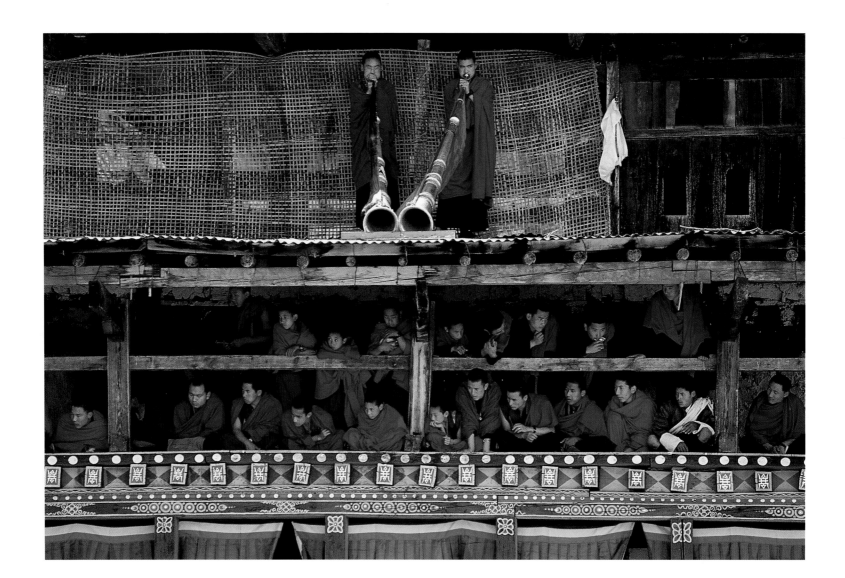

IN THE ARCHERY GROUND behind the *dzong* (**ABOVE**), the monks of Paro Dzong follow the proceedings from the 'grand stand'. (**RIGHT**) The Dance of the Judgement of the Dead is based on the famous Tibetan Book of the Dead (*Bardo Thoedrol*), and it is very long. So, when the giant puppet of Shinje Chhogyel – the Lord of Death – finally appears after two hours, great excitement sweeps through the crowd. The climax of the festival, however, comes in the wee hours before dawn the next morning, with the unveiling of a giant painting of Guru Rinpoche. The 100 ft by 150 ft *thangka* is known as a *thongdrol*, believed to possess the power of lifting all those who see it out of the cycle of rebirths.

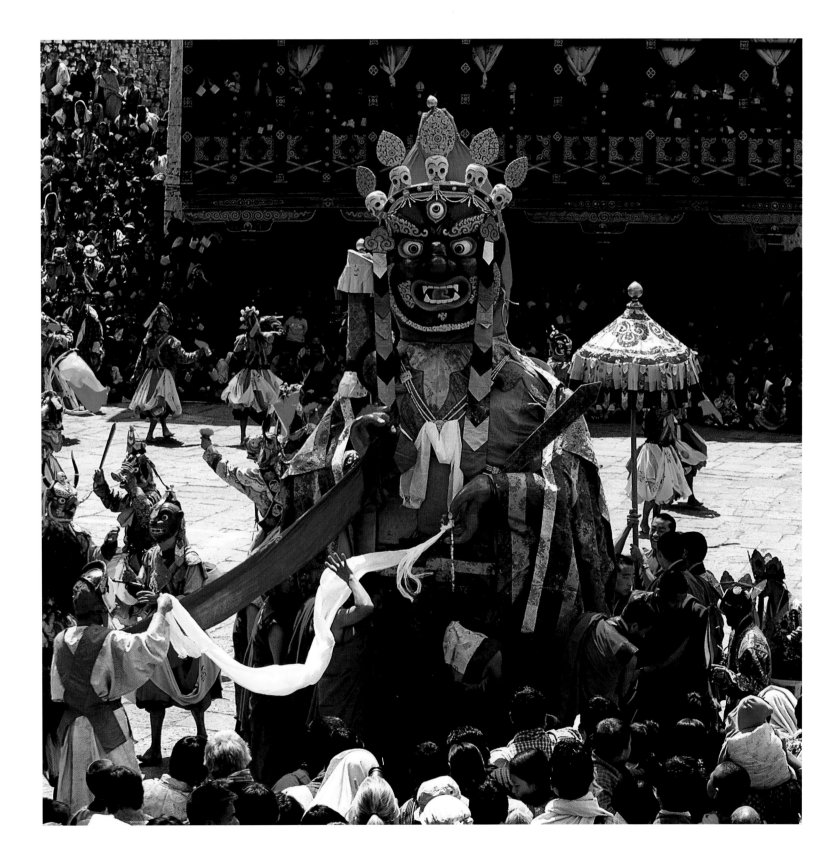

BANGLADESH

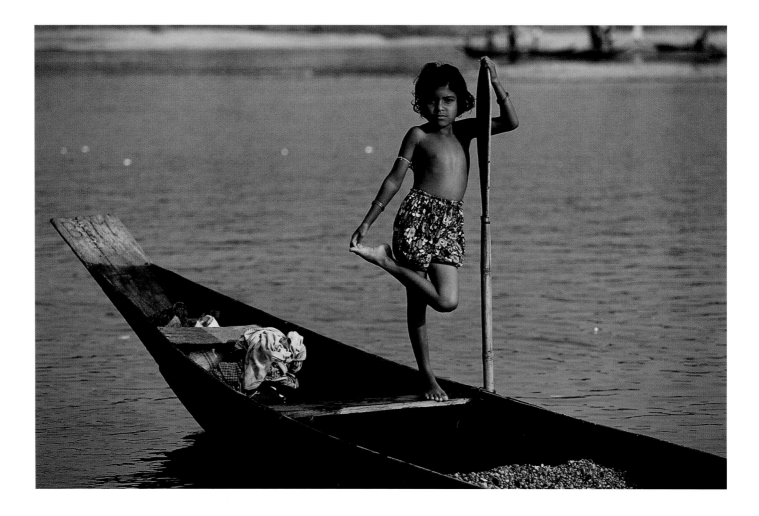

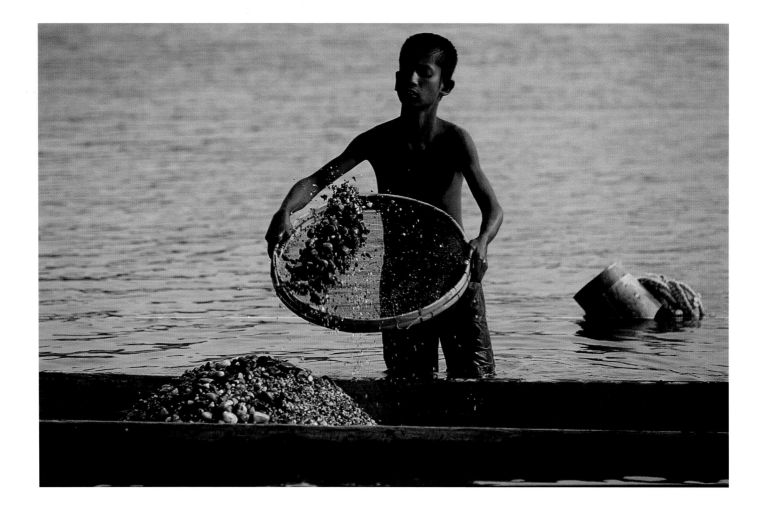

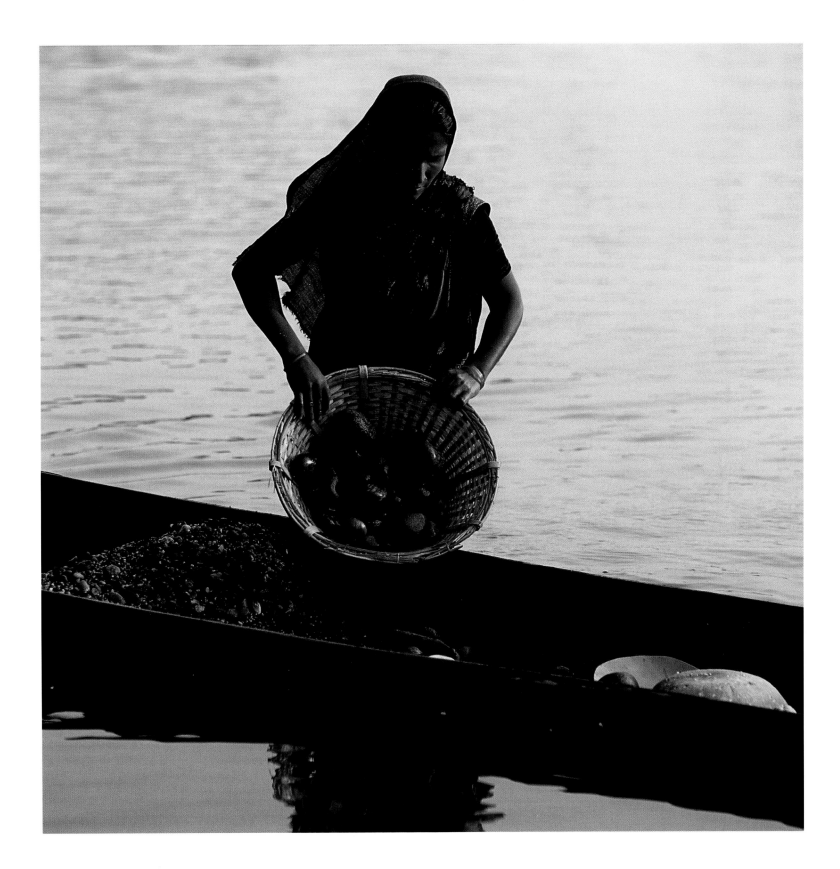

THERE IS A SHORTAGE of stone quarries in Bangladesh, as the country is basically one enormous
river delta, where the Brahmaputra and the Ganges meet the Bay of Bengal. So rocks and pebbles
washed down from the mountains on its northern border have become a precious source. On the
Pijain River near the town of Jaflang, on the border with Assam, hundreds of labourers comb the
banks and dredge the shallow shoreline for stones and gravel. (LEFT & ABOVE) Since it is unskilled
work and the pay is minimal, often the whole family is involved in order to make ends meet.
(PRECEDING PAGES) The Dhaka delta from the air.

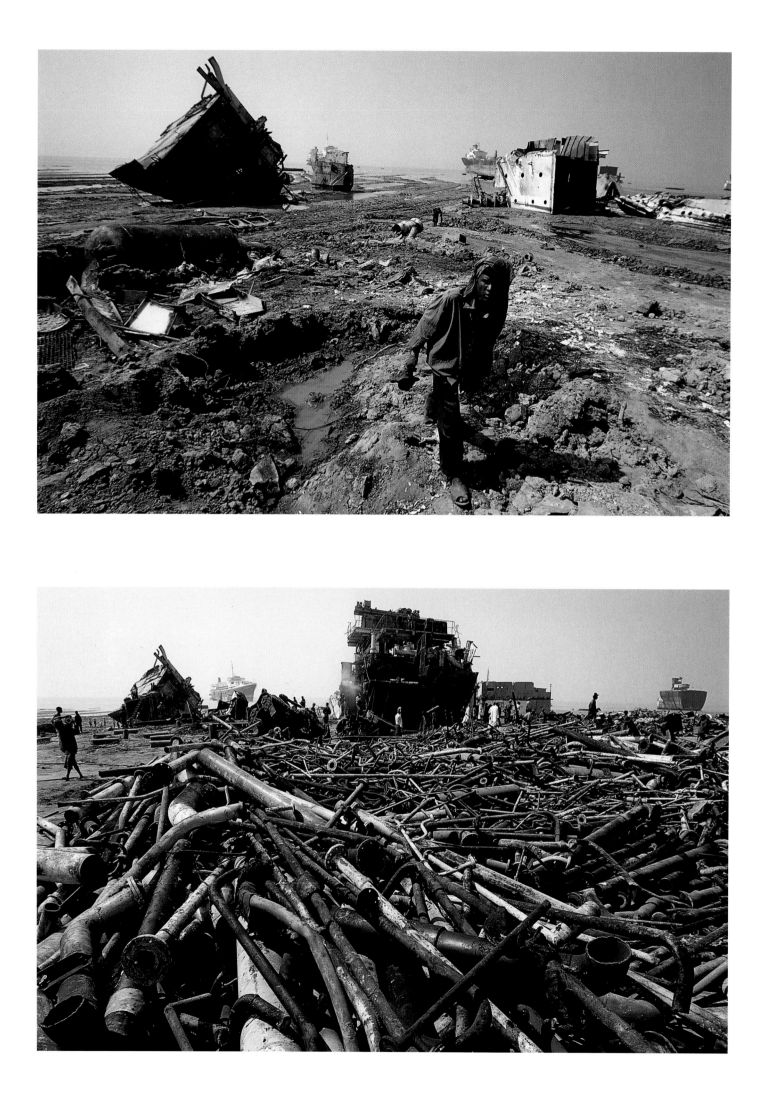

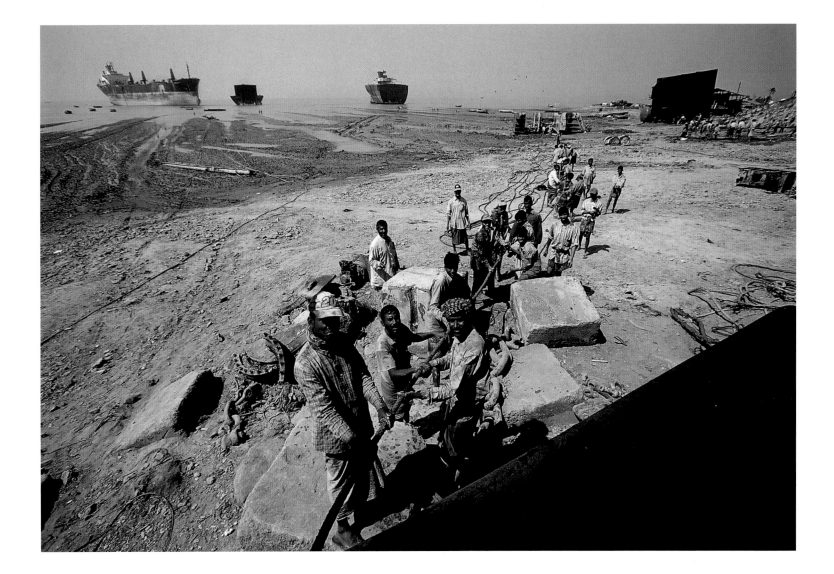

ON A STRETCH OF BEACH outside Bangladesh's second city, Chittagong, hundreds of workers from all over the country swarm over sections of carved-up ships, like flies over carcasses. With the surging demand for bulk steel in Asia, partly fuelled by China's booming construction industry, some ship owners find it more profitable to have a supertanker cut down for scrap, as each one yields enough steel for two skyscrapers. **(TOP LEFT)** A scavenger searching for any saleable scrap left unclaimed on the scarred and battered shore. **(BOTTOM LEFT)** An ocean of pipe fittings by the Bay of Bengal. **(ABOVE)** A crew readies a steel cable for pulling another section of a tanker onto the beach for breaking down.

Bangladesh

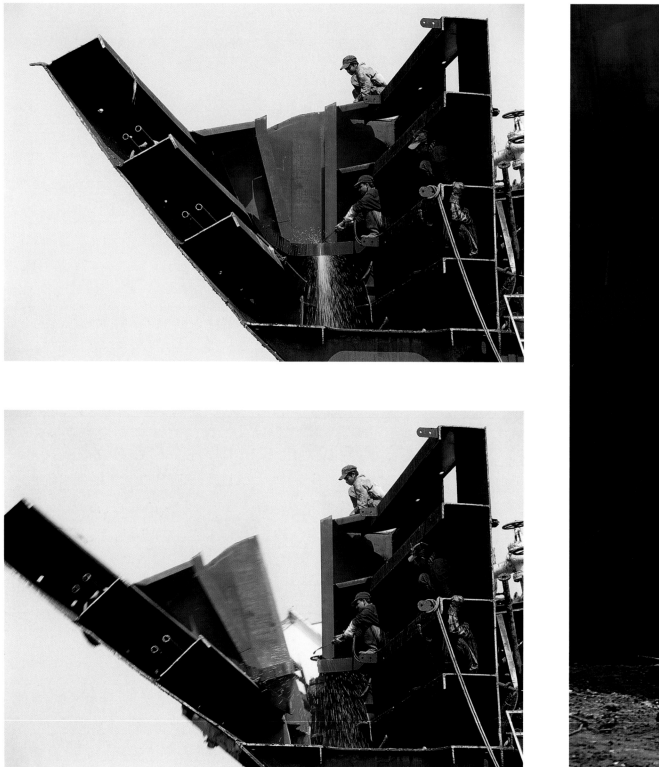

THE SHIP-BREAKING YARDS are low on technology and high on muscle energy; apart from the evil-smelling oxyacetylene torches, it is all sledgehammers and crowbars. **(LEFT)** Wielding his tool like a surgical blade, the welder cuts through a critical joint and a piece of the hull falls neatly away. **(RIGHT)** Light bursts through with a bang as another slice of the ship comes crashing down to the ground.

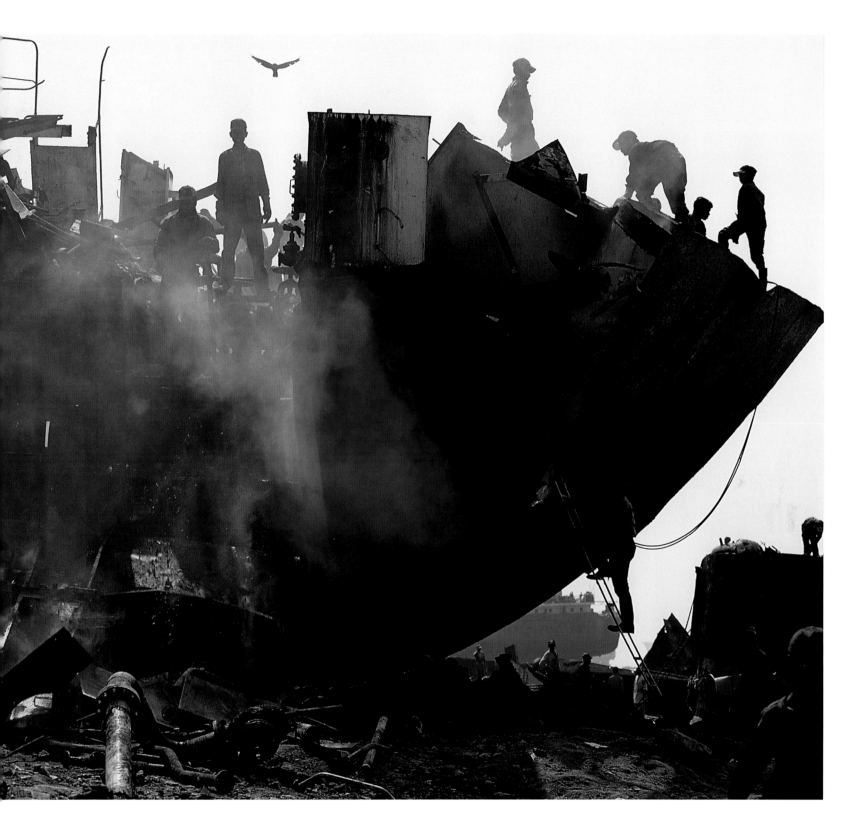

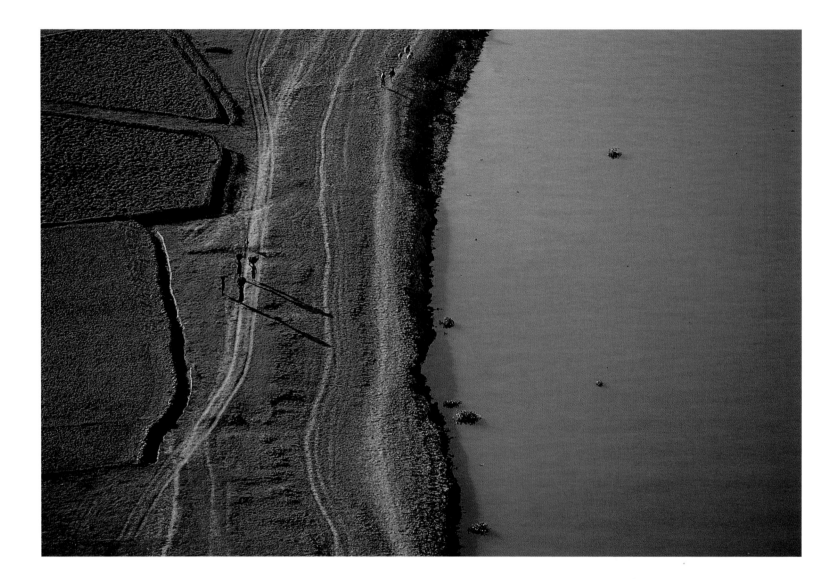

THE TWO HOLIEST RIVERS OF THE HIMALAYA meet up just a few miles outside Dhaka in an alluvial plain the size of the Black Sea. From the air, it is easy to understand why water is both the blessing and the curse of Bangladesh. Stretching to the edge of the horizon, as far as the eye can see, are waterways undulating through lush, green fields. While blessed with some of the most fertile soil in Asia, its wide-open, southern exposure leaves it at the mercy of the whims of destructive monsoons, some with enough force to flood practically the entire country.

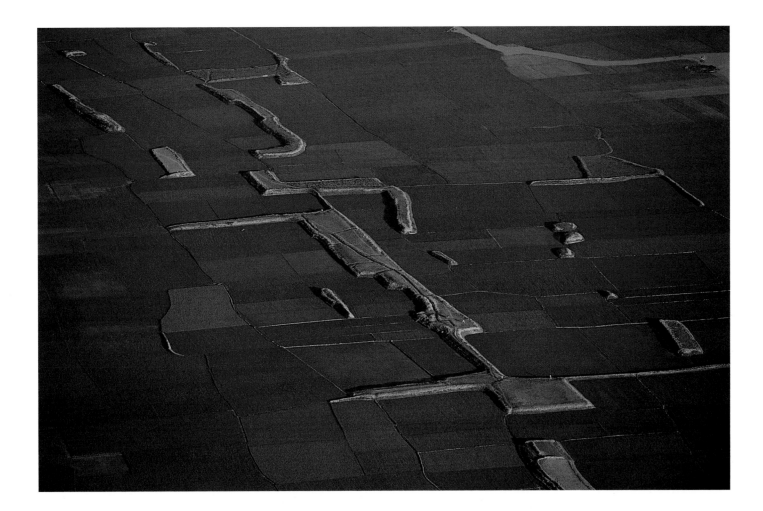

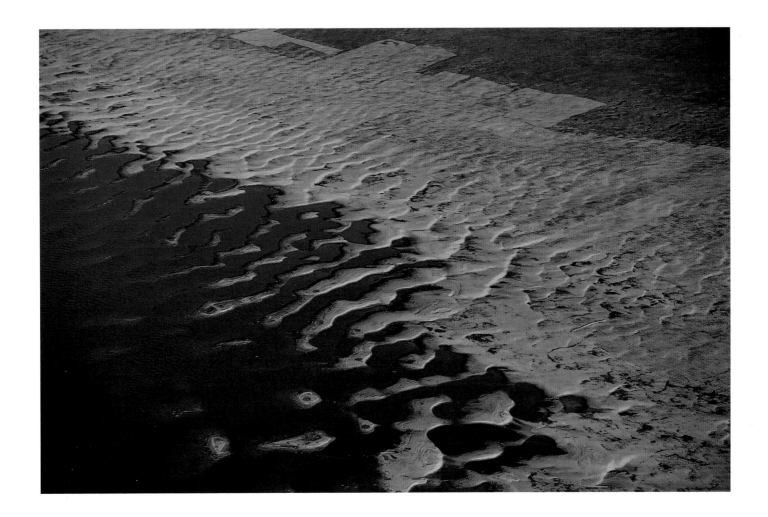

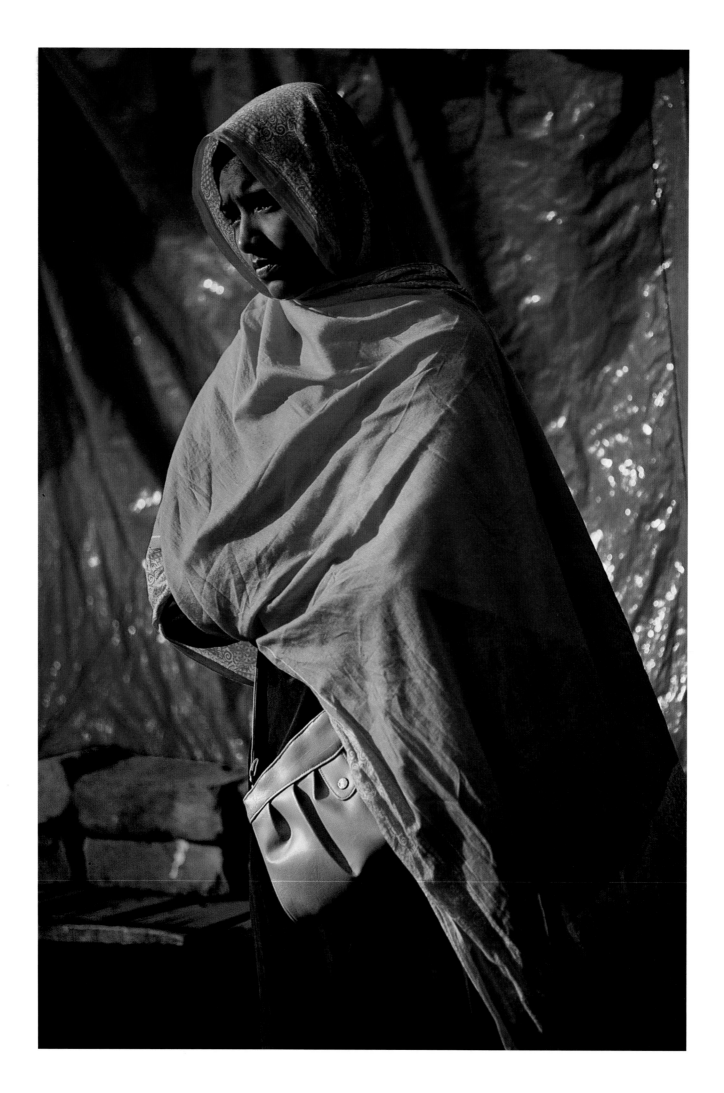

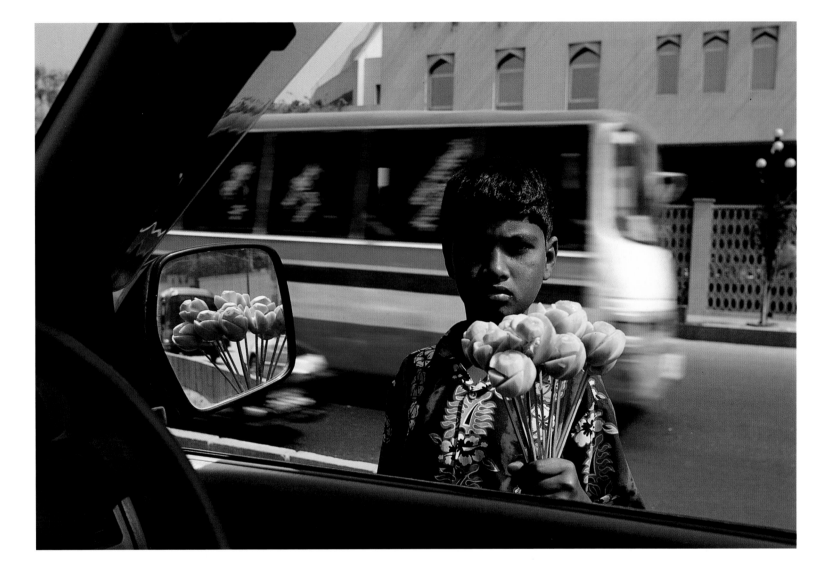

BANGLADESH is one of the poorest and, according to a recent survey, the most corrupt country in the world. Over 15 million people inhabit the capital and a majority of them are unskilled workers living in slums, waiting for the wealth of the country to trickle down through the bejewelled fingers of the elite. But out on the streets, the notorious Dhaka traffic jam is the great equalizer, where brand new SUVs and battered old buses jockey for position with 700,000 trishaws to go nowhere in a hurry. The stationary traffic makes for good business opportunities for street vendors, like this boy (**ABOVE**), who is selling melon (not tennis) balls on a stick. (**LEFT**) A young lady waits patiently at a bus stop.

Bangladesh

179

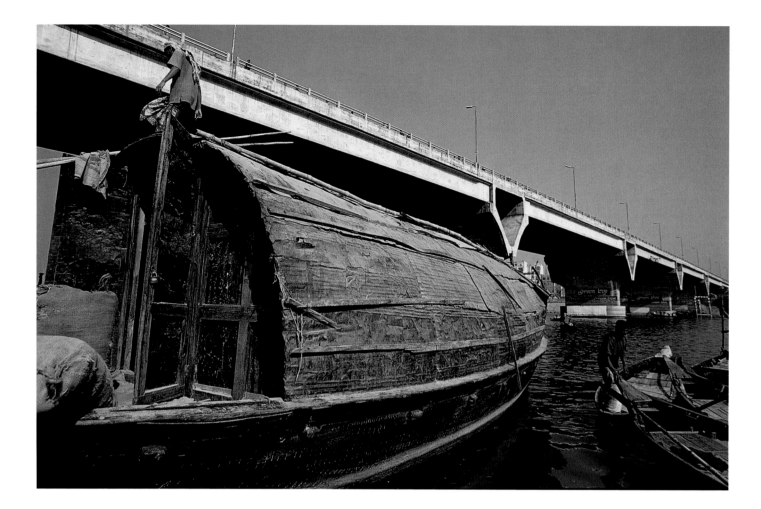

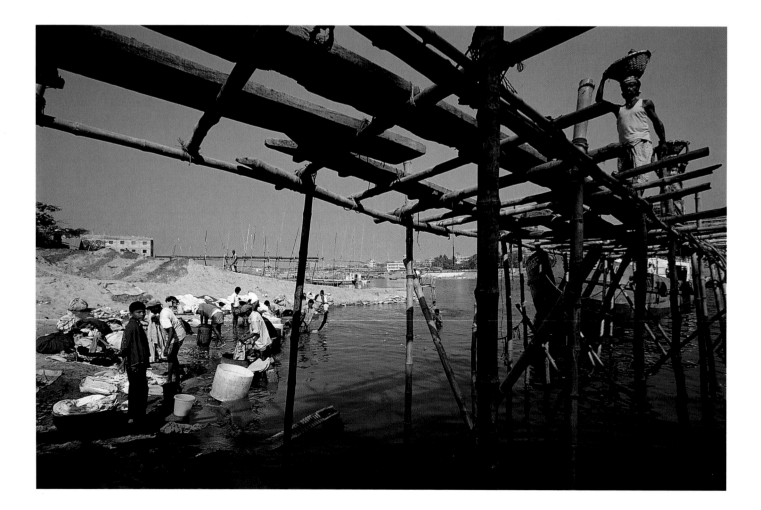

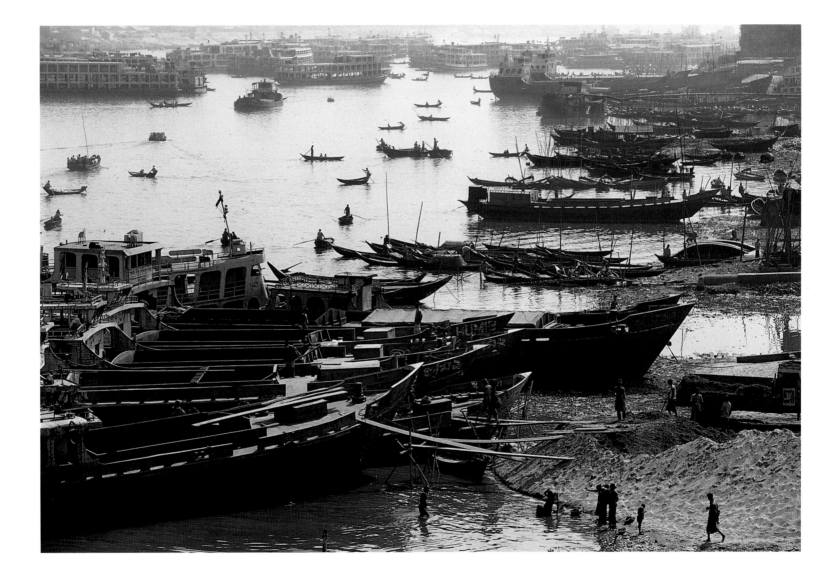

ONCE YOU ARE ON THE BANKS of the Buriganga River at Sadarghat, on the edge of the old city, you begin to get a feel for the real Dhaka, the one that was born and raised by the grace of the water. Though the water is so polluted that the surface of the river has a metallic sheen to it, life continues to thrive in this 'Waterworld'. **(ABOVE)** Sadarghat looks and feels a lot like Mopti on the banks of the River Niger in Mali, only without the goats. **(TOP LEFT)** Under the Friendship Bridge No. 2, a houseboat loaded down with cargo prepares to set sail. **(BOTTOM LEFT)** Cement is off-loaded from a barge moored to the rickety jetty, while clothes get cleaned in the dirty water at the laundry below.

Bangladesh

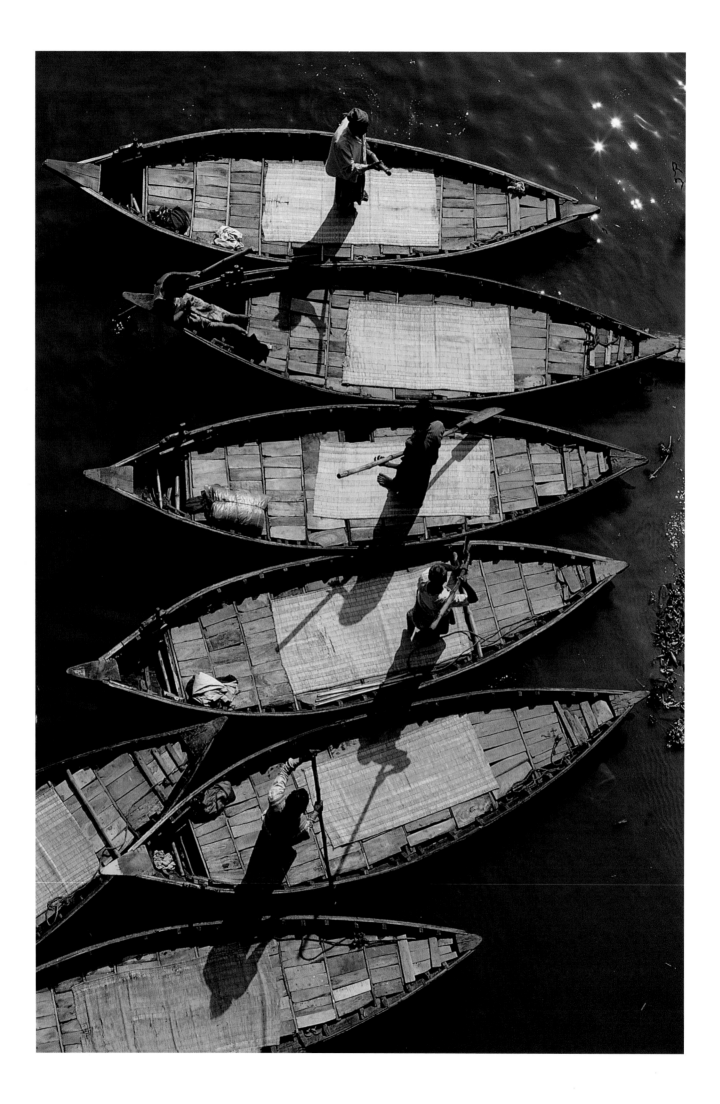

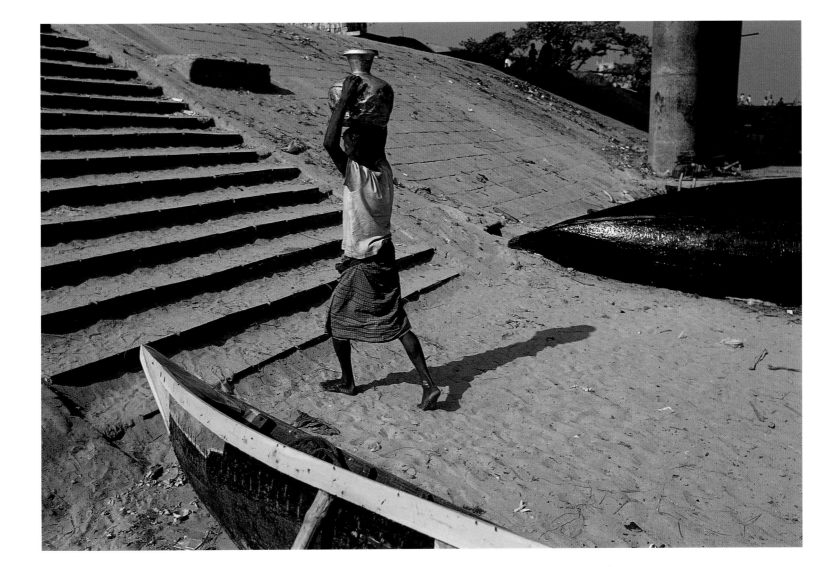

WITH 5000 MILES (1520 km) of navigable waterways and the regular floods that accompany the five-month-long monsoon season, boats are the only reliable form of transport for moving goods and people around the country. The port of Sadarghat is packed with an astonishing variety of water-borne vehicles, from triple-decker ferries to freighters, and barges to junks, battling each other for elbowroom on the quayside day and night. My personal favourite are the water taxis (**LEFT**), which zip in and out of the river traffic just like their road warrior cousins, the trishaws. (**ABOVE**) In the water taxi maintenance yard by the bridge, an old man collects his water supply from the river.

Bangladesh

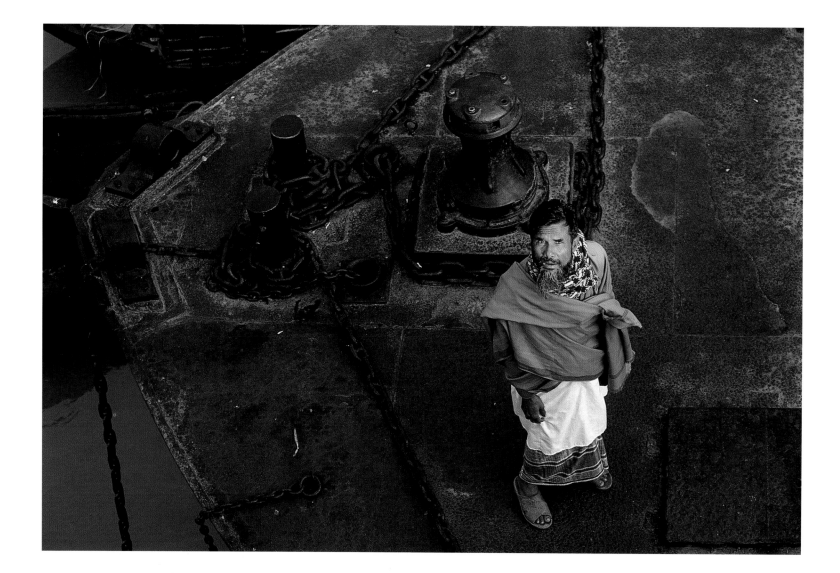

CRUISING ALONG the Buriganga River on board the paddle steamer *P S Ostrich*, with a vodka tonic in hand, is, surprisingly, a bit more agreeable than trekking. And furthermore, the pictures are better. With a more or less stable platform from which to shoot – in between cocktails – the lovely river scenes drifting by at a stately pace, it is very close to what I call ideal filming conditions. But the best is when we dock, where the human traffic getting on and off the ferry offers excellent opportunities. (**ABOVE & RIGHT**) Passengers waiting to board at Moralgunj.

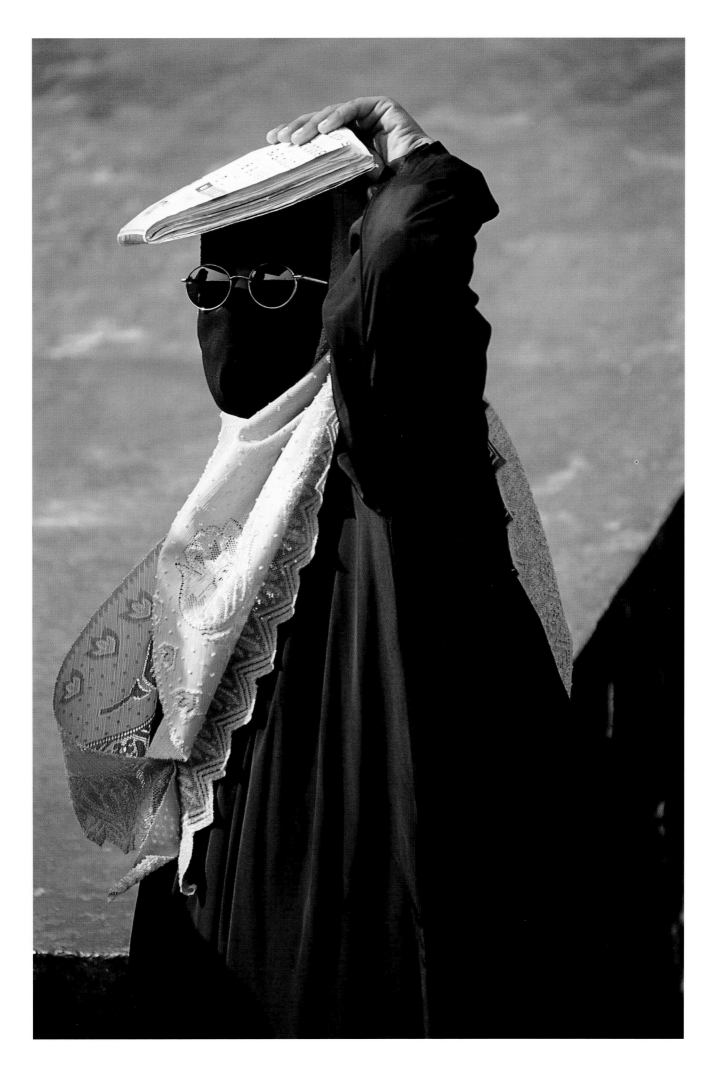

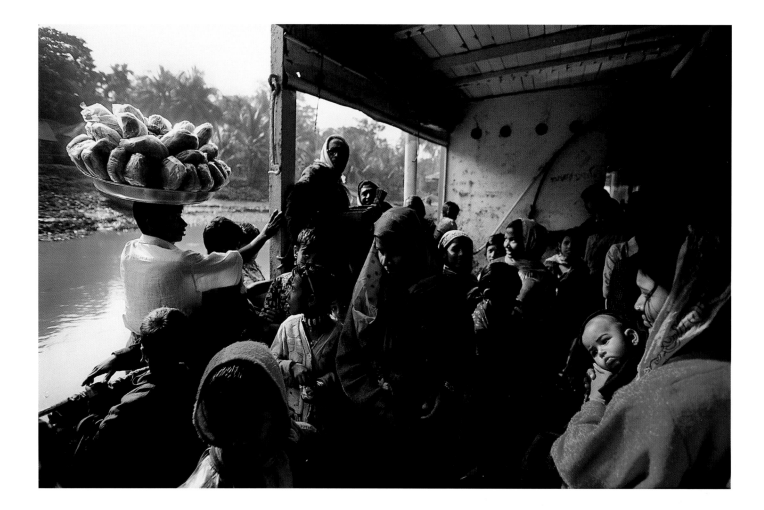

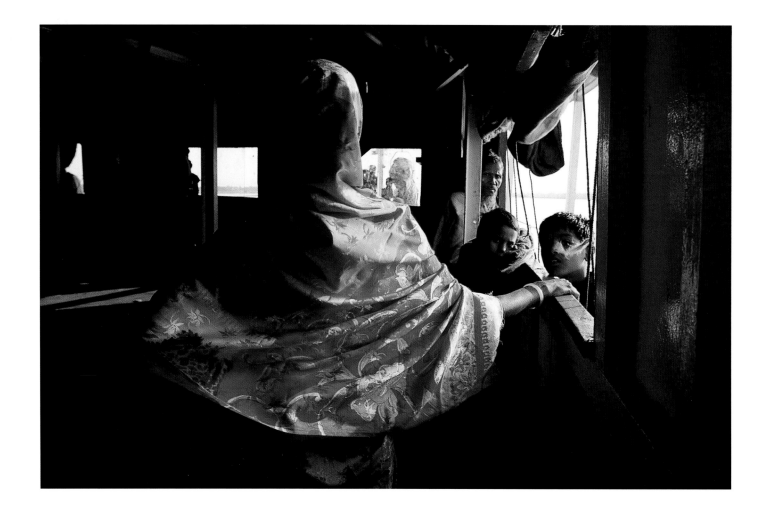

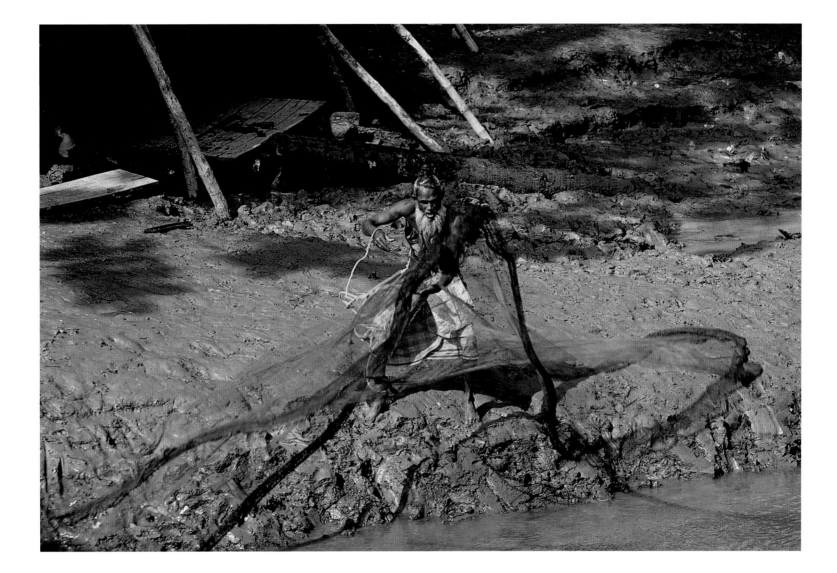

WHILE ROAMING through the crowded second-class cabin of the *Ostrich* (**LEFT**), which carries over 700 passengers, I find myself engulfed by goodwill and curiosity. It is probably the first time any of these people have come face to face with a Chinaman with enormous lenses all over his body, and the great majority of them are very keen to be photographed – well, except for maybe one or two. (**ABOVE**) A fisherman near the jetty at Johlokati.

(**FOLLOWING PAGES**) Dawn at the Sunderbands, approaching the journey's end in the Bay of Bengal.

Bangladesh

187

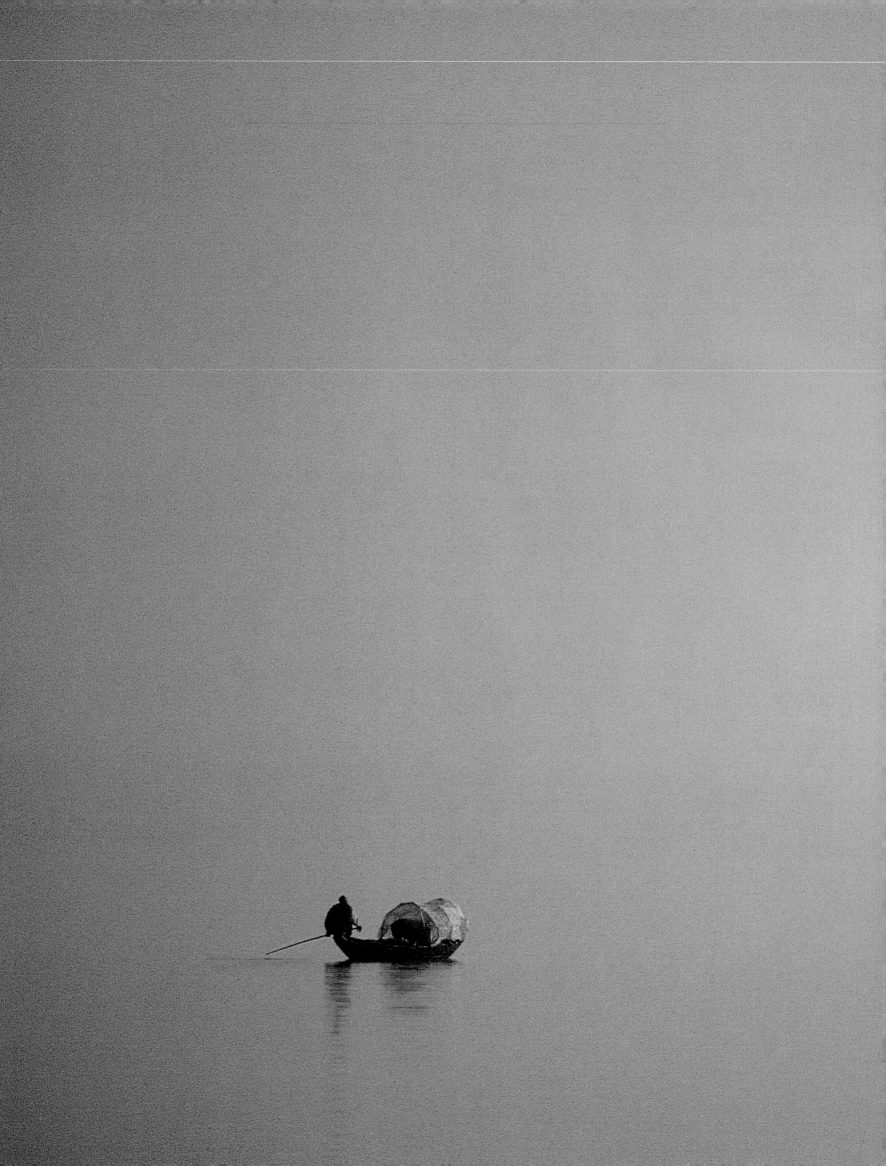

POSTSCRIPT

1.

THE SAHARA TEAM reunited for the *Himalaya* journey. Our beloved General, Roger Mills, assisted by Vanessa (Madame C) Courtney, guided us through the rocky waters of Pakistan, India and Bangladesh. John Paul Davidson (JPD) took us through the heart of the range in Nepal, Tibet and China with the help of Claire Houdret and Nina Huang, and then through Assam, Nagaland and Bhutan with Havana Marking, Natalia Fernandez and Yangden Dorjee. Father and son team Nigel (Quasi) and Peter (Junior) Meakin operated the cameras while John Pritchard recorded the sound – until he was struck down by altitude sickness in Tibet, and Chris Joyce made a valiant effort in filling his enormous shoes in China and Bhutan. And there's Michael Palin, who kept walking in front of the camera and making long speeches throughout the entire journey. Here are a few glimpses behind the scenes from the filming of the *Himalaya* series.

2.

5.

9.

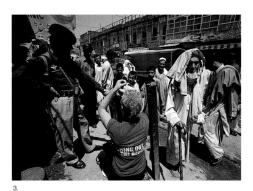

2.

6.

10.

3.

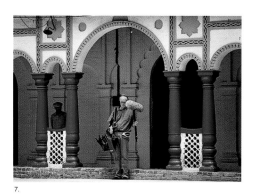

7.

11.

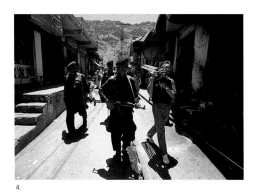

4.

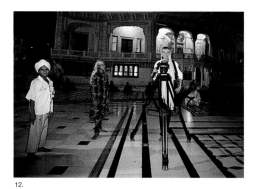

8.

12.

1. The Meakin Brothers up to their usual high jinks near Lowari Pass, Pakistan.

2. Quasi and tripod come down to earth in the North-West Frontier, Pakistan.

3. Junior doing some 'high-security loading' in Peshawar, Pakistan.

4. Mike with his posse of bodyguards in Darra Adam Khel, Pakistan.

5. John feeling up Prince Malik Ata in Taxila, Pakistan.

6. Nigel and a soldier suffering from AMS on board the helicopter in Concordia.

7. John recording the muezzin call at the mosque in Chitral, Pakistan.

8. General Mills lights up at the Chitral Fort, Pakistan.

9. Junior plays with reflector while John tidies up the palace in Lahore, Pakistan.

10. The crew filming at their favourite location, a brewery in Islamabad, Pakistan.

11. Quasi Meakin stars in 'Legless in Amritsar', India.

12. Madame C – Goddess of Tripod – at the Golden Temple in Amritsar, India.

13. Nigel and a Tibetan nun at the Astrology Centre in Dharamsala, India.

14. General Mills directing the troops from the rear in Srinigar, Kashmir.

15. A gang of football hooligans on holiday, Lake Dal in Srinigar, Kashmir.

16. Michael and Adrian on their way to Lekhani to meet the Maoists, Nepal.

17. The crew filming Gurkha recruitment in Lekhani, Nepal.

18. An early-morning jibe-arm shot at the campsite in Lekhani, Nepal.

19. Claire working the phones on location in Bhaktapur, Nepal.

20. Junior Meakin powering along out of Derali towards base camp, Nepal.

21. The crew on the final crawl towards Macchapuchare Base Camp, Nepal.

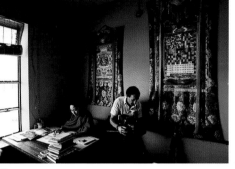

13.

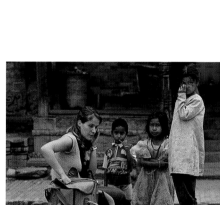

17.

20.

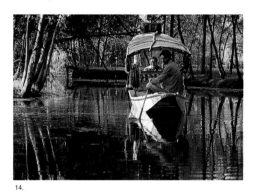

14.

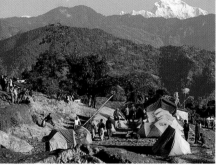

18.

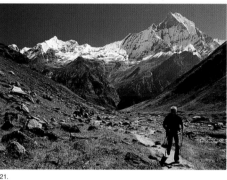

21.

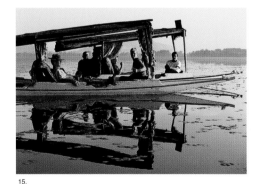

15.

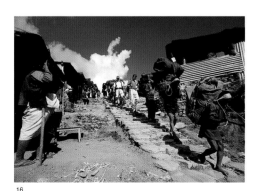

16.

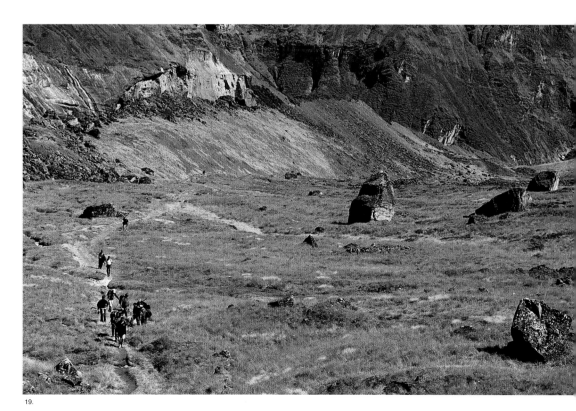

19.

FILMING IN THE HIMALAYA

22. The crew filming outside the cave of Milarepa, the great Tibetan saint.

23. The crew moving slowly at the 17,000-ft Tong La Pass, Tibet.

24. Multi-award-winning Sound Recordist versus Headhunters in Nagaland.

25. Migmar taking a bit of yak for a walk at Rongbuk guesthouse, Tibet.

26. JPD befriending a pit-roast contender in Gyantse, Tibet.

27. Michael churning yak butter in a nomad's tent in Qinghai.

28. John chasing a yak in Qinghai.

29. John recovering from chasing a yak in the People's Hospital in Lhasa, Tibet.

30. JPD directs in the nude in sub-zero temperatures at the Yangbaijing, Tibet.

31. Chris Joyce, John's body double, strikes a pose at Lugu Lake, Yunnan.

32. Nina beating the pants off Yang in Chinese chess at Tiger Leaping Gorge.

33. JPD doing a bit of set dressing with Yunnan ham in Namu's childhood home.

34. Quasi with the drummer boys of Majuli in Assam.

35. Nigel and JPD searching for missing shots at Jomolhari Base Camp, Bhutan.

36. JPD inside his tent, commonly referred to as the 'hamster nest', Bhutan.

37. The crew at the Paro Tsechu with the Lord of Death, Bhutan.

38. The Atsara (jester) introduces the film magazine to his phallus, Paro, Bhutan.

39. The Meakins fiddle about while Mike pretends to write at the Paro Dzong.

40. 'Take me home now!' Nigel and John in Dhaka traffic, Bangladesh.

41. A P2C (Piece to Camera) in the middle of the Buriganga River, Bangladesh.

42. Setting up the last shot of the series at the Bay of Bengal.

22.

25.

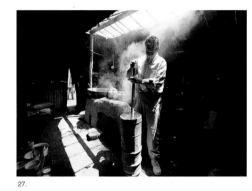

27.

23.

26.

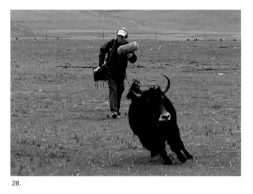

28.

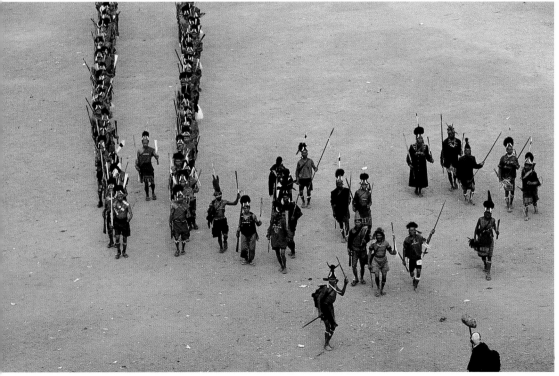

24.

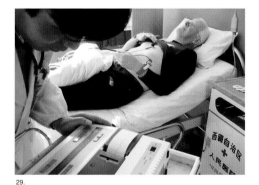

29.

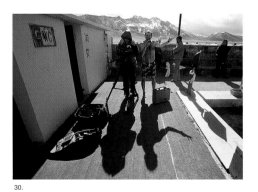

30.

31.

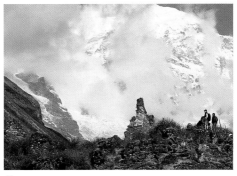

35.

32.

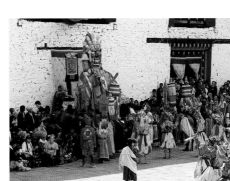

36.

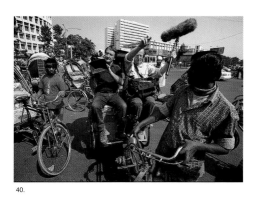

40.

33.

37.

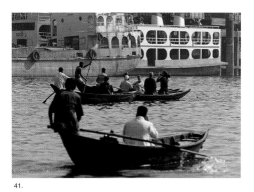

41.

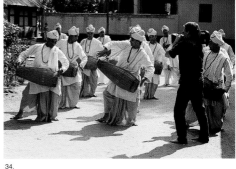

34.

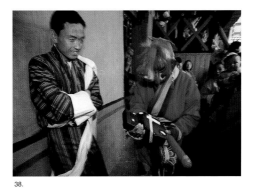

38.

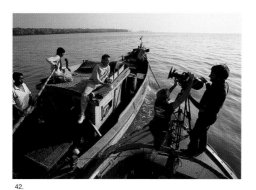

42.

39.

After

nearly 30 years, tears for the dead finally came on flight TG320 from Kathmandu to Bangkok. Before George can finish the first refrain of 'While my guitar gently weeps…', tears are pouring down my face like a broken dam, dripping off my chin and onto the iPod in my lap. I turn my face away from the woman sitting next to me. Outside, the blurry outline of the Himalaya sparkles in the morning light.

I cry on planes, a lot, that's no secret. Sonia never tires of recounting to her friends how her father once bawled his eyes out on a London-Hong Kong flight during the movie *Independence Day*, when Will Smith decides to marry the stripper (sorry, exotic dancer) before going off to 'kick some alien arse'.

But these tears are different. They are not the aftermath of jetlag, or the unwitting emissions of twisted passions speeding at 500 miles an hour 30,000 feet in the air. They are drops squeezed from a heart of stone, through floodgates broken by fear; a flow of grief and guilt and shame for all the loved ones who have passed away without my ever shedding a single tear. Not even in private; not until now.

One week before, while I lay semi-conscious in the stone hut at Macchapuchare Base Camp, inside the palm of the Annapurna, they all came around for a visit. I was gasping for breath in between fits of gut-wrenching coughs – a strangely comforting affirmation that I was still alive and unwell. As I floated along the edge of sleep and sentience, they came. One after another, they appeared in the pitch-black room, a space so utterly cold and dark and silent that it may as well have been the *bardo*.

As I fought off images of exploding porcupines, gladiators in spiked armour wrestling giant crocodiles inside my chest and Cinderella stuffing her broken slippers down my throat, visions of my friends' lives, and sometimes their violent deaths, played out on the spectral screen that enveloped my feverish brain. Shivering from irresistible chills in the core of my bones, I sweated out the burning hallucinations spawned by flu and fear, and struggled to stay awake. More than once through the long bitter night, I thought if I went to sleep, I would not wake again.

Clapton's exquisite solo cuts through the reverie. Ignoring the tears that continue to gush from my eyes, and the furtive glances from my fellow passenger, who is politely pretending to be engrossed by her in-flight magazine, I sit stone-still through the turmoil inside, while the music washes over me, with a tremendous feeling of relief. I remain frozen like a statue for most of the flight, as song after song pulls at the heartstrings, loosening the knots and unlocking the secret dungeons where deep feelings buried in long-forgotten memories struggle with each other for liberation.

Finally, the music stops; the programme has run through the entire W, X, Y and Z songs and is back on main menu. I wipe the tears from my face with the back of my hand and glance out the window. The mountains are gone; in their place is the gaping mouth of the Bay of Bengal and the immense flood plain beyond. The confluence of the Ganges and the Brahmaputra rivers sprawls out to the horizon like the roots of a massive tree, or perhaps arteries of a giant's heart.

By nightfall, the top respiratory specialist in Hong Kong will either check me into a hospital, or warn me to take it easy on the cocktails. One way or another, in ten days' time, ready or not, I will be up at Everest Base Camp in Tibet, over 17,500 feet above the rivers below.

Twelve days later, everyone is suffering. Apart from the Tibetan contingent, the rest of the crew is wandering around with a slight daze in their eyes, if not lying flat out in bed recovering from the day's filming. Earlier, I'd attempted to do t'ai chi, hoping to improve my circulation. But the body gave out completely about three-quarters of the way through the set of exercises, just as I was 'fishing for a needle in the bottom of the sea'.

Half an hour later, I'm still trying to catch my breath. Inside the courtyard of the Rongbuk Guesthouse, Migmar walks by with an enormous dried leg of yak on his shoulder and a big grin on his face. A herd of 15 yaks is parked helter-skelter in between the Land-cruisers, while the nomads gamble with the cooks in the kitchen. As I sip my tea on a broken bench, waiting for the light to be right, it occurs to me that altitude sickness is a bit like jet lag in reverse. Instead of the physical being waiting for the spirit to arrive like a piece of lost luggage, up here, it is the soul that has to loiter around while the body is out somewhere searching for oxygen. The realization depresses me; this kind of disconnect is surely bad news for photography, where a split-second can be an eternity. I worry about leaving Tibet empty-handed.

The wind picks up and the temperature drops dramatically, a grim reminder that we have chosen to be in Tibet at the onset of winter. In the distance, the north face of Everest catches fire in the evening sun, as a tongue of orange cloud peels away from the mountain to reveal the highest peak in the world.

'How are you feeling, John?' 'Oh fine, fine, absolutely fine.' He croaks; his face is grey in the fading light. It is obvious that he is anything but fine. But that's just John's way of coping, not wanting to be any trouble to anyone. He would have said the same thing had I asked him if he would like to have Rat and Kidney Pie with a glass of 1968 Bat's Piss for supper. Outside, night is falling as our convoy winds its way up another set of dirt tracks. The 200-mile journey from Shigatse is, as usual, taking a lot longer than what we've been told, and we'll be lucky if we make it to Lhasa before midnight. John's date with the doctors will have to wait until the morning.

'Are you sure you're alright, do you want a green-job? How about some oxygen?' 'No, no, I'm fine. I think there's still some left in here.' He lifts his head towards me as he holds up the aerosol can. I catch a whiff of his breath and a shiver runs up and down my spine. It is a smell that you never forget. The last time I was so close to it was at the Queen Mary Hospital in Hong Kong, where my grandfather whispered his last words into my left ear 30 years ago. It is the unmistakable sickly-sweet aroma of death.

If the Sahara journey was about survival, then the Himalaya was about coming to terms with mortality. It was not so much that this journey was any more dangerous or life-threatening than the previous ones, because it wasn't; we had been in more difficult places and stickier situations. Apart from the unpredictable effects of prolonged

exposure to high altitudes and travelling around the Afghan-Pakistan border during the Iraq invasion, we were familiar with all the different risks involved. And having travelled together for all these years, we knew that there are at least two certainties in this life on the road where change is the only constant: asparagus will make your pee smell funny, and death will come to us all some day. So, psychologically, we were prepared.

And I took it as a given that the 'Meaning of Death' would come up in conversation because it is an integral part of the territory. After all, the Buddha first penetrated its mysteries in the foothills of Nepal, inside the shadow of the Himalaya. And the knowledge of its secrets, recorded in sacred texts such as *Bardo Thoedrol* (Book of the Dead), were kept hidden for centuries in remote monasteries on top of inaccessible mountains inside the Tibetan plateau. And even though I'm still a little fuzzy on the actual logistics of reincarnation, such as, what do I have to do to avoid coming back as a three-legged dog in a third-world country or as a village idiot in Texas? I am comfortable with the concept that death is not an end but another beginning, and that the soul retains its essence after leaving the body. So, intellectually, I was ready for it. But, as I was to discover later, it was one thing to accept something intellectually, and quite another to have the bastard knocking at your door.

But what I could never have anticipated was the emotional burden of being inside the hypnotic powers of the Himalaya. Everything, from the dirt tracks, strewn with the rubble of the last rock fall, on which we travelled, to the minute figures working the tiny strips of green terraces clinging to monumental rock faces, carried a psychological weight. Because the awesome and omnipresent peaks were a constant reminder of their own violent birth and the fragility and insignificance of the human lives existing under them. Along with the seemingly endless stream of news about the passing of friends or family members on deathwatches, the shadow of mortality grew longer by the day, until it became almost a constant companion for the best part of the journey.

Yet the mountains continued to amaze us each day with indescribable beauty. And despite the long string of illnesses inflicted on the crew, we continued to be inspired by the vitality and dignity with which the people of the Himalaya conducted their harsh lives against insurmountable odds. In the end, I think it was the combination of this indomitable spirit of the people and the spectre of imminent oblivion that hung all over us like a bad suit that galvanized us to push harder even as our bodies grew weak. To treasure life itself and learn to value every moment.

Being up in the Himalaya has taught me more about myself than perhaps any of the previous journeys. Sometimes I feel as if I've been deconstructed and rebuilt again by the same energy that created the mountain range when the plates collided 50 million years ago. And by the time you read this, hopefully you will have gleaned from the pages how much I love and admire its people. This book is for them, a celebration of their beautiful spirit and their breath-taking home, *Viva Himalaya!*

Basil Pao. June 2004.

ACKNOWLEDGEMENTS MY GRATEFUL THANKS TO EVERYONE WHO MADE
THE HIMALAYA JOURNEY POSSIBLE AND THIS BOOK A REALITY. THANK YOU
FOR YOUR FRIENDSHIP, GENEROSITY, HARD WORK AND SUPPORT, I HOPE
YOU WILL ENJOY THIS BOOK AS MUCH AS I HAVE ENJOYED MAKING IT.

SPECIAL THANKS TO STEVE ABBOT, ISHRAQ AHMED, DHASHA BENJI,
PAUL BIRD, MIRABEL BROOK, VANESSA COURTNEY, JENNIFER CONDELL,
HIS HOLINESS THE DALAI LAMA, JOHN PAUL DAVIDSON, YANGDEN DORJEE,
DOJE, MICHAEL DOVER, LYN DOUGHERTY, NATALIA FERNANDEZ, SUE GRANT,
CLAIRE HOUDRET, LHAMU NINA HUANG FAN, JUSTIN HUNT, RICHARD HUSSEY,
ANNE JAMES, CHRISTIAN JOYCE, STELLA LAI, LI BEN ZHAO, CLAIRE MARSDEN,
DARIO MATINELLI, NIGEL MEAKIN, PETER MEAKIN, ROGER MILLS,
MICHAEL PALIN, JOHN PRITCHARD, DAVID ROWLEY, AUSTIN TAYLOR, TSE XIU,
MIGMAR & TEAM, DUKAR TSERING, MAQSOOD UL-MULK, SHERPA WANGCHU
& TEAM, & HOLLY WILLIAMS.

THIS BOOK IS BASED ON THE SERIES HIMALAYA WITH MICHAEL PALIN

WRITTEN BY MICHAEL PALIN
SERIES PRODUCER & DIRECTOR: ROGER MILLS
PRODUCER/DIRECTOR: JOHN PAUL DAVIDSON,
CAMERA: NIGEL MEAKIN, PETER MEAKIN
SOUND: JOHN PRITCHARD, CHRISTIAN JOYCE (CHINA, BHUTAN)
LOCATION MANAGERS: VANESSA COURTNEY (PAKISTAN, INDIA, BANGLADESH)
CLAIRE HOUDRET (NEPAL, BHUTAN), NINA HUANG (TIBET, CHINA)
HOLLY WILLIAMS (CHINA) HAVANA MARKING, NATALIA FERNANDEZ (ASSAM)
YANGDEN DORJEE (BHUTAN)

FILM EDITORS: ALEX RICHARDSON, SASKA SIMPSON (CHINA, ASSAM)
MUSIC: ANDRE JACQUEMIN & DAVE HOWMAN (PASKISTAN, INDIA)
DAVID HARTLEY (NEPAL, TIBET, CHINA) DUBBING MIXER GEORGE FOULGHAM
TITLE SEQUENCE & GRAPHICS: BERNARD HEYES DESIGN

EXECUTIVE PRODUCERS: ANNE JAMES, STEVE ABBOT
PRODUCTION MANAGERS: MIRABEL BROOK, SUE GRANT
PRODUCTION CO-ORDINATOR: NATALIA FERNANDEZ
PRODUCTION ACCOUNTANT: LYN DOUGHERTY

A PROMINENT TELEVISION PRODUCTION FOR BBC

FIRST PUBLISHED IN UNITED KINGDOM IN 2004 BY WEIDENFELD & NICOLSON.
REPRINTED 2004.
ISBN 0 297 84370 2
DESIGNED BY BASIL PAO. ASSOCIATE DESIGNER: STELLA LAI
PRINTED AND BOUND IN ITALY BY PRINTER TRENTO
WEIDENFELD & NICOLSON, WELLINGTON HOUSE, 125 STRAND, LONDON WC2R 0BB

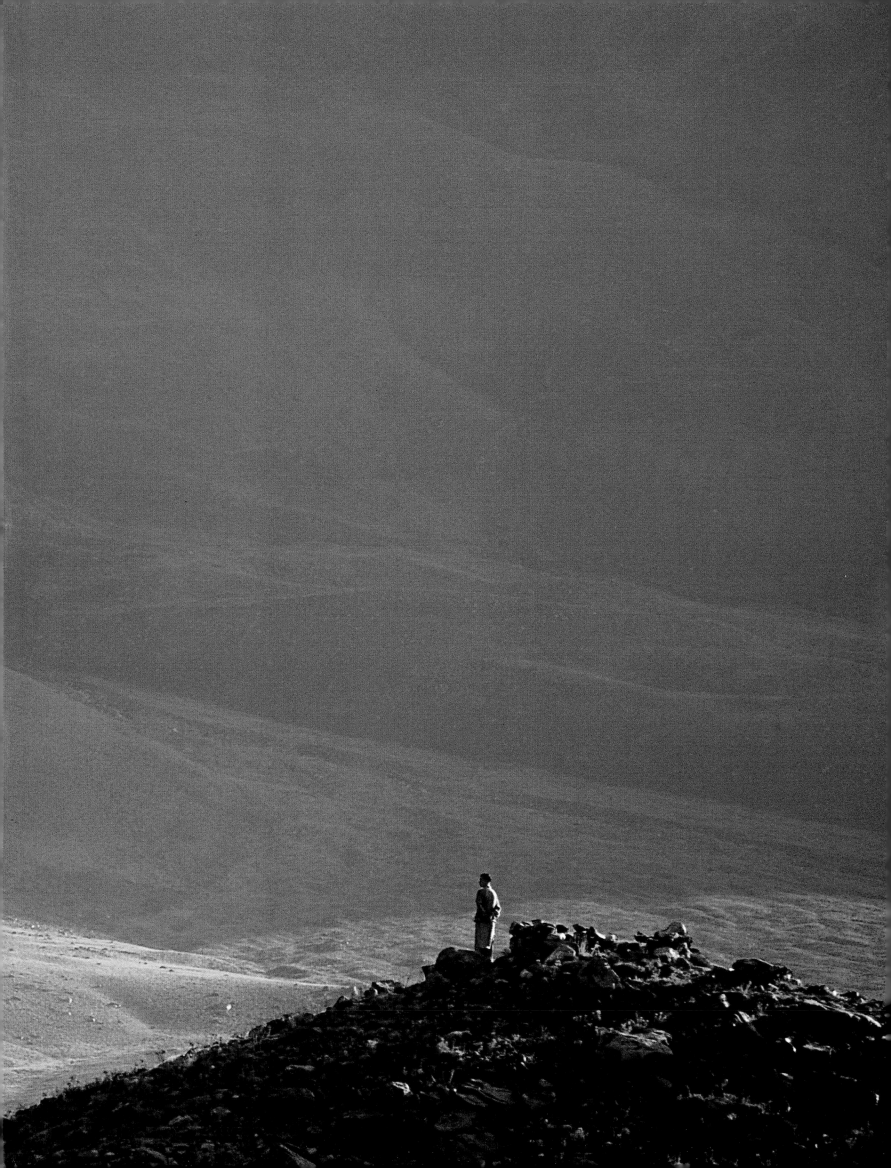

GOOD PEOPLE SHINE FROM AFAR, LIKE THE PEAKS OF THE HIMALAYA;
BAD PEOPLE ARE NOT SEEN HERE, LIKE ARROWS SHOT BY NIGHT.

FROM THE DHAMMAPADA BY THE BUDDHA

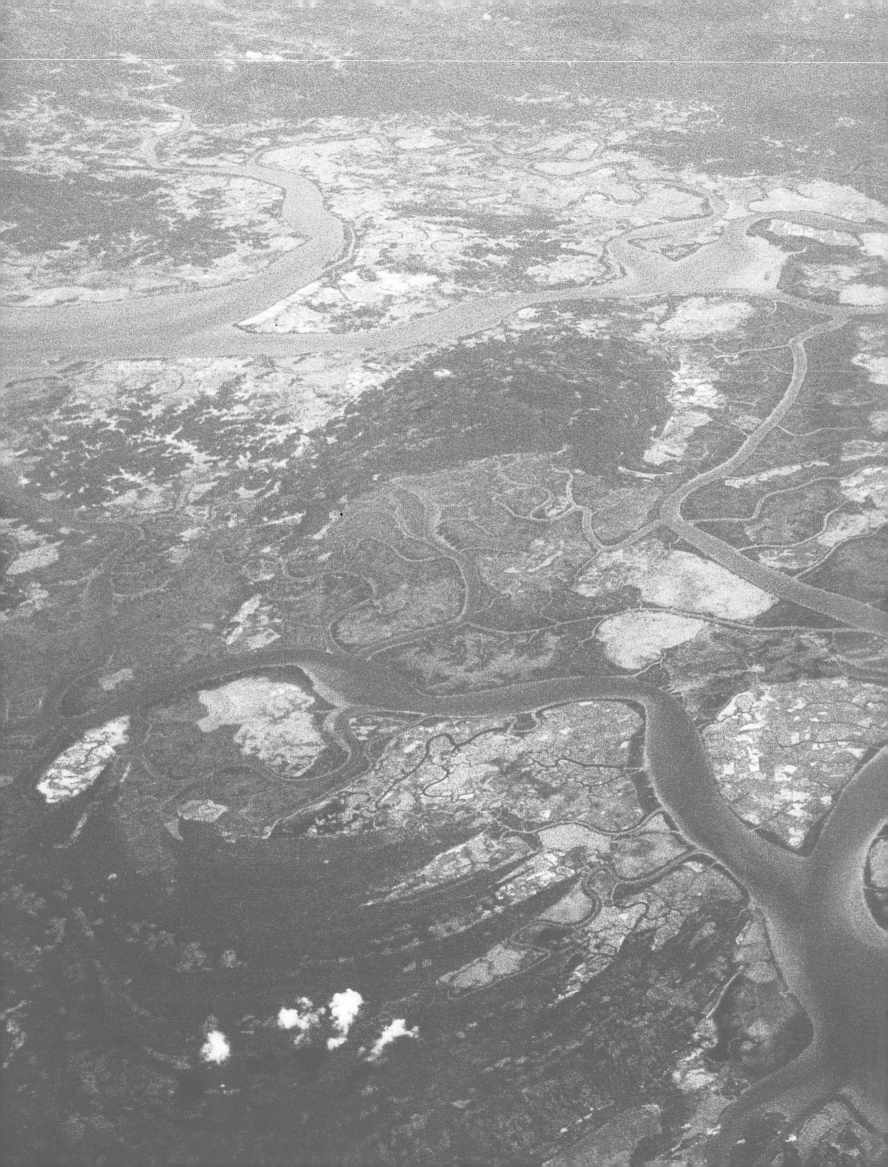